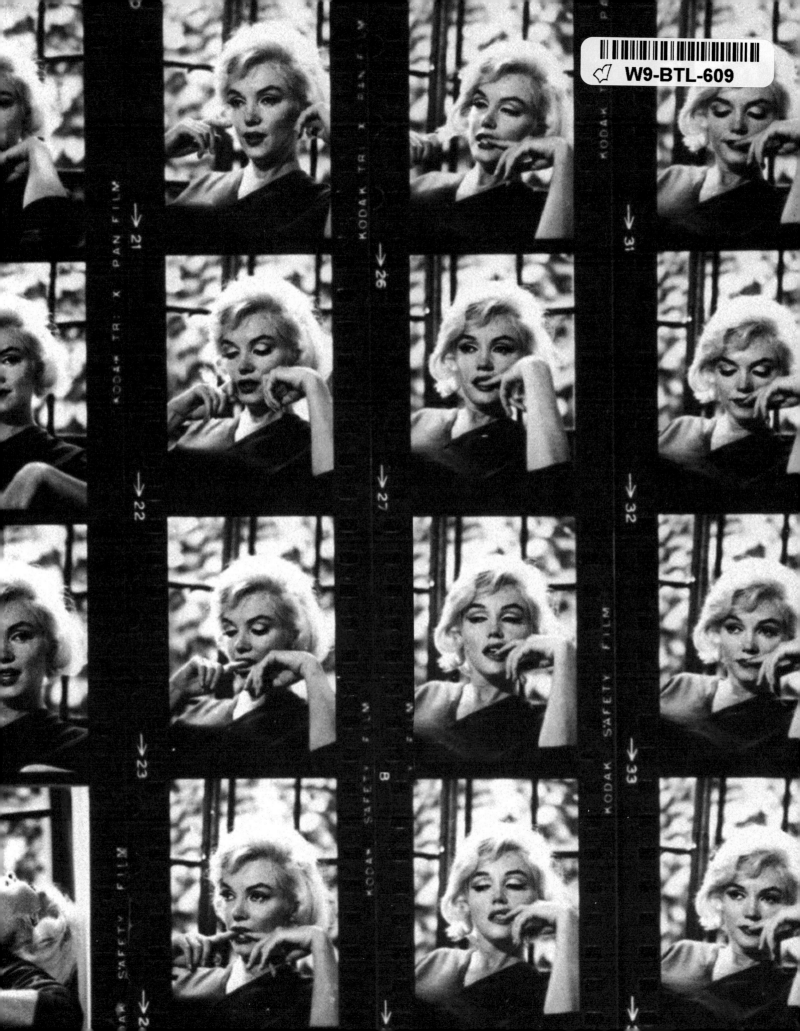

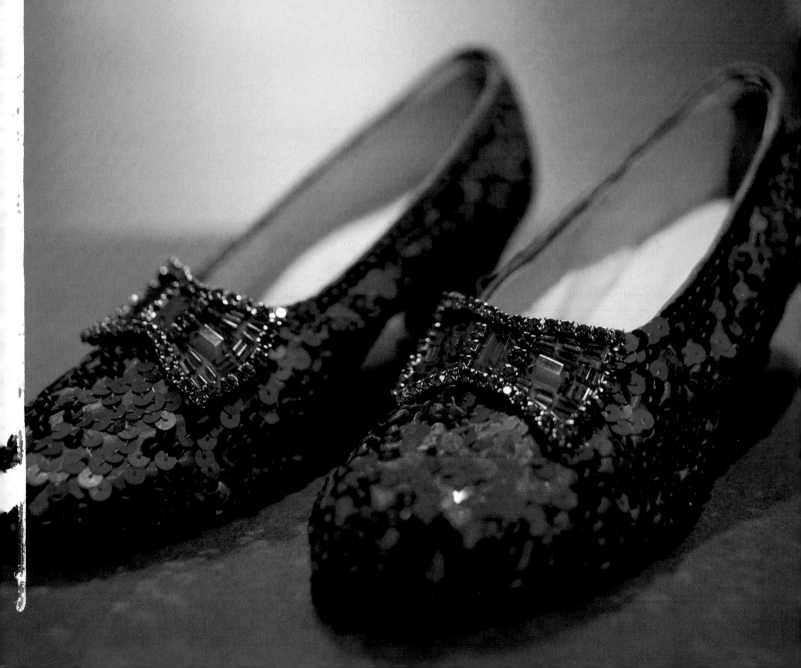

LIFE

Gone Too Soon

*Their Lives Were
Not Long
But Mattered*

..., Ada Skarl (Paris)

President Andrew Blau
Business Manager Roger Adler
Business Development Manager Jeff Burak

Editorial Operations Richard K. Prue (Director), Brian Fellows (Manager), Keith Aurelio, Charlotte Coco, Tracey Eure, Kevin Hart, Mert Kerimoglu, Rosalie Khan, Patricia Koh, Marco Lau, Brian Mai, Po Fung Ng, Rudi Papiri, Robert Pizaro, Barry Pribula, Clara Renauro, Hia Tan, Vaune Trachtman

Time Home Entertainment

Publisher Richard Fraiman
General Manager Steven Sandonato
Executive Director, Marketing Services Carol Pittard
Director, Retail & Special Sales Tom Mifsud
Director, New Product Development Peter Harper
Director, Bookazine Development & Marketing Laura Adam
Publishing Director, Brand Marketing Joy Butts
Assistant General Counsel Helen Wan
Book Production Manager Suzanne Janso
Design & Prepress Manager Anne-Michelle Gallero
Brand Manager Roshni Patel

Special thanks: Christine Austin, Jeremy Biloon, Glenn Buonocore, Jim Childs, Susan Chodakiewicz, Rose Cirrincione, Jacqueline Fitzgerald, Carrie Frazier, Lauren Hall, Malena Jones, Brynn Joyce, Mona Li, Robert Marasco, Kimberly Marshall, Amy Migliaccio, Brooke Reger, Dave Rozzelle, Ilene Schreider, Adriana Tierno, Alex Voznesenskiy, Vanessa Wu

Published by LIFE Books,

an imprint of Time Home Entertainment Inc.
135 West 50th Street
New York, New York 10020

ISBN 10: 1-60320-143-2
ISBN 13: 978-1-60320-143-8
Library of Congress Control Number: 2010939520

"LIFE" is a registered trademark of Time Inc.

We welcome your comments and suggestions about LIFE Books.
Please write to us at:
LIFE Books
Attention: Book Editors
PO Box 11016
Des Moines, IA 50336-1016

If you would like to order any of our hardcover Collector's Edition books, please call us at 1-800-327-6388.
(Monday through Friday, 7:00 a.m.— 8:00 p.m. or
Saturday, 7:00 a.m.— 6:00 p.m. Central Time)

Endpapers: Marilyn Monroe at her Brentwood, California, home during her last-ever interview. The piece ran in LIFE on August 3, 1962, two days before Monroe died at age 36. Please see page 44. *Photograph by Allan Grant*

Previous page: Dorothy's ruby red slippers, once worn by Judy Garland. Please see page 114. *Photograph from Everett Collection*

Right: Saluting Robert F. Kennedy's funeral train. Please see page 19. *Photograph by Paul Fusco/Magnum*

LIFE

Gone Too Soon

*Their Lives Were
Not Long
But Mattered*

LIFE

Gone Too Soon

*Their Lives Were
Not Long
But Mattered*

Opposite: John Belushi.
Please see page 56.

KEN REGAN/CAMERA FIVE

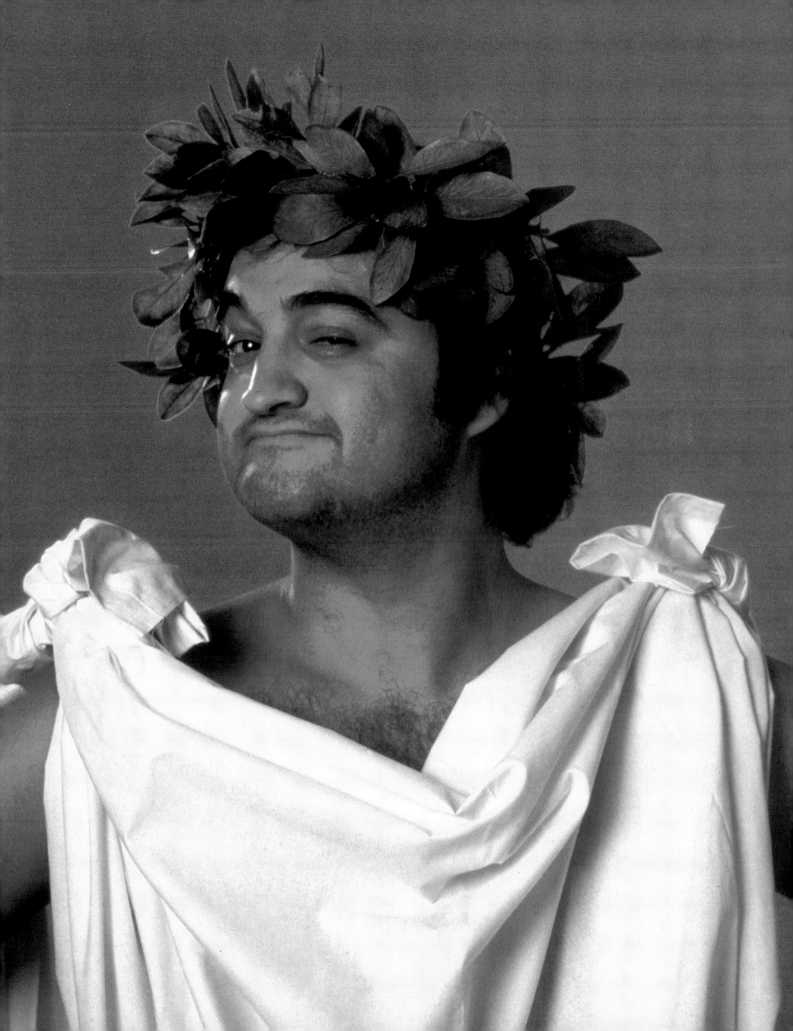

"Did you hear?"

YOUR FRIEND COMES UP TO YOU, puts a hand gently on your elbow, and asks if you've heard the news. You will remember that moment—the time, the place, the friend, the particular slant of light, the scent in the air—for the rest of your life.

Where were you when you learned John F. Kennedy or Robert F. Kennedy or Martin Luther King Jr. had been assassinated? Where were you when you heard the news about Janis or Jimi or Jim—or Elvis or John or Kurt? Where were you when someone told you Michael Jackson had died, and you said to yourself: *No, that can't be right.*

But the news bearer was always right, because a person dying before his or her time is nothing to joke about, nothing to be uncertain about.

The deaths of the people we celebrate in these pages stunned us, or others who came before us. Certainly many Americans of the time could recall exactly where they were when they learned of Abraham Lincoln's death, and millions of movie fans in countries around the world froze on the spot when they heard that Valentino was gone. This is not a new phenomenon.

We react in this way because of love. We loved these people. We idolized some, respected others, were entertained or influenced or inspired by many more. Each of them came to occupy a special place in the fabric of our lives. And then they left us. Too soon.

We have used the word *celebrate*. Indeed, this book is intended as a celebration. We come not to mourn these many personalities—that time has passed—but to revisit and hopefully rekindle the spirit that made them matter. Coming alive again in the pages that follow is the dynamism of JFK, the beauty of Marilyn Monroe, the hilariousness of John Belushi and Gilda Radner, the preternatural cool of Steve McQueen, the thrill that swept the arena when Elvis Presley hit the stage. If it is not quite the same as it was when they were with us—how can it possibly be?—these words and intimate pictures

CARL MYDANS

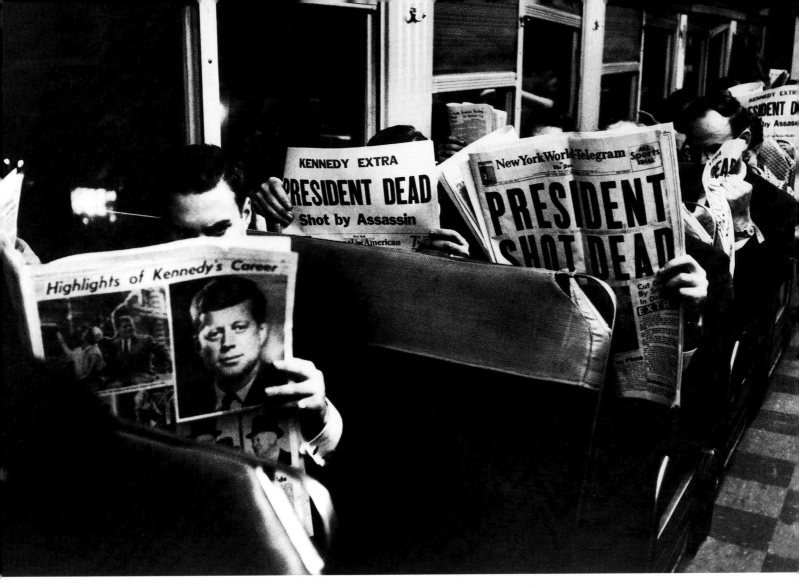

nevertheless take us close. One of the subjects herein, the singer-songwriter Jim Croce, wrote in "Photographs and Memories": "All that I have are these/to remember you by." That's true, and therefore we gather together in these pages mementos of times gone by, and of special people who were gone too soon.

So, now: Look.

Remember.

Celebrate.

A FINAL NOTE TO SHARE, if we may: We here at LIFE Books celebrate and remember now our beloved colleague Hildegard Anderson, who recently passed away. Hildie had a long and accomplished career in journalism, and brought great talent, intelligence and enthusiasm to the office every day. We miss her dearly, and this book is dedicated to her memory.

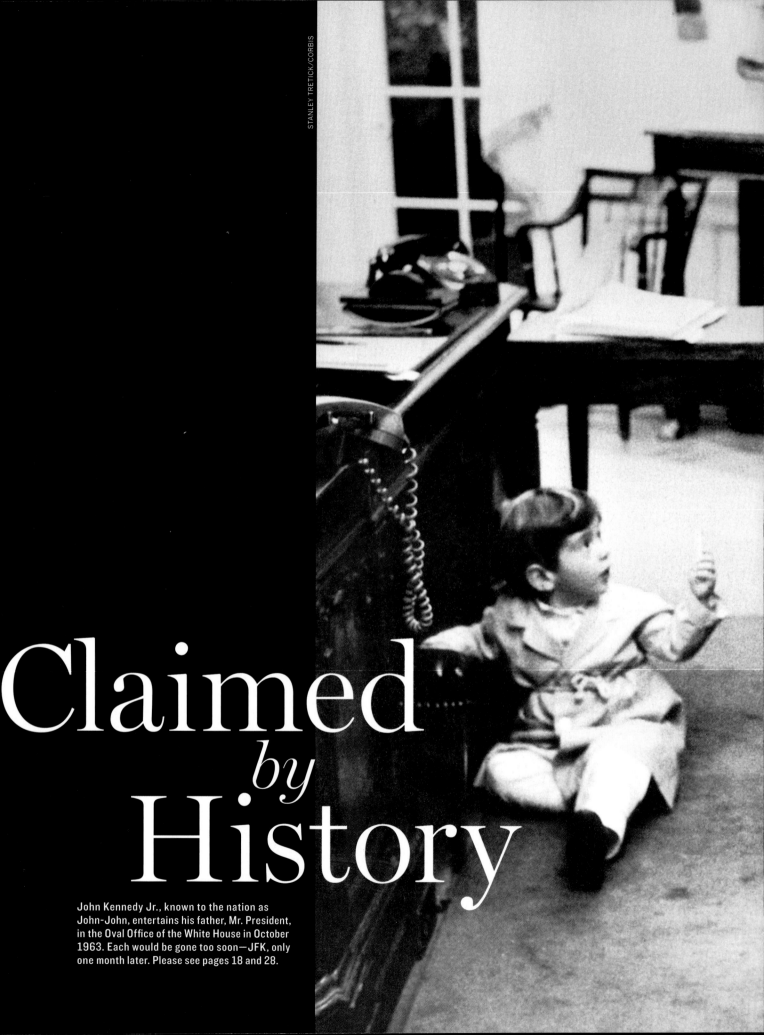

Claimed
by
History

John Kennedy Jr., known to the nation as John-John, entertains his father, Mr. President, in the Oval Office of the White House in October 1963. Each would be gone too soon—JFK, only one month later. Please see pages 18 and 28.

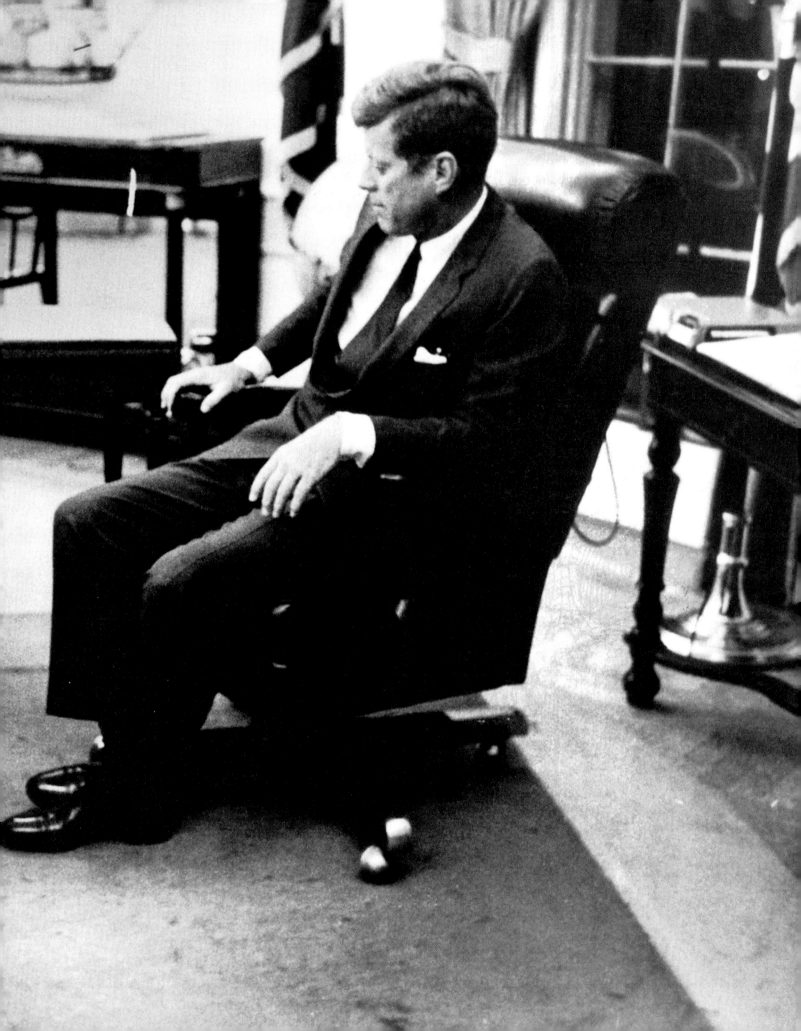

King Tut

COURTESY SUPREME COUNCIL OF ANTIQUITIES AND NATIONAL GEOGRAPHIC SOCIETY

Circa 1341~1323 B.C. TUTANKHAMUN, AN EGYPTIAN PHARAOH of the New Kingdom, offers an irresistible place to start our exploration of those who left the scene too soon—not necessarily because he was grievously mourned (we can only speculate) or showed a predestination for greatness (we cannot know), but because, ever since the 1922 discovery of his tomb near Luxor, we do know that he died young—he was only 18 or 19 years old (opposite, a rendering based on CT scans of his mummy)—and might have had a much larger impact than he did. As it was, he ruled for a decade, seems to have fathered two daughters, and issued edicts concerning which deities were acceptable for the Egyptian citizenry. He was assassinated, say some, but the wider view is that he died of malaria, or of an infection after suffering a bad broken leg, or of complications from both.

Tut, in his modern-day celebrity (his most enduring legacy, thanks to his reliquary, is certainly to tourism), has come to symbolize the youthful ruler as victim of events. But even in the historical epochs before Christ, he is not alone. There was Alexander the Great, for instance, who in the fourth century B.C. conquered most of the civilized world, then died of a fever in his early thirties. And there was Cleopatra VII, who sought to rule over the Roman Empire but misplayed her hand and was compelled to do the romantic and noble thing by having an asp bite her, thus ending her colorful life in 30 B.C. Tut, Alexander, Cleopatra: Whether they were gone too soon or soon enough is a matter of conjecture, but as real-world historical figures with storybook tales to tell, they are unbeatable.

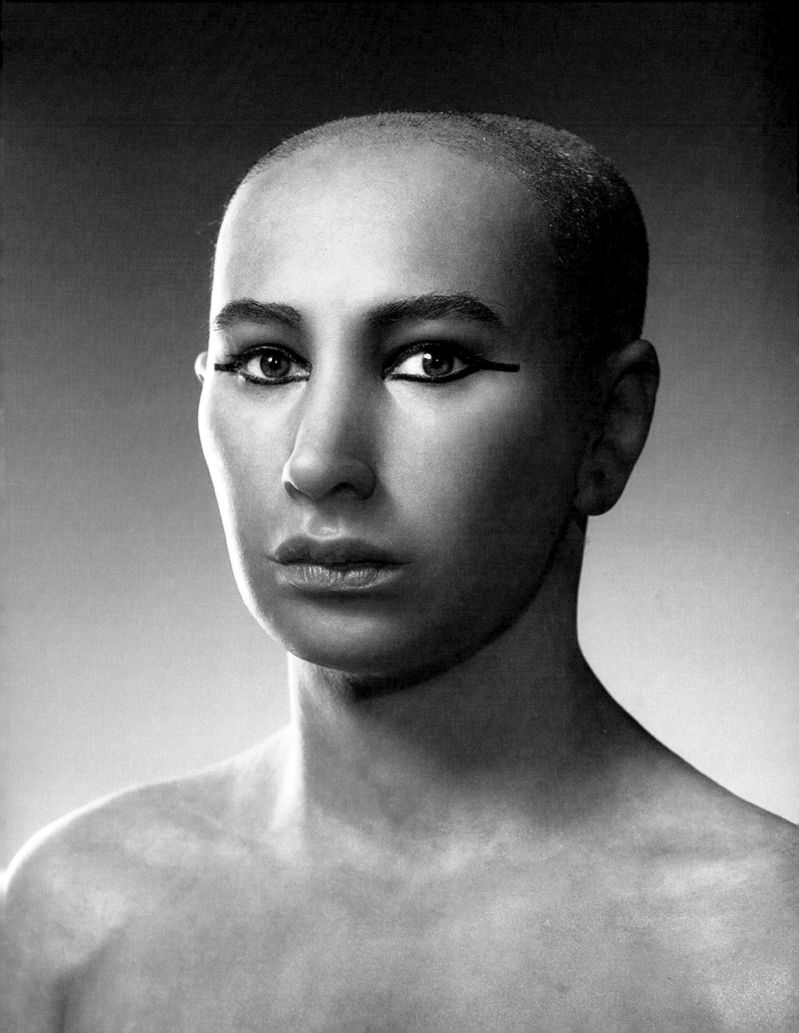

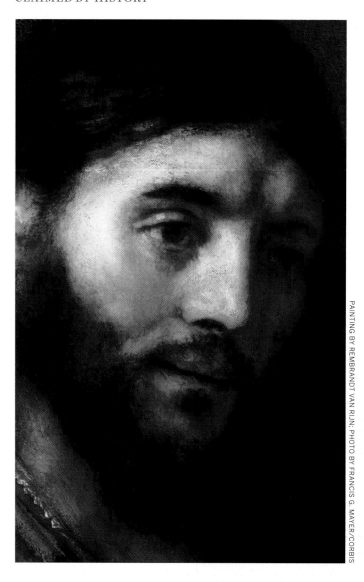

Jesus

Circa 5 B.C.~A.D. 29 THE INFLUENCE OF THE carpenter's son from Nazareth has been so immense, it is often lost that he was, in his fleshly incarnation, but a charismatic adolescent and philosophically brilliant young adult; most historical accounts see him crucified by or shortly after age 32. To picture him as a wizened sage, as many Renaissance artists did, is entirely incorrect. He was, in fact, a radical—a firebrand.

At a time when there was not only strong-arm rule by kings but also, in the streets of the Middle East, greed, violence and lawlessness, notions of pacifism and charity were wholly alien. The idea of giving one's cloak to a needy stranger—a brother, Jesus suggested—did not have much currency in Palestine then. After Jesus was martyred, disciples carried forth his principles bravely and clandestinely. Christianity, though persecuted in its early years, proved unstoppable. After a converted Jew named Paul and the first pope, Peter, took the theology to Rome, where they were killed by the authorities (becoming two more who were gone too soon), the religion slowly rose to become the ruling faith of the empire and eventually the world's largest community of worship. Peter and Paul—and Jesus—were followed by thousands upon thousands of others who died young in the name of Christ. People die in his name, and for his beliefs, today.

Pocahontas

Circa 1595~1617 AS WITH TUT, this is an entry about a historical figure who "represents" a certain aspect of the tragedy that is premature death. The Pocahontas story, in its bare facts as opposed to its romanticism, is, perhaps, about bravery, but it is also about victimhood. Matoaka (her real name) was born the daughter of Chief Powhatan in Virginia. Whether she intervened as a teenager and saved the life of the English colonist John Smith is debated, but even if so, she did not have a love affair with the man. She did later marry the Englishman John Rolfe, had a son, Thomas (opposite), and traveled to Europe, where she died of illness at age 21 or 22. She was in her day and especially later used as a symbol of colonial–Native American amity, and on occasion she may have acted as a catalyst of peace. But in the end, hers stands as a life that might have been much more peaceful—and longer—had the fates of history not intervened.

The life of Sacajawea was different, if today it is similarly legendary—which is to say, distorted. Born near present-day Salmon, Idaho, circa 1788, the teenaged Shoshone certainly did accompany and greatly aid Lewis and Clark on their explorations of the American West. Whether they might have succeeded without her will never be known. She married Toussaint Charbonneau and bore two children before dying of fever in what is now South Dakota in 1812. The U.S. Mint has made a Sacajawea dollar coin to honor this intrepid woman, and Native American lore has her living to the ripe old age of 80 or even 100. As with Pocahontas, we want to touch her heroism, and have it endure.

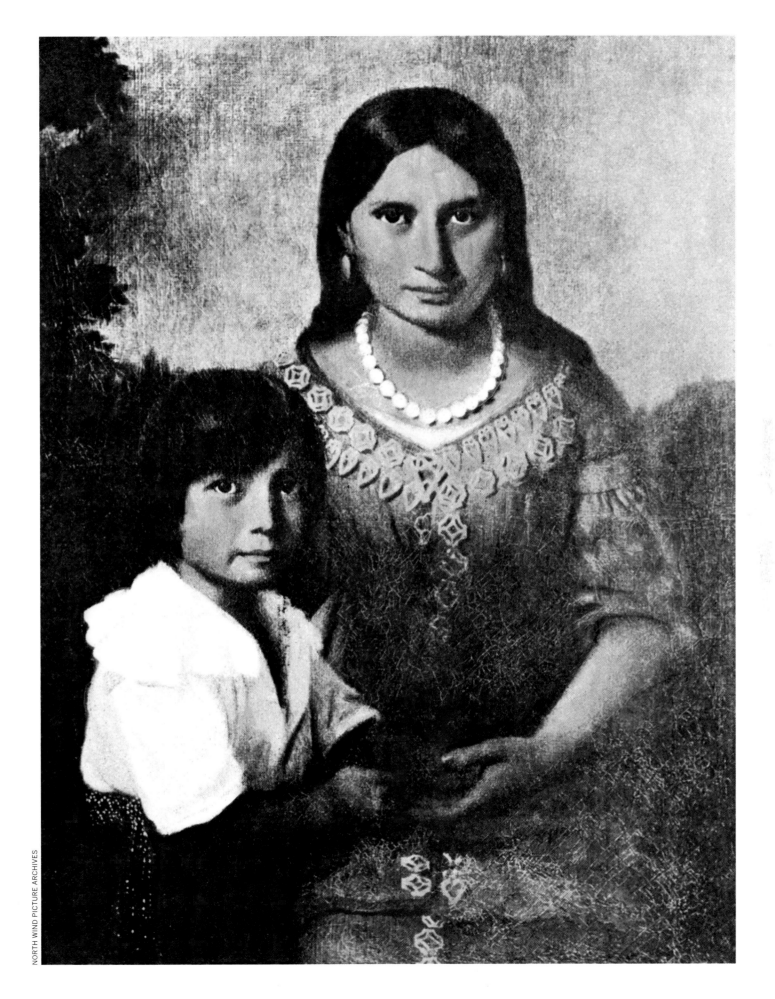

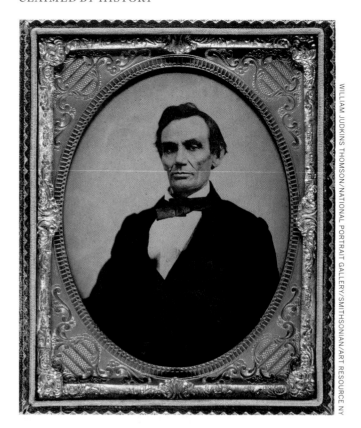

Abraham Lincoln

1809~1865 HE LIVED 56 YEARS in a time when that wasn't an unduly unfortunate human measure, and certainly many of his years were hard ones, and exacted a physical as well as psychological toll. So how is it that we consider him to have been taken too soon? Well, some of the people in these pages must be judged by what more they might have contributed— in this case, what Lincoln might have been just on the verge of contributing—had life and fate not transpired as they did.

To be sure, by the time the assassin's bullet felled the President at Ford's Theatre, Lincoln's had already been a titanic life. It is needless to say that the election of this largely self-taught lawyer-politician to the presidency of the United States was a watershed moment for our nation, and that his perseverance and leadership during the Civil War contributed greatly to who we are today. During the war, he was bold enough to sign the Homestead Act and the Emancipation Proclamation, and he delivered the lofty Gettysburg Address. And then he was cut down. The administration of his successor, Andrew Johnson, was a failure. In fact, Johnson was the first (and for more than a century, the only) U.S. President to be impeached. What might Lincoln (above, in 1858) have done differently? How might Reconstruction have proceeded under his guidance and leadership? We will, of course, never know.

Amelia Earhart

1897~1937 WE ASSERT A YEAR OF DEATH HERE, but as everyone knows, Amelia Earhart didn't die, she "disappeared." This occurred during her attempt to become the first woman to fly around the world when, having already traveled 22,000 miles on earlier legs of her journey— she was three-fourths of the way to her goal—she and her navigator, Fred Noonan, vanished into clouds above the South Pacific. Her last report, as recorded by the ship *Itasca*, was "WE MUST BE ON YOU BUT CANNOT SEE U BUT GAS IS RUNNING LOW BEEN UNABLE TO REACH YOU BY RADIO WE ARE FLYING AT ALTITUDE 1,000 FEET." She and Noonan had been headed for Howland Island, a speck of land barely two miles long. They probably didn't make it, though stories suggesting alternative fates, as well as efforts to find the plane, persevere to the present day.

When the world lost Amelia Earhart, it lost not just an adventuress, but an icon. This woman from the Midwest was more than just a Lady Lindy, she was a role model in her own right. In 1928 she became the first woman to cross the Atlantic in an airplane, and in 1932 she became the first woman to make the crossing solo. She was almost killed on that trip when her Lockheed Vega went into a spin, hurtling toward "whitecaps too close for comfort" before she could pull the plane up. But Earhart survived the plummet and went on to worldwide fame (opposite, in County Derry, Northern Ireland, after that triumphant flight). With her serene beauty and inherent charisma, she became a trendsetter in matters of style; she can be seen as an early feminist flag-bearer. Her legend has only grown greater with her mysterious "disappearance."

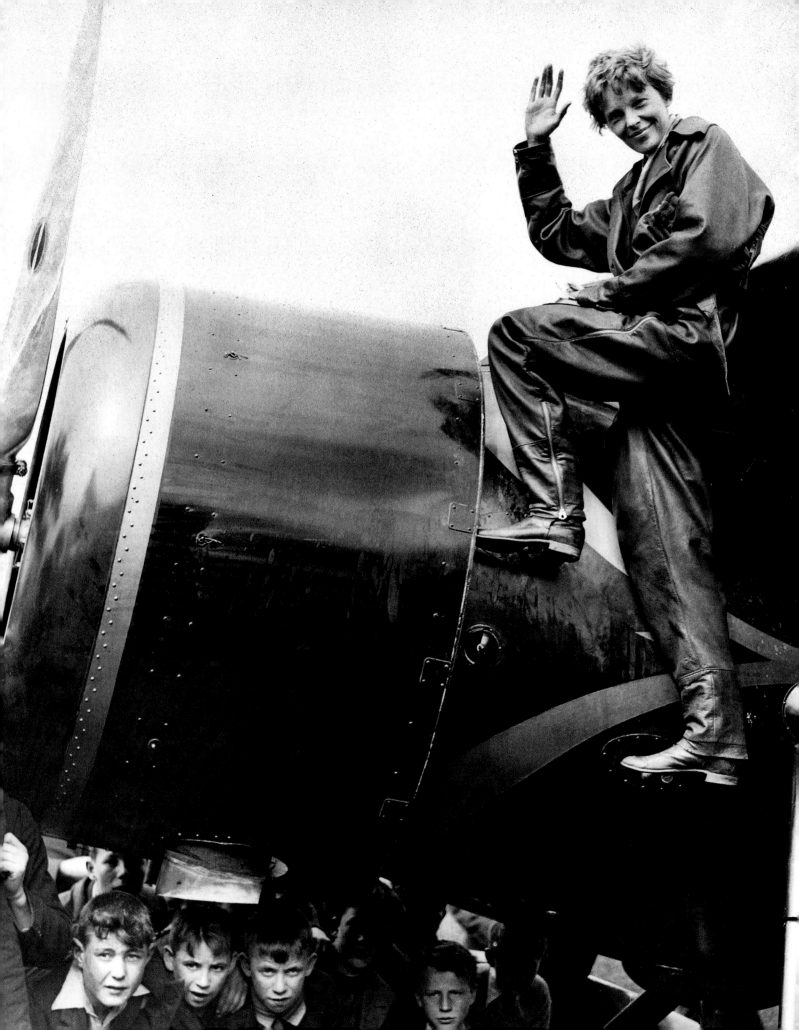

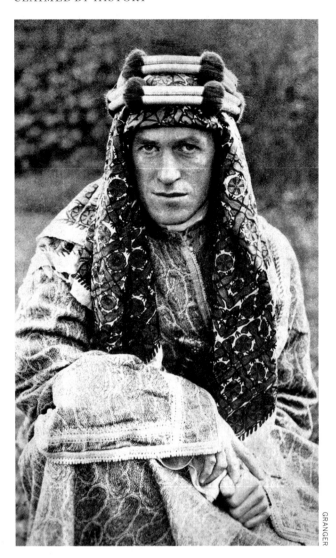

GRANGER

Lawrence of Arabia

1888~1935 HE WAS MORE—and you might say, less—than a big-screen movie. Thomas Edward Lawrence was an exemplar of what can be seen as the old-school, stiff-upper-lip British serviceman, an officer and a gentleman to the ultimate degree. He had already been involved with the British Army during World War I (pictured here during the war), when his actions in the Arab Revolt against the Ottoman Turks (1916–1918), a revolt not only supported by but essentially engineered by the English, made him famous. The politics involved in that conflict matter less to us in considering Lawrence than do the man's intrepid nature: his derring-do and inspiring leadership. He was a soldier who commanded British men quite like himself and Arabian men utterly different from himself. He was unique.

This was made clear in his memoir of the years in Arabia, *Seven Pillars of Wisdom*, and in heart-stopping journalism from the front by the famous Lowell Thomas. If Lawrence of Arabia became more myth than man, this certainly wasn't the first time such a thing had happened with a hero.

And then this dashing figure died young, back in England, crashing one of his motorcycles. Events like this can solidify a legend, and major Hollywood motion pictures that win multiple Academy Awards can cement one. So it was with Lawrence of Arabia.

Anne Frank

1929~1945 AS WE MENTIONED in our introduction, the deaths of many of the people included in this book elicited a public and widespread gasp of sadness or of shock when the word spread that, for example, Abraham Lincoln or Marilyn Monroe or John Lennon had died. In this case, however, who besides her closest relations knew of Anne Frank's passing?

At the time of her death, she was still an adolescent. Anne Frank had been born in Germany and raised, from the age of four, in and around Amsterdam in the Netherlands, which came under Nazi occupation during World War II. The Franks were Jewish, and when official persecution of members of their religion worsened in 1942, the family went into hiding. The diary written by the young teenager, Anne, while she was a de facto prisoner of the Germans, sequestered in hidden rooms in her father's office building, is an altogether extraordinary document: intimate, moving, precociously literary. It was created with no reasonable expectation that it might ever be read by anyone but Anne.

The Franks were betrayed and captured in 1944. Only the father would survive the concentration camps, and he returned to Amsterdam after the war to find, among other things, his daughter's journal. It was published in the Netherlands in 1947, and in English five years later as *The Diary of a Young Girl*. It has become one of the most widely translated and read books in the history of the world, and Anne Frank (opposite, at about 12 years old) has become, like Pocahontas, a transcendent symbol of victimhood, and also of innocent youth caught in the vortex of events.

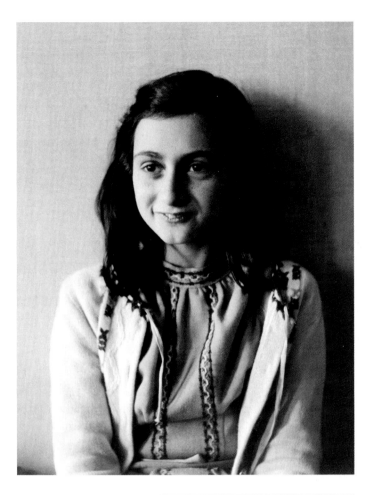
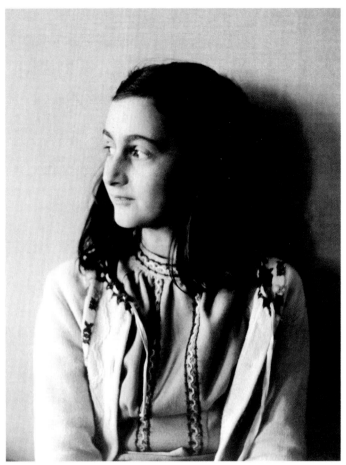
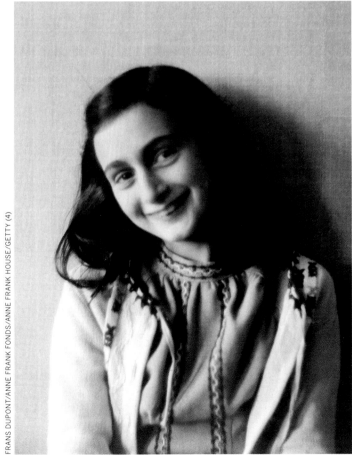
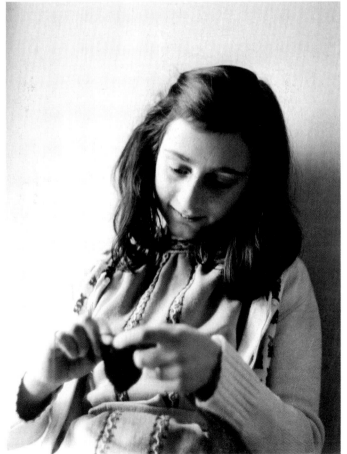

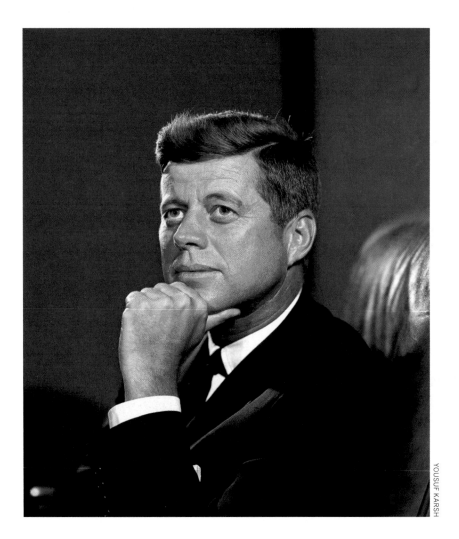

YOUSUF KARSH

John Fitzgerald Kennedy

1917~1963 THE 35TH PRESIDENT of the United States was the youngest ever elected to the office. He was dynamic, charismatic and, yes, sexy. He and his beautiful young wife changed the tone of their country. One could argue with JFK's politics, but no one could argue with the man's appeal.

One of the bright and dashing sons in a wildly aspirant Irish-American family from Massachusetts, Kennedy had performed nobly in World War II and indifferently in Congress when he edged Richard Nixon by the barest of margins in the 1960 presidential election. He immediately offered his nation what Frank Sinatra had sung of in the campaign's theme song: high hopes. Kennedy appealed to his countrymen's better angels in his inauguration speech, and his too-brief administration was marked by lofty aspirations but also by desultory low points. The Peace Corps thrived and the space race was ignited with a goal of nothing less than the moon. Meanwhile, there was the Bay of Pigs fiasco, and the United States trudged into its disastrous entanglement in a place called Vietnam. Kennedy faced down the Soviet Union during the Cuban Missile crisis, but at the time of his assassination in Dallas in 1963, there simply hadn't been enough history by which to judge his presidency.

There had been, however, sufficient time to judge the man. America had never seen anything like him, and the fact that America was denied more of him remains a terrible injustice.

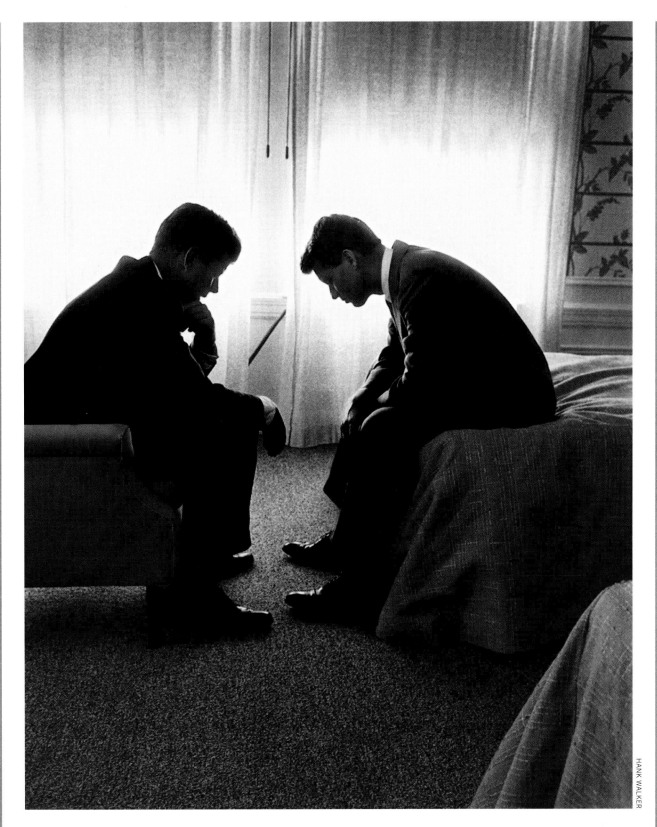

One Family's American Tragedies

The Kennedys have long had supporters and detractors. But no one can argue with the fact that they are a family that has been visited by sorrows and twists of fate that are Shakespearean in scope. Well before Lee Harvey Oswald pulled the trigger, the oldest of four brothers, Joe Kennedy Jr., who had been expected to spearhead the family's ambitious campaigns, was shot down during World War II. Then Joe's younger sister Kathleen died in a plane crash in Europe in 1948. Yet to come would be the death of JFK's only son, John Jr. (please see page 28). But between, in turbulent 1968, was the assassination of the third brother, Bobby (seen above, at right, in a LIFE photograph, strategizing with Jack during the 1960 presidential campaign). He was on the verge of his own Democratic presidential nomination when Sirhan Sirhan gunned him down in L.A.'s Ambassador Hotel after a speech.

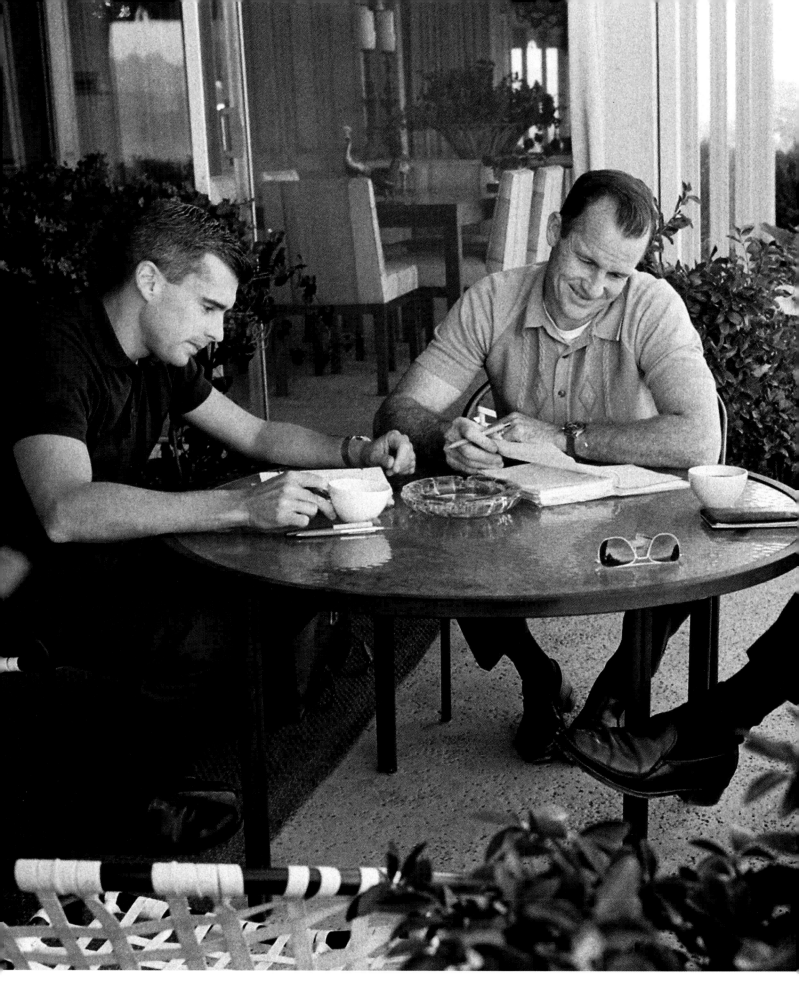

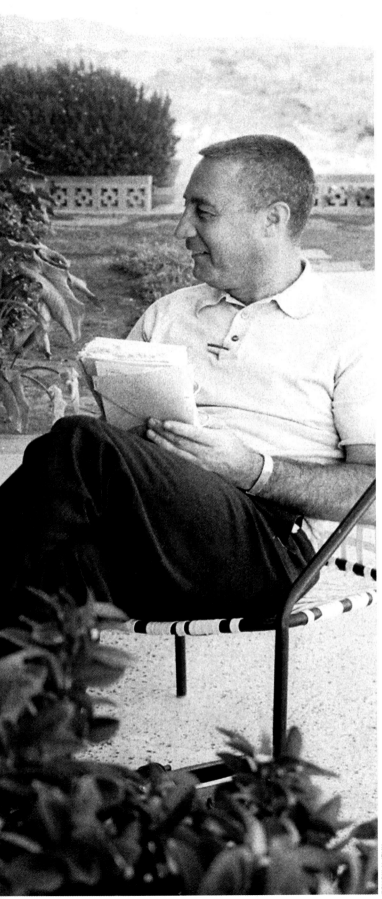

RALPH MORSE

The *Apollo 1* Astronauts

Died 1967

ALTHOUGH THERE HAD BEEN a human death—hushed up—in the Soviet space program, there had not been one in the U.S. effort. Americans certainly realized that this was risky business—a tin can atop a firecracker, after all—but the string of Project Mercury and then Gemini successes had led to a general confidence, if not quite a sense of complacency. The astronauts, meanwhile, knew there were always dangers, and were constantly lobbying for increased safety measures; this was made clear by investigations in the aftermath of the *Apollo/Saturn-204* tragedy, which would retroactively be called *Apollo 1*.

The mission was to be the first in a string of several that would lead to a lunar landing. Three astronauts were chosen for the crew: (from left) Roger B. Chaffee, Edward H. White and, as command pilot, Virgil "Gus" Grissom. This last man was by far the best known, having been one of the original Mercury Seven astronauts, the second American to fly in space after Alan Shepard and the first ever to fly twice (he was aboard *Gemini 3*). As a team, the crew expressed concerns to NASA that the new, larger Apollo Command Module had flaws—specifically, that there were fire hazards—and Grissom, showing his wife, Betty, a lemon at one point, said "I'm going to hang it on that spacecraft." Before he could, the worst possible outcome did happen when, during a test on January 27, 1967, on Launch Complex 34 at Cape Canaveral, Florida, a fire broke out in the pure-oxygen atmosphere of the cockpit, and all three astronauts were killed.

The incident was a chastening wake-up call to the nation and, particularly, for the aeronautics administration. There would be other dire moments, but no other deaths, in future Apollo missions before Neil Armstrong became the first man to set foot on the moon in 1969.

Martin Luther King Jr.

1929~1968

THIS ATLANTAN WAS BORN into the Christian ministry, descendant in a line of preachers and preordained to become one himself. He followed his destiny, meanwhile securing postgraduate degrees up north, and then found himself caught up in the tenor of his times. He was a gifted speaker and a gifted leader, and in 1957 he founded the Southern Christian Leadership Conference, which advocated a nonviolent struggle for justice. In march after march he led them: in Birmingham, Montgomery, Selma, Washington, D.C.—where he declared his dream, "that my four children will one day live in a nation where they will not be judged by the color of their skin but by the content of their character."

Because of his tactics and persona, he was not seen as "radical" like others who were fighting for equality in this era, and he was listened to by many who turned a deaf ear to the Black Panthers, certainly, and to Malcolm X, who would also be assassinated. Malcolm would be gone too soon as would Martin, and also the young girls who died in the church bombing, and the justice seekers who were murdered in the incident portrayed in the movie

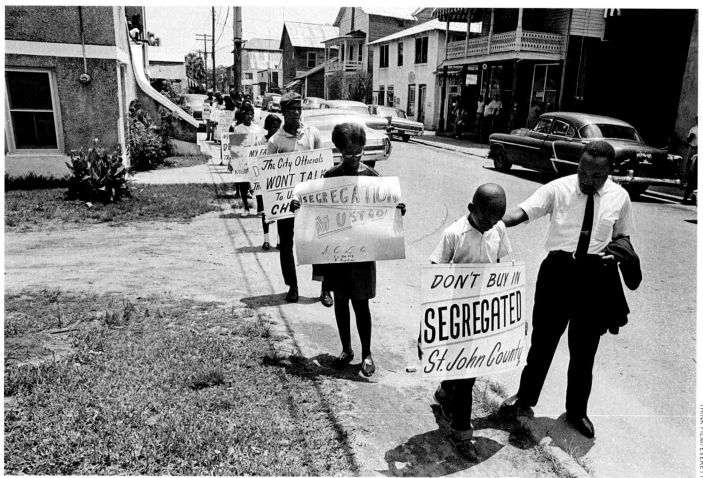

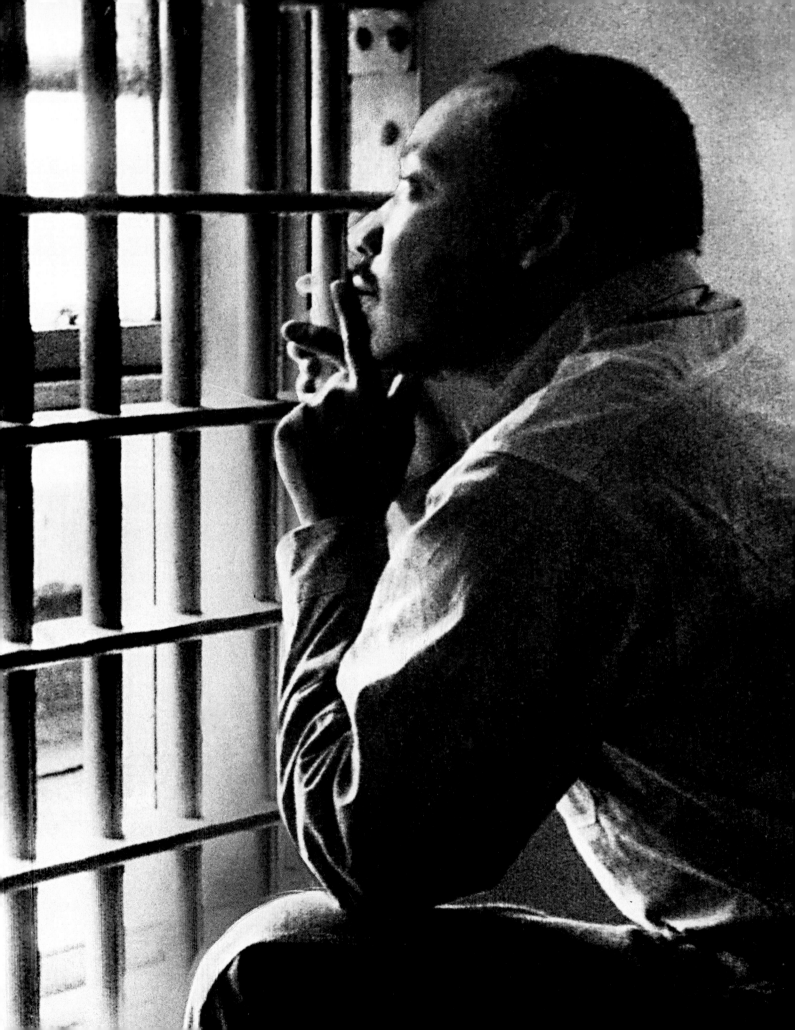

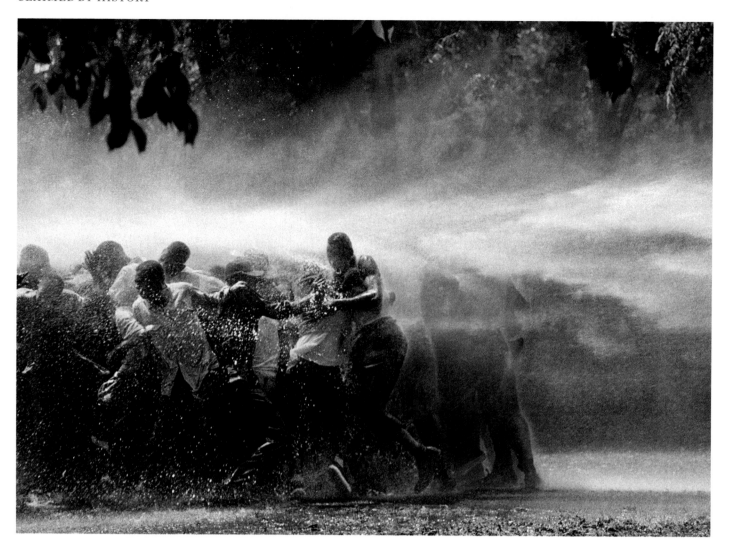

Mississippi Burning, and the anonymous many who were lynched in the dead of night, and . . .

On the opposite page are a few of these stories, and above we see another—King-led protesters being hit with a fire-hose barrage from police and firemen in Birmingham, Alabama. When the photographer, Bob Adelman, later handed a print of this picture to King, the civil rights leader paused, then said, "I am startled that out of so much pain some beauty came." On the previous two pages are other scenes from the front lines: King walking with young blacks in St. Augustine, Florida, in 1964, and pensively peering from a cell in the Jefferson County Jail in Birmingham in 1967. He was arrested more than once in that city, and in St. Augustine as well. Though he practiced nonviolence, he was clearly in harm's way.

King, along with President Lyndon Baines Johnson, is the man most responsible for the Civil Rights Act of 1964 and the Voting Rights Act of 1965, and those acts are the ones most responsible for the stature of all minorities in the United States today. Hated by some just as vigorously as he was revered by others, he was killed in Memphis by a bullet from the rifle of James Earl Ray. When his body was borne to its rest in Atlanta (right), his work was far from being finished, but it was started.

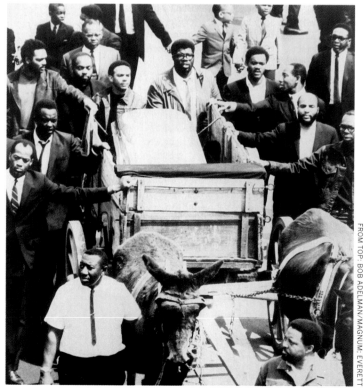

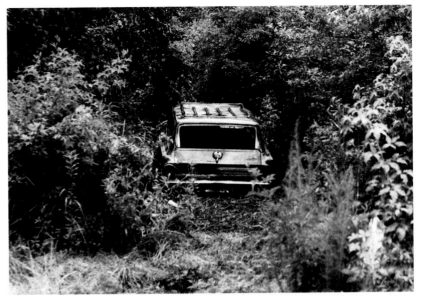

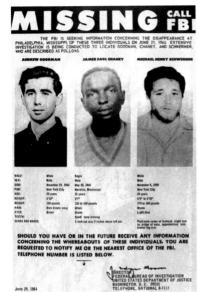

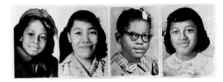

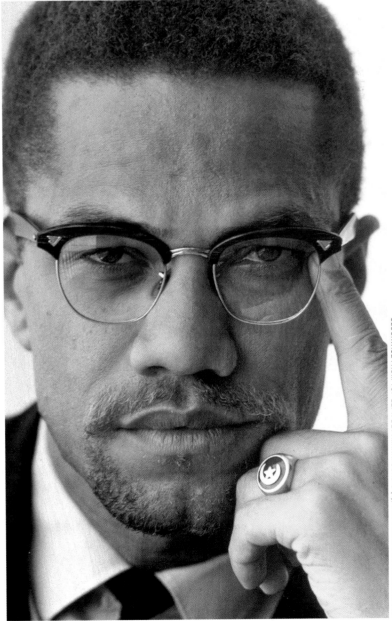

Other Victims of the Civil Rights Wars

Tragically, Martin Luther King Jr.'s was far from being the only life claimed in the 1950s and '60s as African Americans and their sympathizers battled for racial equality.

As we have noted, many of the victims are anonymous. Some are not. At right is Malcolm X, a leader of the Black Muslims, who was assassinated in New York City in 1965. He was, to many mainstream Americans, more radical and altogether scarier than King, but the reason for his killing likely had to do with his separation from the Muslim movement, not retribution from any racist white element.

In 1964, during the Freedom Summer campaign, three volunteer activists—James Chaney, from Mississippi, and Andrew Goodman and Michael Schwerner, from New York—went missing after the car in which they were traveling in Mississippi (top) was intercepted on a rural road. Their bodies were eventually found in an earthen dam; they had been shot dead by a white mob. It took until 2005 before a leader of the local Ku Klux Klan was convicted in this case.

The Klan was also responsible for the 16th Street Baptist Church bombing in Birmingham on September 15, 1963, which claimed the lives of four girls, aged 11 to 14 (from left, above, Denise McNair, Carole Robertson, Addie Mae Collins and Cynthia Wesley). Again, the wheels of justice moved slowly; it wasn't until 1977 that one of the four men who planted the bomb was convicted. Two more suspects have been jailed in recent years.

Diana Spencer

1961~1997

LADY DI WAS, as British Prime Minister Tony Blair observed in the aftermath of her tragic and untimely death, "the people's princess." Born into England's upper class and chosen by Prince Charles to be his bride (the ceremony of their marriage, watched by millions around the world, was said to be "the wedding of the century"), Diana maintained throughout the common touch. She was beautiful but not unapproachable; royal but never superior or austere. The public sympathized with her as she underwent various traumas, be they with things as everyday as weight loss or as life-changing as the problems in her marriage. People in the United Kingdom and beyond applauded her fine, hands-on parenting of her two boys (opposite, with Harry), and her strenuous efforts on behalf of children at risk and other humanitarian causes (below, comforting an elderly Yugoslav refugee in Hungary in 1992). If she was, as some claimed, a master manipulator of her public image, that didn't really matter at the end of the day. Di had much to give, and was engaged in the business of giving it, when her life was cut short by a horrific car crash in Paris: Diana and her companion, hotel scion Dodi al-Fayed, were fleeing in a Mercedes being driven by an employee of al-Fayed's family who was operating under the influence, while a fleet of salivating paparazzi chased.

The global outpouring of grief that followed in the wake of the tragedy stunned everyone, not least Queen Elizabeth II and other members of the royal family, who were forced to realize that this woman, who had become a part of them (only to be divorced from them), was beloved in a way that they were not, nor could ever be. Diana, sometimes frail and sometimes flawed, always concerned about others, always compassionate and always charismatic, was unique.

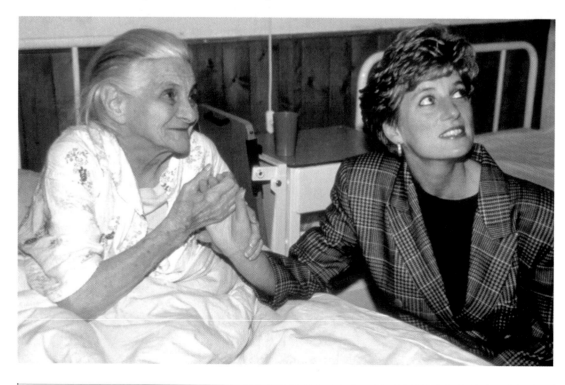

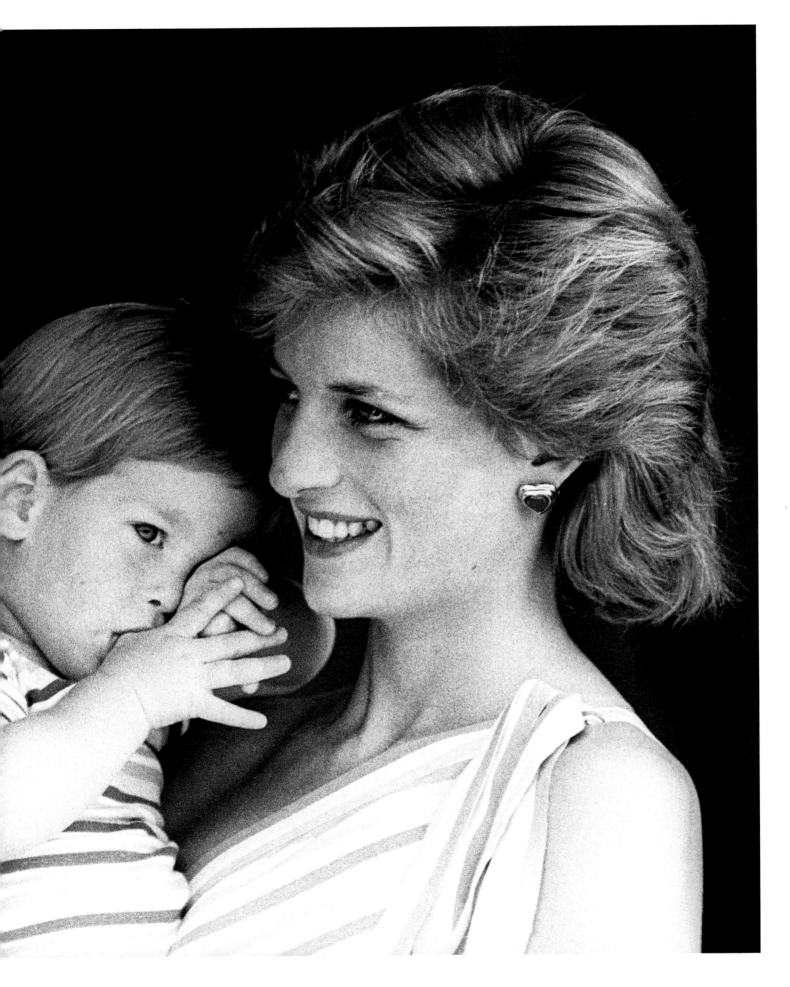

John Fitzgerald Kennedy Jr.

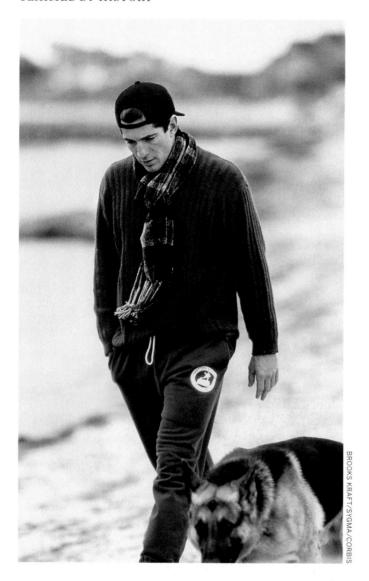

1960~1999

HE WAS AMERICA'S PRINCE. Born even as his glamorous parents, Jack and Jackie Kennedy, assumed residence in the White House, this child, along with his older sister, Caroline, somehow belonged to all the people. John-John's picture, crawling underneath his dad's desk in the Oval Office (pages 8 and 9) or parading about in a Halloween costume for JFK's amusement, leaped off the pages of LIFE, gladdening everyone. Then, only briefly later, there was the image of this boy boldly saluting his father's casket as it was borne through the streets of Washington, D.C., to Arlington National Cemetery, a photograph that further devastated a shell-shocked nation.

Protected by their mother, John and his sister grew up quietly enough into sturdy young adults (left, John in Hyannisport, Massachusetts, in 1998). John graduated from Brown University and looked toward the law, then became a magazine publisher, even as the celebrity mags—not least *People,* which named him Sexiest Man Alive one year—took keen note of the fact that he was quite as handsome as either of his parents. John's dating life was minutely chronicled, and then he slipped away to privately marry his true love, Carolyn Bessette. She was at his side when the small plane he was piloting to Martha's Vineyard in the summer of 1999 crashed into the Atlantic.

BROOKS KRAFT/SYGMA/CORBIS

Tim Russert

1950~2008

THE PUBLIC—NOT THE PRESS and not the pundits—decides who among us has been taken too soon. When the television newsman Russert succumbed to a heart attack at age 58, the public made it clear that it had lost a friend. Some commentators carped that a similar degree of mourning (Bruce Springsteen delivering a eulogy from the stage, the *NBC Nightly News* dedicating its broadcast to a deceased colleague) would never have attended the death of a print journalist. That missed the point. The lamentation had nothing to do with the information Russert had conveyed to his audience throughout the years. It had to do with the bond, not dissimilar to the one built in the 1960s between Walter Cronkite and watchers of the CBS Evening News, that had been forged between one man and his millions of devotees.

He was very evidently an affable bloke, even when he was grilling his guests with gusto on *Meet the Press.* Through his books it became clear that he was a devoutly religious family man, a man of certain values. He had a sense of humor. He worked tirelessly.

All of these personal traits added to his appeal in a time when the country seemed increasingly rootless, humorless, uncertain, frayed and too often mean-spirited. Russert (opposite, in 2005) represented something; perhaps it was a safe harbor. He seemed, as said, like a friend. When he died, the public—no one else—decided that he had died much too soon.

DENNIS VAN TINE/LFI

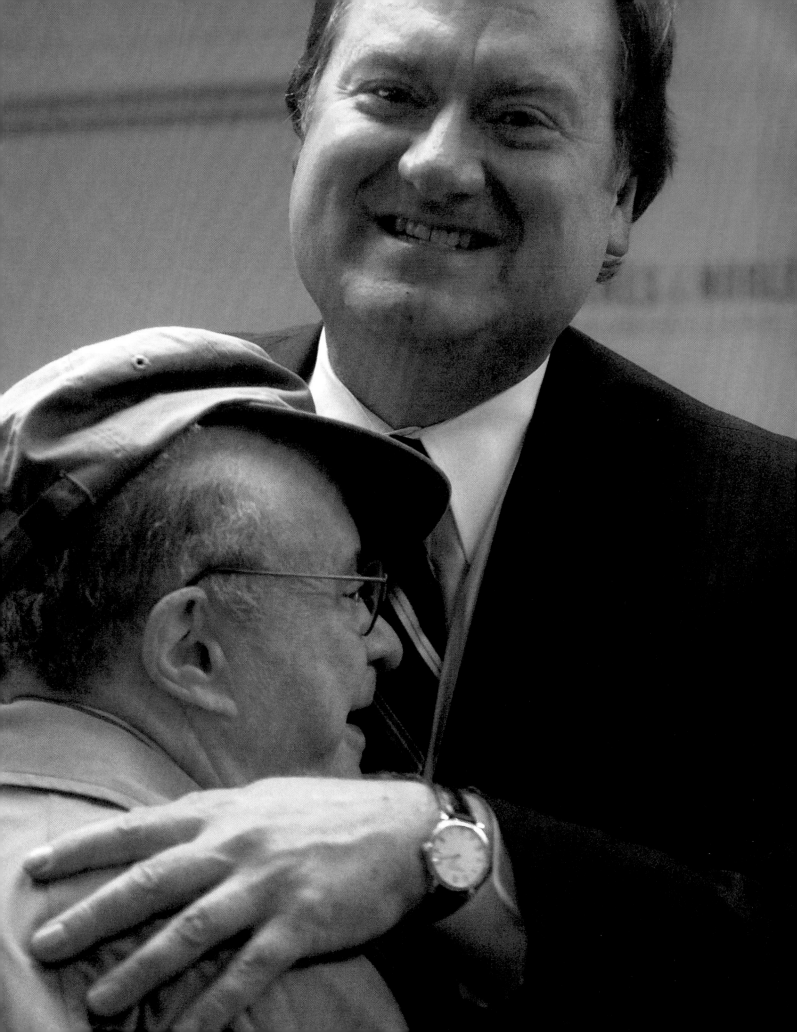

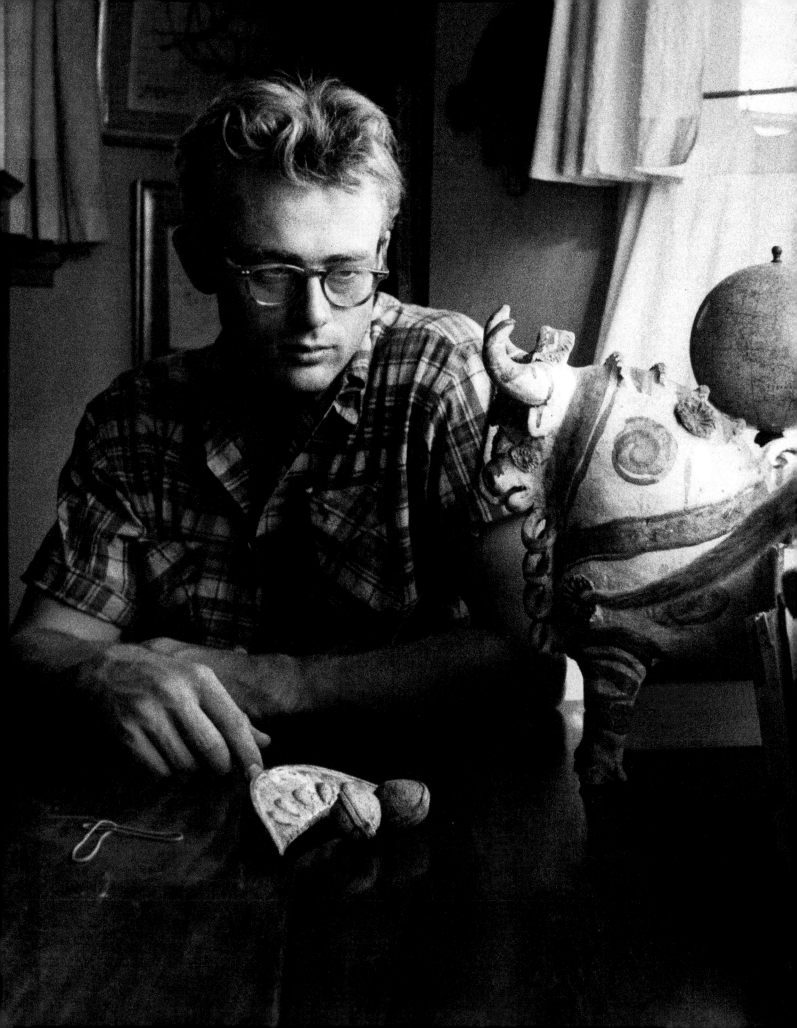

Kings *and* Queens *of* Hollywood

James Dean, whose story is told on page 41, scared the bejeezus out of adult America, just as Marlon Brando did. But he was a pussycat at heart.

Rudolph Valentino

1895~1926 IN POPULAR CULTURE, his death at age 31 pretty much ignited the concept of a shining star extinguished too soon. With his astonishingly good looks, slicked-back hair and smoldering sexuality, Valentino, a native of Italy (and the source of the phrase "Latin lover"), was, along with Charlie Chaplin, Mary Pickford and Douglas Fairbanks, on the uppermost rung of silent film stars. Of that million-dollar quartet, he was the one who inspired not just laughs or love but lust—passion, deep and unconquerable passion. As *The Sheik* and other not-far-from-the-bone personas, he made women swoon and men want to trade places.

In August of 1926, he was hospitalized in New York City, suffering from appendicitis and gastric ulcers. His multitudinous fans demanded to know what was up, and doctors were cautious with their reports from the get-go. When peritonitis and then pleurisy became complications, the official obfuscations only served to heighten the intrigue. And then Valentino died, and the keening and wailing began in earnest. There were suicides, according to the popular lore, and tens of thousands jammed the streets outside St. Malachy's Church in New York City to pay their respects and display their grief. The mass hysteria extended worldwide, for Valentino's fame and allure had known no bounds.

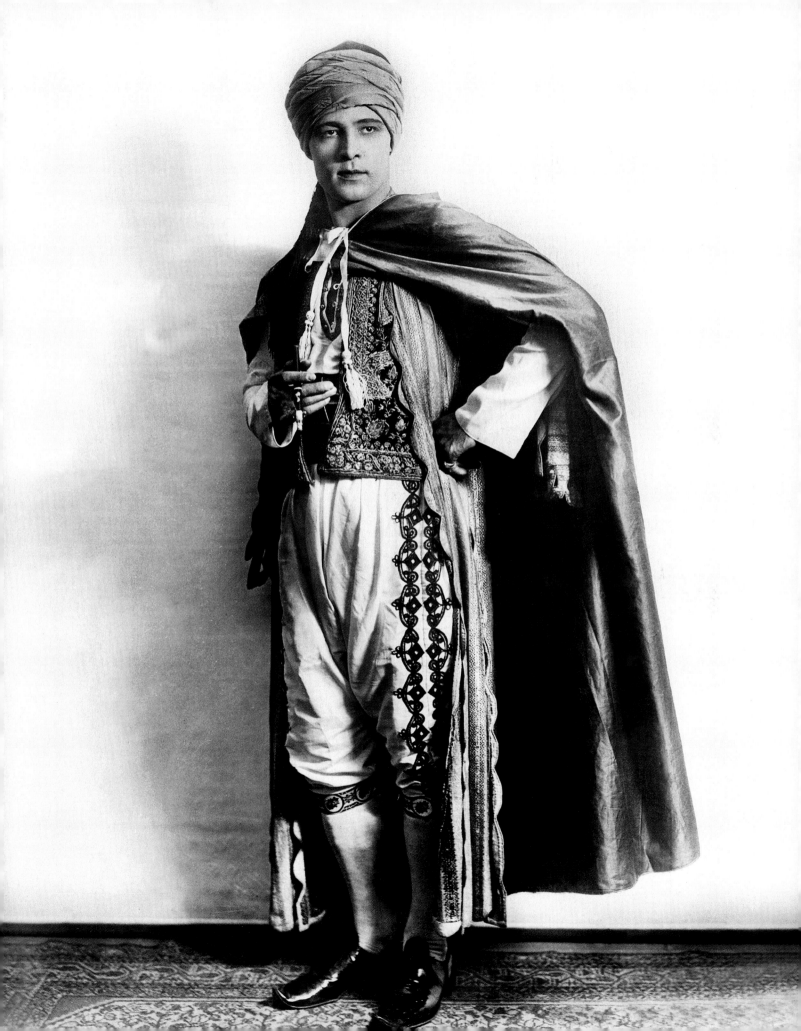

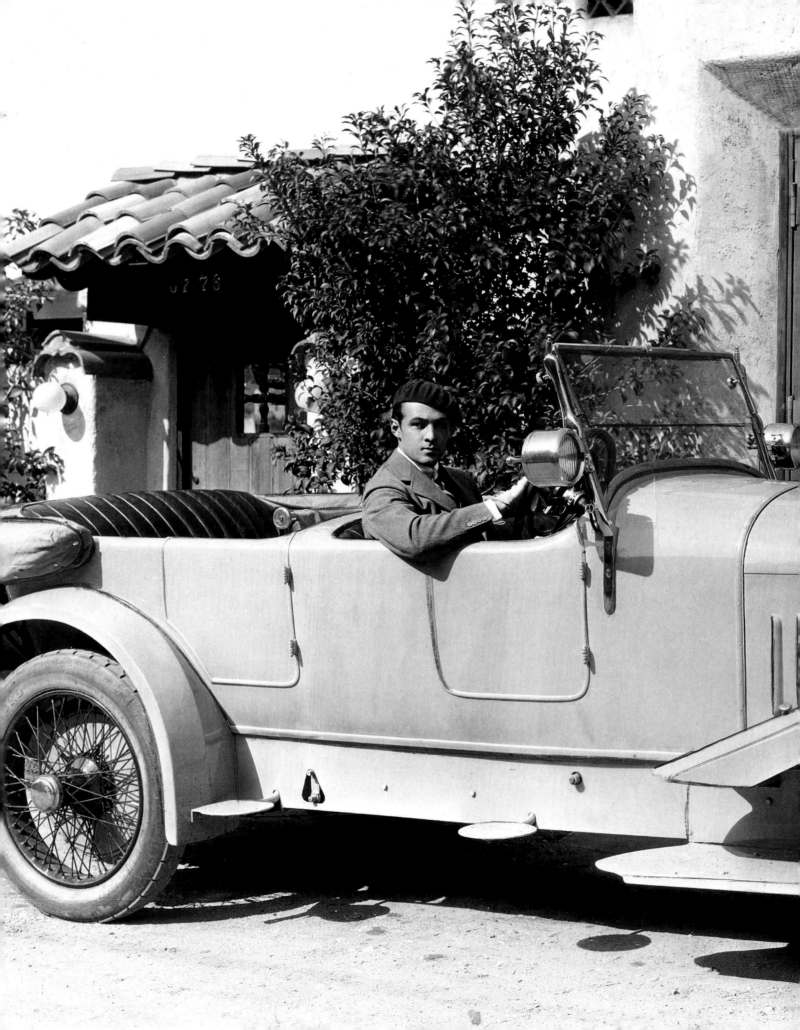

Today, movie superstars can go all sloppy in public and be seen as even more cool. In Valentino's day, the persona was supposed to be the person—and he never disappointed. Here, he cuts a dashing figure at the wheel of his 1923 Avions Voisin. Just by the way, he was reportedly nearsighted and a terrible driver.

EVERETT

Will Rogers

1879~1935

HE WAS, FOR A TIME, the top-paid and arguably most famous movie star in the land. This never could have been predicted for William Rogers, born in the Indian Territory of Oklahoma. He was, first, an authentic cowboy; among his talents was dexterity with a lasso. He showed off his skill on the vaudeville circuit and this led to a gig with the Ziegfeld Follies. With his folksy charisma, Rogers (opposite, with Shirley Temple, in 1935) soon became known coast-to-coast as a comedian and he made a string of successful films. He took his sly social commentary straight to the people with a nationally syndicated newspaper column. As perhaps America's most popular citizen—everyone liked Will Rogers—he became the country's most prominent unofficial ambassador, traveling around the globe three times. Rogers loved to fly and was an enthusiastic booster of the nascent aviation industry. He was killed in a small-plane crash in far northern Alaska with his friend, the famous flyer Wiley Post, at the controls.

Rogers, in anticipating the inevitability of his demise, displayed his customary wit and encapsulated perfectly his approach to life: "When I die, my epitaph or whatever you call those signs on gravestones is going to read, 'I joked about every prominent man of my time, but I never met a man I didn't like.' I am so proud of that, I can hardly wait to die so it can be carved. And when you come to my grave you will find me sitting there, proudly reading it."

Jean Harlow

1911~1937

KEYSTONE/EYEDEA

SHE WAS THE ORIGINAL blonde bombshell, the gleaming megastar that all others, from Marilyn to Madonna, were modeled after. An only child, she was nicknamed Baby while growing up in Kansas City, Missouri, and she would be called that the rest of her life.

Young Harlean Harlow Carpenter moved to Hollywood with her mother, who hoped to become a star herself, in 1923. They were forced to retreat to Kansas City when her mom's plans didn't pan out, but the teen had seen the bright lights. After eloping at age 16, she was back in L.A., living in Beverly Hills. The beauties do get noticed in Tinseltown, and when she signed in at Central Casting after being invited to audition for Fox Studios, she used her mother's maiden name, Jean Harlow. She acted, early on, opposite Laurel and Hardy, and was the girl in the corner in several movies. Then came, in 1930, *Hell's Angels*. "It doesn't matter what degree of talent she possesses," said *Variety*, expressing the view of many, "nobody ever starved possessing what she's got." Harlow would not starve, but she would suffer. Her fame increased with films such as *The Public Enemy* and *Platinum Blonde* (at left, rehearsing songs for 1933's *Hold Your Man*), even as her acting was routinely savaged by critics and her personal life was becoming one large mess. Her second husband was found dead in their home, and the rumor mill wondered if Harlow had had something to do with that. But the demi-scandal only increased her allure, and in the Depression years she was one of the most bankable stars.

Harlow had been sick as a child, with scarlet fever, and she became sick several times more, which took a toll on her kidneys in a day before antibiotics could treat kidney disease. When she died at age 26, of kidney failure, the kind of turbulent mourning that had attended the death of Valentino ensued again. Baby was gone.

EVERETT

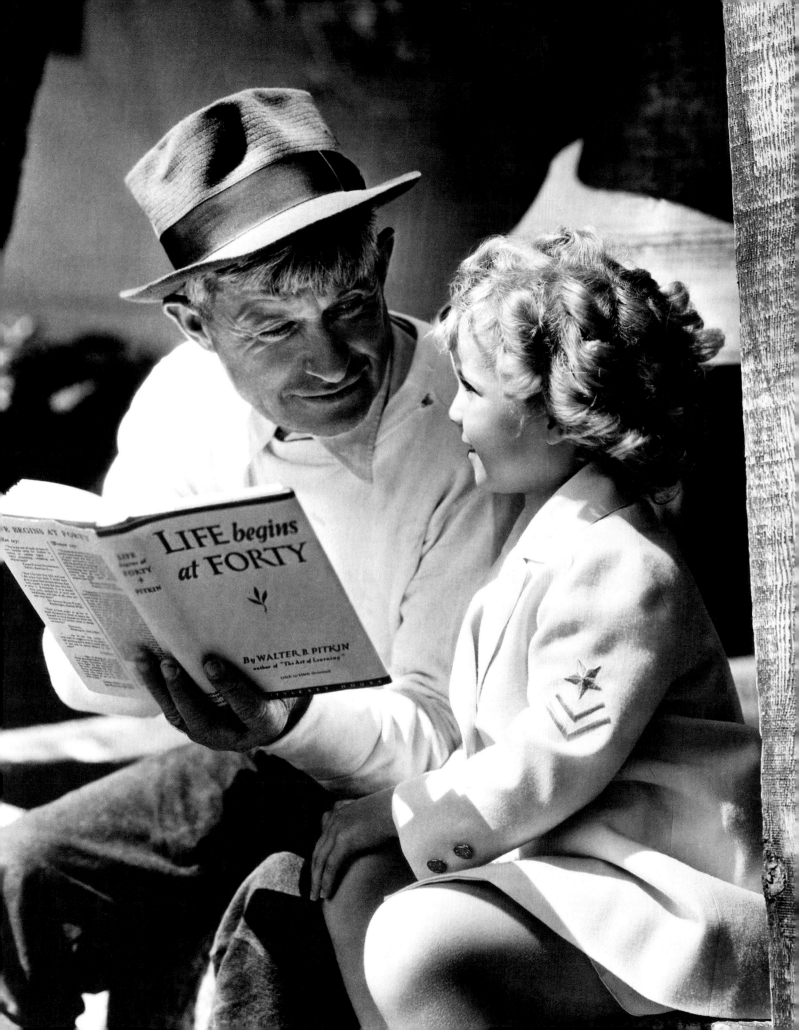

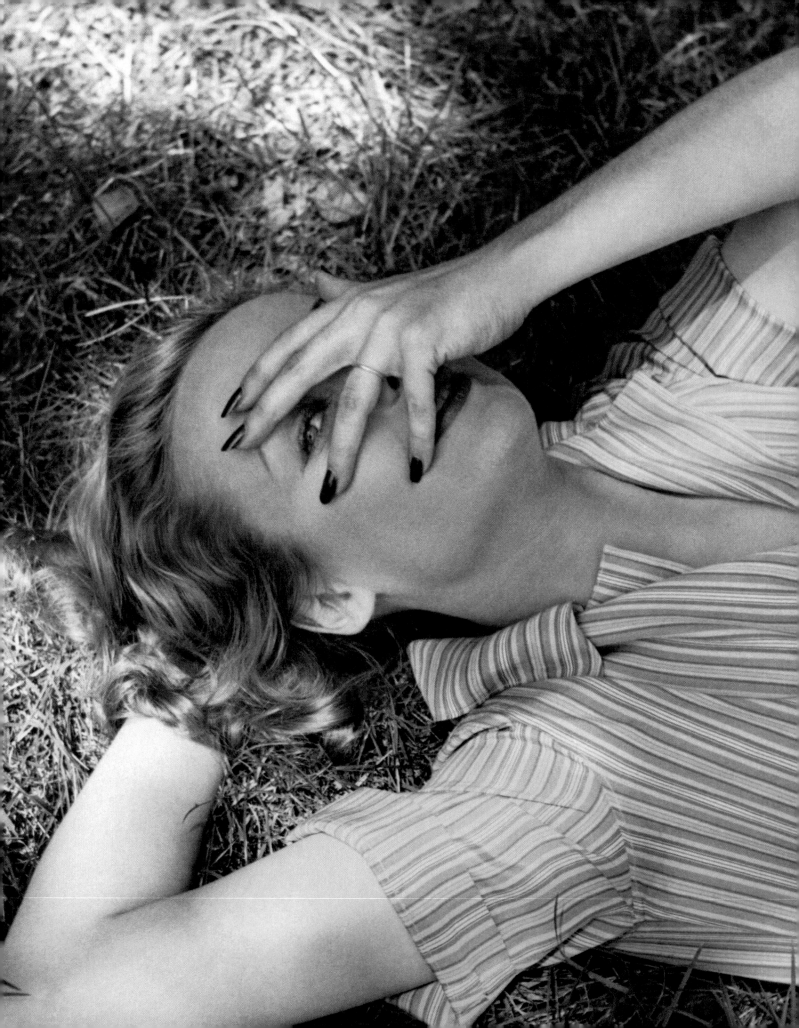

Carole Lombard

1908~1942

SHE WAS BRIEFLY, like Will Rogers, the very biggest thing in Hollywood. The sassy, lovely Lombard was, in the late 1930s, earning a half million dollars per movie—the highest paid actor in Hollywood, better remunerated than her husband, Clark Gable, five times more highly paid than President Franklin D. Roosevelt. The public adored her and flocked to her romantic comedies; her stature was not unlike that of Sandra Bullock or Julia Roberts today. The native Indianan, who was as funny off-screen as on, and whose fans among the glitterati of Los Angeles were as legion as those lining up at the box office in Paducah, could, at the height of her fame, do no wrong.

That was very much the case when, after the bombing of Pearl Harbor and the U.S. entry into World War II, she traveled home to the Midwest to appear at a war bond rally. What a wonderful gesture. On January 16, 1942, on her way back to California, the plane in which she was traveling crashed into a mountain in Nevada, killing all 22 aboard. She was 33 years old, and America paused in its focus on the war to grieve the loss of this beloved actress. Gable (below, with Lombard in 1935), who himself was destined to die relatively young at age 59, was distraught. He soon entered the Army Air Forces and flew missions with a motion picture unit attached to a bomb squadron in Europe. In 1944 he was present at the launch of a newly built Liberty ship, the S.S. *Carole Lombard*.

Today, she is too little remembered. In her day, there was no one bigger—or finer.

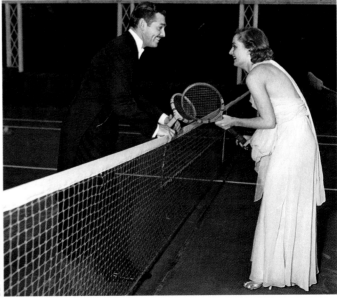

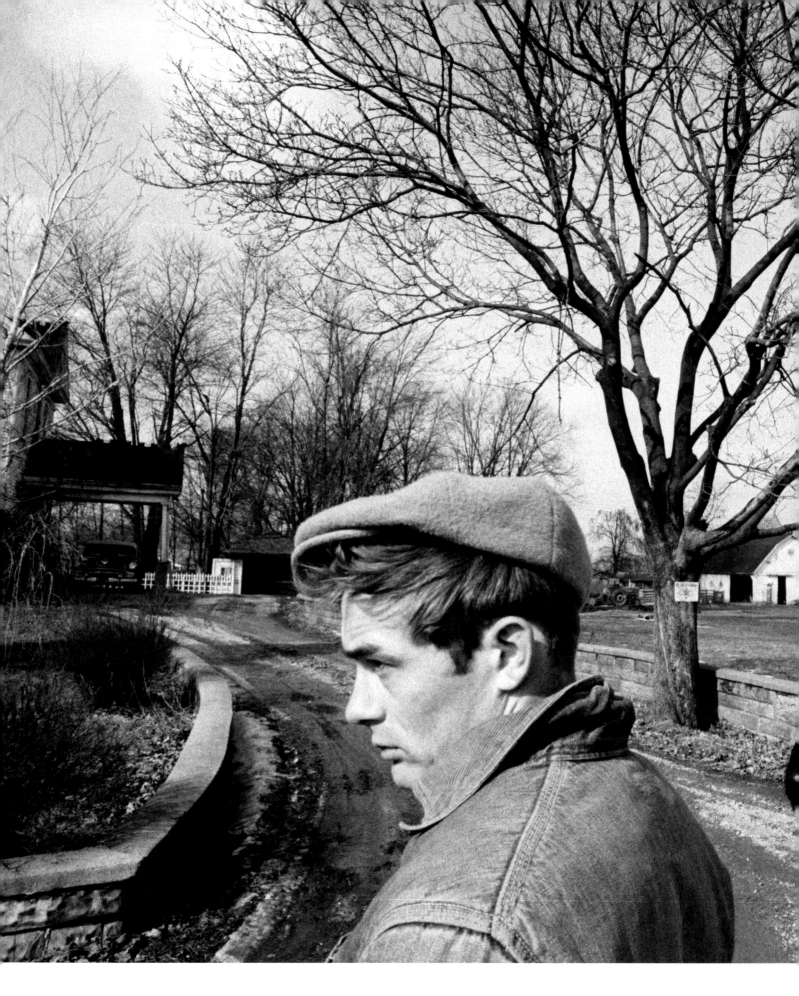

James Dean

1931~1955 Between 1951 and '53 he appeared briefly in four now forgotten films, and was uncredited in each of them. In 1955 *Rebel Without a Cause* and *East of Eden* were released, both starring Dean, and the following year came *Giant*. In the midst of this astonishing burst of fame, on September 30, 1955, Dean drove his Porsche 550 Spyder, which had been readied for an upcoming race in Salinas, California, into a head-on collision on U.S. Route 466. Seldom if ever had a real person's end so seamlessly blended with his public persona, and thus was the legend that remains James Dean forged. Three films, really—that's it—and today the estate still earns $5 million a year. He certainly had talent, he certainly was handsome, but the circumstances of his short time in the spotlight and then this sudden death at the wheel made James Dean an icon for all time.

He, too, was from the Midwest—Marion, Indiana—and moved with his family to California, in this instance to Santa Monica. His mother died when he was nine, and James was sent back to Indiana to be raised by kinfolk on a farm (at left, he returns to his uncle's acreage in 1955). He relocated again to California for college, but dropped out to become an actor. Chapter One of that quest included those uncredited parts, and Chapter Two was a relocation to New York City to study Method acting with Lee Strasberg at the Actors Studio, a nurturing ground for such as Paul Newman and Julie Harris. Dean learned his lessons well, made a mark in serious television dramas and on the stage, and then was ready for the whole world to know him.

The world knew him but briefly, and what people know of him today is entirely image. James Dean was no accident; he really was somebody to be reckoned with. The extent of what was lost on the highway that day will never be known.

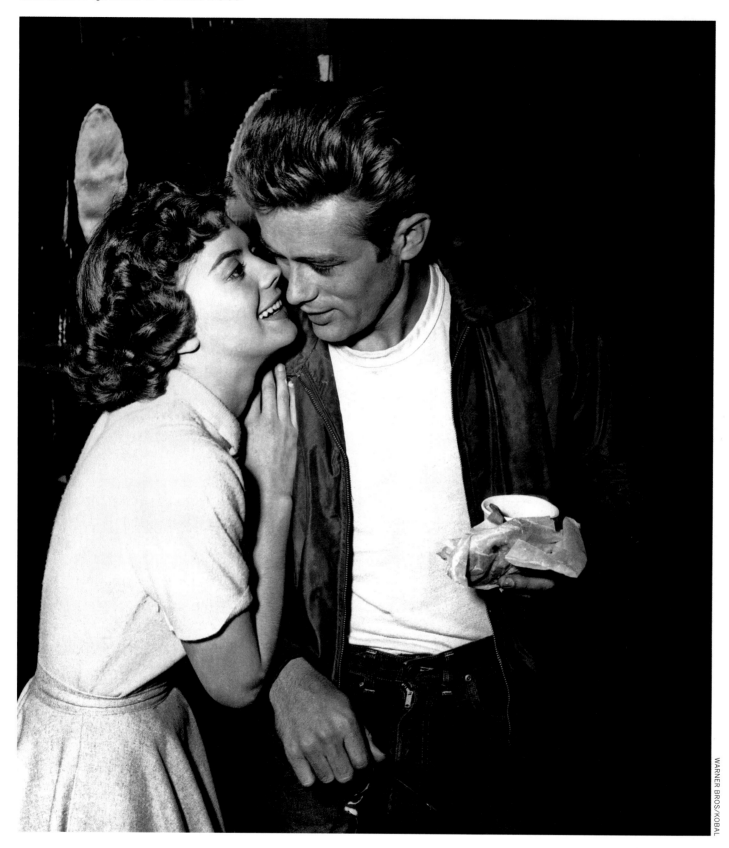

WARNER BROS./KOBAL

Here we have two ill-starred costars in 1955's *Rebel Without a Cause:* Natalie Wood and James Dean. For Wood's story, please see page 52.

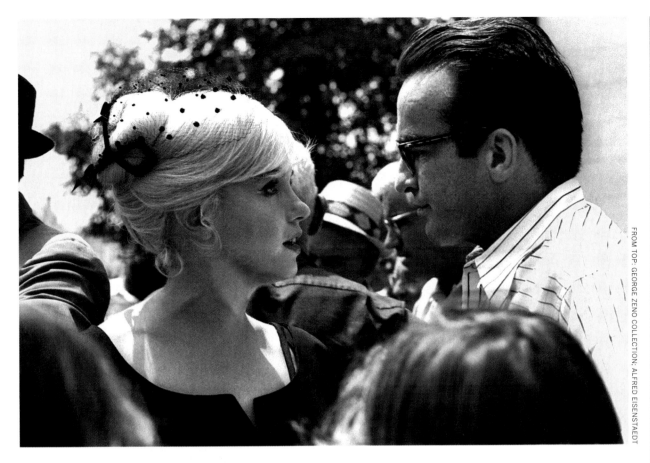

FROM TOP: GEORGE ZENO COLLECTION; ALFRED EISENSTAEDT

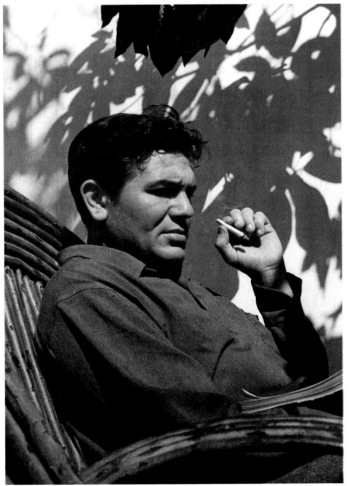

The Brooding Young Man, Invented

James Dean is not the only product of this 20th century mold; there was Marlon Brando and there would be Montgomery Clift. But first there was John Garfield (left). The son of Ukrainian Jews, Garfield, born Jacob Garfinkle in 1913, emerged from a hard-knocks youth in New York City to become a Broadway mainstay and then a Hollywood star. In films including *The Postman Always Rings Twice* (1946) he brought something entirely new to the male lead role: a combination of toughness and vulnerability, intelligence and cunning, depth of character and fierce animalism. What all of these actors conveyed on the screen is often credited to the Method, but it is as much about the men themselves. Garfield died of a heart attack at age 39.

As for Montgomery Clift: He was born in Nebraska in 1920 and was at work on the New York stage by age 14. Clift continued as a stage success for a decade before giving Hollywood a shot. He was soon noticed in films such as *Red River* (1948), *The Search* (his first of four Academy Award nominations, 1948) and *The Heiress* (1949), and his performance opposite Elizabeth Taylor in 1951's *A Place in the Sun* made him perhaps the biggest male lead in the land. After a car crash in California, Clift resorted to alcohol and drugs to numb the pain. The final decade of his life is seen by film historians as "the longest suicide in Hollywood history." On the set of the 1961 film *The Misfits*—the last in the careers of both Marilyn Monroe and Clark Gable— Monroe said that their costar Clift (above, with Marilyn) was "the only person I know who's in worse shape than I am." He would outlast her by four years before dying in the bedroom of his New York City townhouse.

And now, on the following pages, Marilyn's own, equally sad story . . .

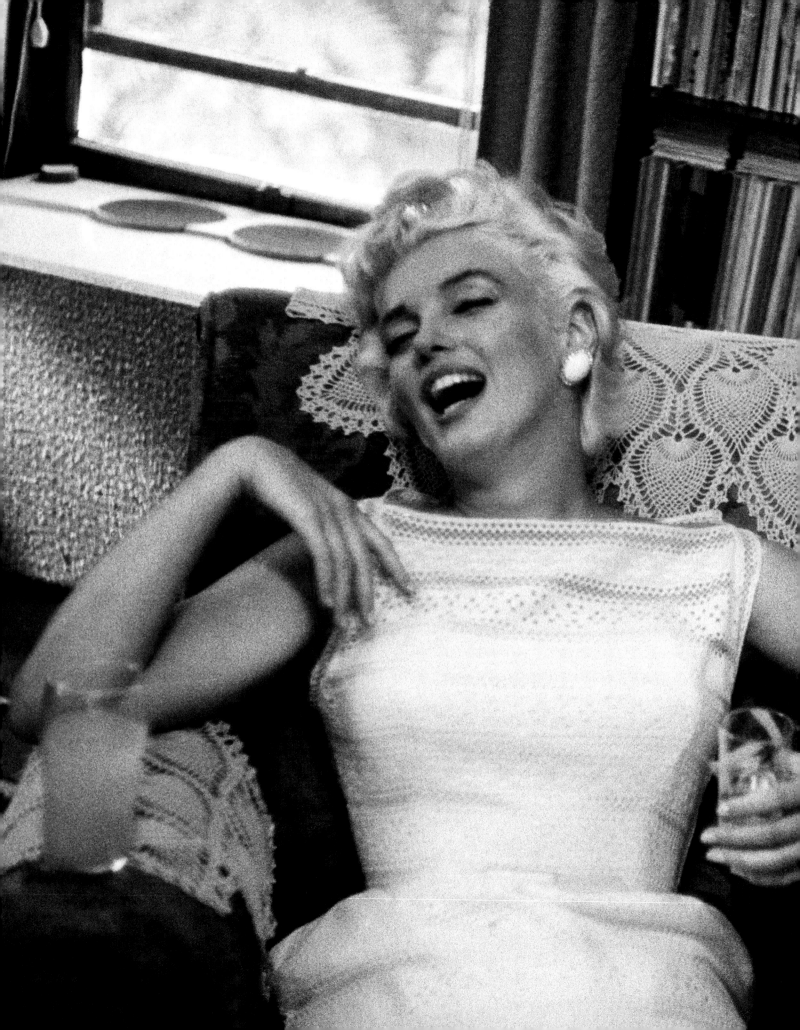

Marilyn Monroe

1926~1962

VALENTINO WAS AN ICON, Harlow was an icon, James Dean was an icon. There would be icons to come: Elvis, Michael Jackson. But in *Webster's* next to the word icon, there is a picture of Marilyn. Or there should be.

The trajectory (and, indeed, even many of the details) concerning Norma Jeane (Mortenson) Baker's extraordinary and very sad life are familiar to serious students of American iconography: Emerging from a super-troubled childhood that included an absent dad and a mentally unstable mom, she married young, scrabbled to make ends meet (perhaps prostituting herself on the streets of Hollywood), and eventually found herself with some modeling assignments. Her pinup career led to a first movie contract in 1946 and her reinvention as Marilyn Monroe, a more voluptuous, more desirable and, if possible, blonder version of Jean Harlow. Monroe (at left, in Bement, Illinois, in 1955, where she will preside as the requisite celebrity at the town's centenary celebration; on the following page, in Nevada in 1960 while filming *The Misfits*) eventually recoiled at the typecasting that she herself had once encouraged, and made her way to the Actors Studio. She did have talent, as evinced in films such as *Bus Stop* (1956), *Some Like It Hot* (1959) and, again, *The Misfits*, but she stands today as the greatest-ever example of a movie star who was so much larger than the sum of her parts.

She married the famous former baseball star Joe DiMaggio but, while their love was real and would prove to be enduring, she could never make matrimony work. Increasingly unstable and unreliable, she came to lean on drugs. Whether her death was from an overdose of barbiturates; whether, if so, this was an accidental or intentional circumstance; whether she might have been murdered; whether, if so, this had anything to do with hushing up her entanglements with the Kennedys . . . All of this conjecture will never, ever end. The legend of Marilyn Monroe has been growing larger year by year since the actress first sizzled on the screen, and it only continues to grow today.

EVE ARNOLD/MAGNUM

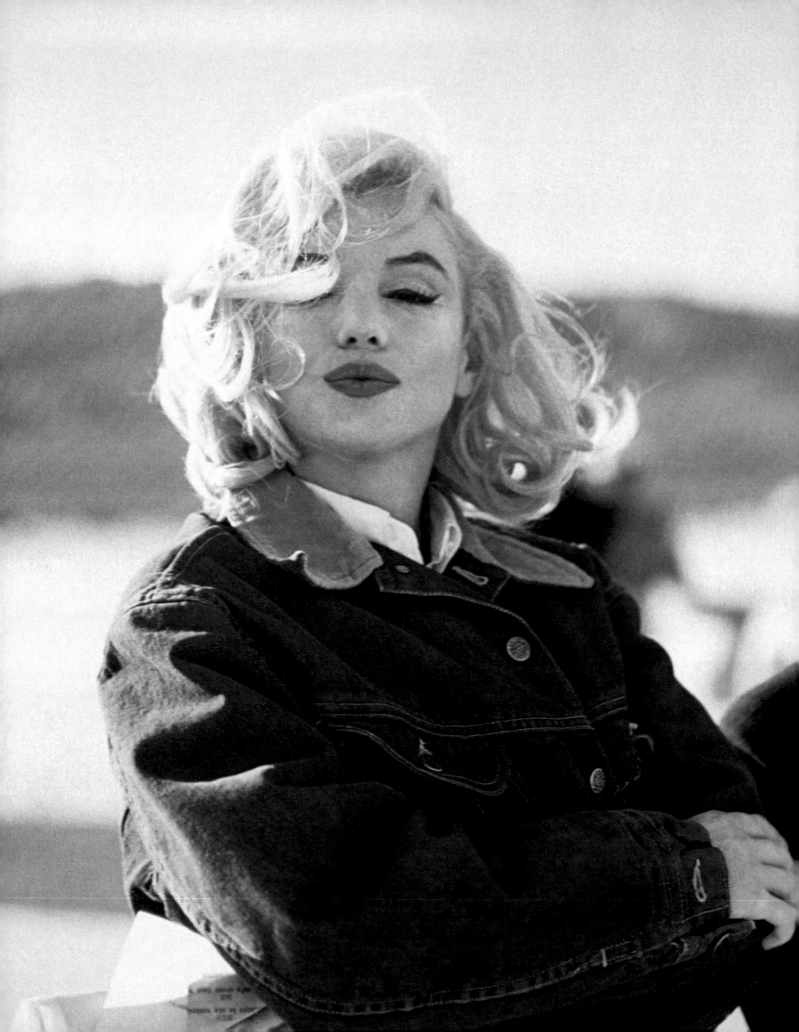

WILLIAM HELBURN

EVE ARNOLD/MAGNUM

In Marilyn's Shadow

Starlets have forever come and gone, some gaining greater celebrity than others. But it must be wondered if the magnitude of the Marilyn Monroe saga has led to a situation where any and all future starlets will be measured against the standard bearer and be judged wanting. To take the case of another blonde bombshell whose career trailed Monroe's by only a few years, we look at Jayne Mansfield (above, in New York City with her daughter, Mariska Hargitay—yes, *that* Mariska Hargitay—in 1965). She was a talented woman—an accomplished musician as well as a comic actress—who starred in Hollywood and on Broadway, made lots of money for herself and others and certainly gave the magazines everything they needed in terms of pictures and scoop. When she died at age 34 in a 1967 car accident, however, much of the public reaction recalled Monroe's similarly premature death. There may, indeed, never be another star to topple Marilyn Monroe.

Steve McQueen

1930~1980 EVEN WITH JAMES DEAN and Montgomery Clift having come—and gone—before him, this is the man eternally to be regarded as the king of cool, a Hollywood incarnation of the West Coast jazz stylings of such as Chet Baker and Gerry Mulligan. McQueen certainly was cool in real life, and in the movies he maintained that cool at all times, whether bouncing his car up and down the San Francisco hills in the famous chase sequence in *Bullitt* (1968), roaring his motorcycle over fences and hills in the famous flight sequence in *The Great Escape* (1963) or facing down a runaway fire in *The Towering Inferno* (1974). (Very hard to stay cool in that one.) In the original version of *The Thomas Crown Affair* (1968), McQueen was so cool he made audiences shiver. Many of the women in the audience cooed and shivered simultaneously.

He is the authentic model for the actor who did his own stunts, which added to his backstory and to his mass appeal. He raced motorcycles—he owned well over a hundred—and automobiles; in his struggling years, he had helped support himself with purses won at weekend races. During much of that storied scene in *Bullitt*, McQueen was actually behind the wheel.

But speed, at least not the vehicular kind, did not claim him. He did, over the years, take his measure of drugs and drink. Nevertheless, when he became sick with abdominal tumors in the late 1970s, he laid the blame on earlier asbestos exposure. Whatever the cause, he died not long after he had become the highest-paid movie star in the world. Since he was such a singular personality, his legacy has extended, and today his personal effects command tens of thousands of dollars—in some cases, millions—among collectors of cool 'cycles, cool cars, cool shades and even cool watches.

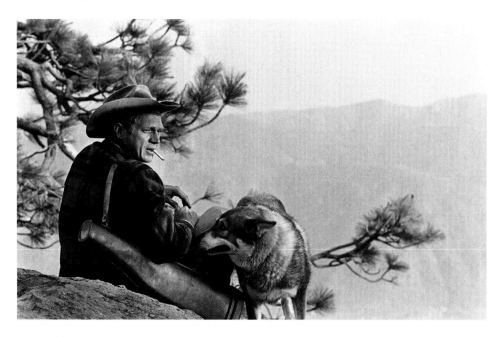

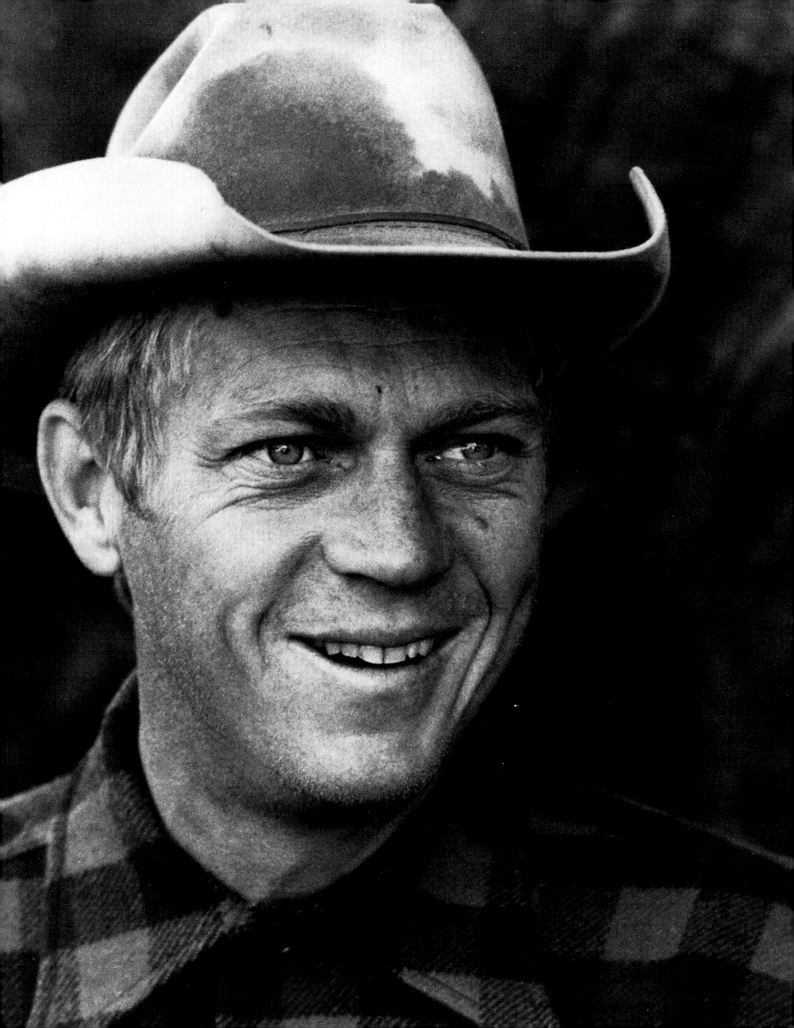

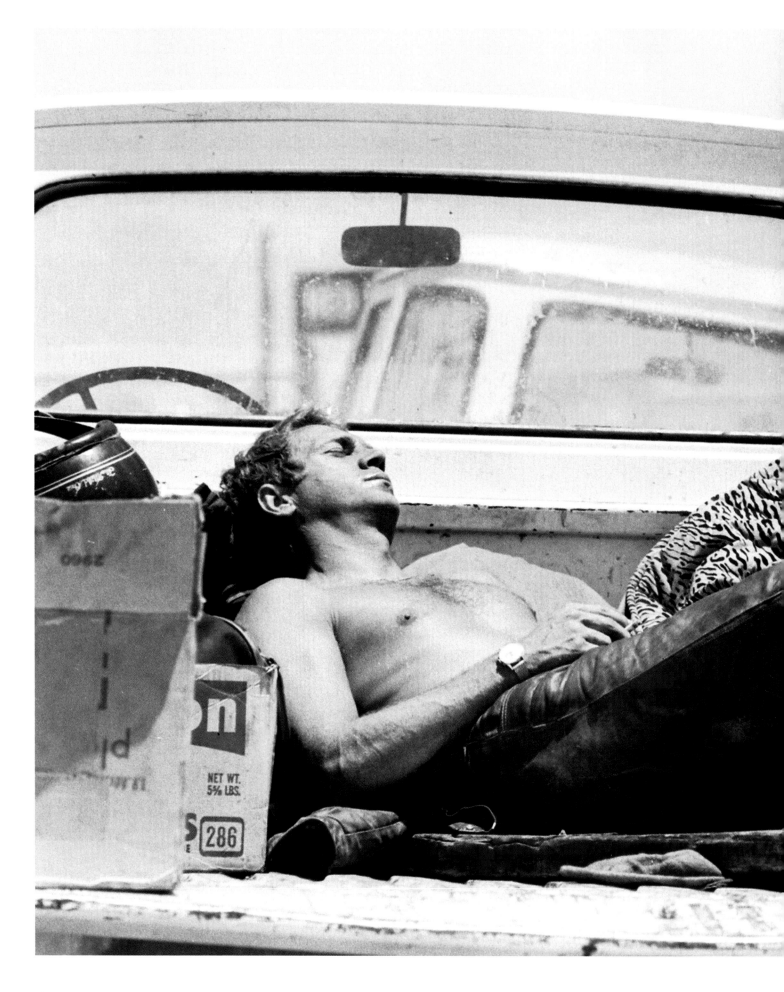

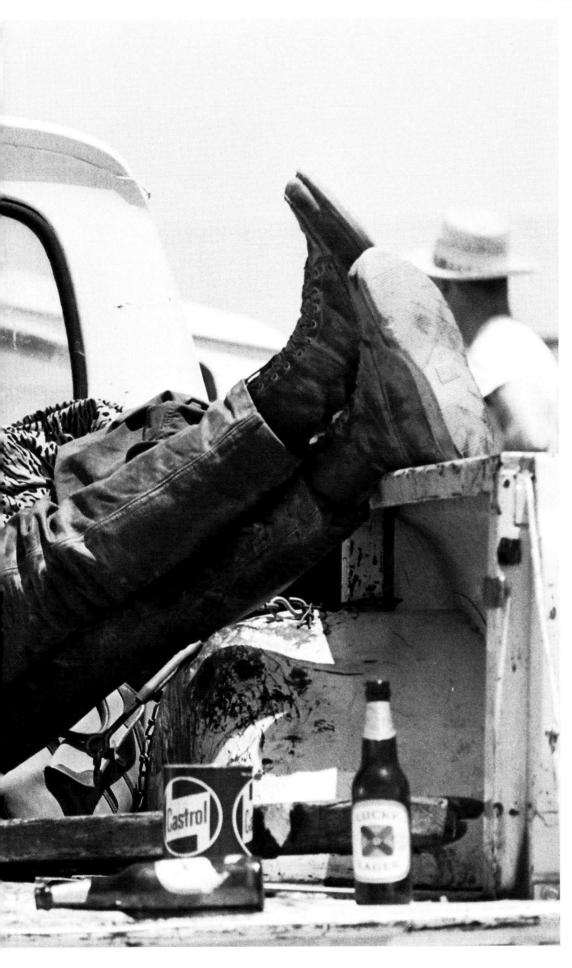

McQueen's ease and affability are on display in the two pictures seen on the pages immediately previous and the one here, which were all taken for LIFE by John Dominis during a three-week visit to McQueen's Palm Springs, California, home in the spring of 1963.

Natalie Wood

1938~1981

SHE WAS A HOLLYWOOD RARITY, an earlier Drew Barrymore: a child star, a teen star and then a real star. She made her first movie at the age of four and excited audiences before she was 10 with her precocious sophistication in the 1947 hit *Miracle on 34th Street*. To this day, if you tell a television watcher during an annual Christmas season TV rebroadcast that the little girl on the screen is actually a young Natalie Wood, the answer will be, "Nooo! Can't be!"

This is because she would become best known as a dark-haired, doe-eyed teenaged dream opposite James Dean in *Rebel Without a Cause* (1955); as Maria in *West Side Story* (1961); as the burlesque dancer Gypsy Rose Lee in *Gypsy* (1962); and as the stunningly beautiful star of the romances *Splendor in the Grass* (1961) and *Love with the Proper Stranger* (1963). In the first half of the '60s, no one contributed to the waning of the dumb blonde as principal object of a man's desire more than Natalie Wood did.

She was a different kind of sex symbol, somehow more sophisticated and serious than those who had come before. But in other ways she was very much a child of Hollywood. She had affairs, as an adolescent and shortly thereafter, with men old enough to be her father, and her subsequent dating résumé included Steve McQueen, Warren Beatty, Dennis Hopper and Elvis Presley, so there you are. But she also had the good fortune to marry Robert Wagner—twice. They were together when, after perhaps too much drinking, she drowned in the ocean at age 43 as their boat was anchored off Catalina Island in Southern California.

JOHN DOMINIS

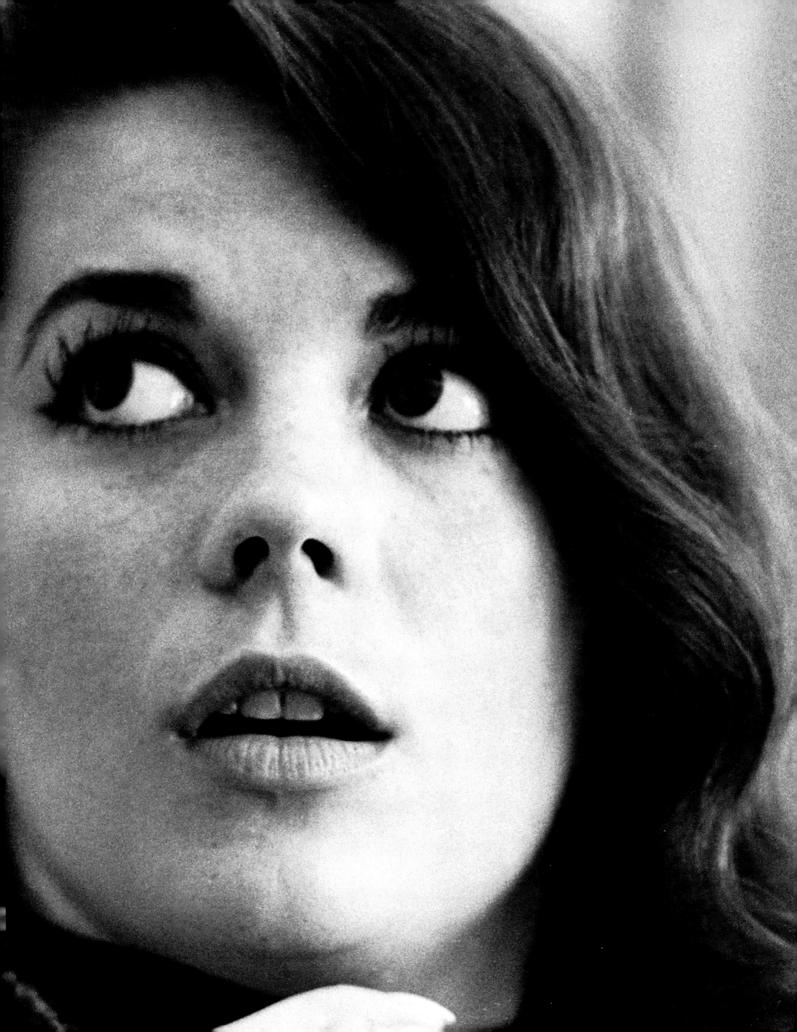

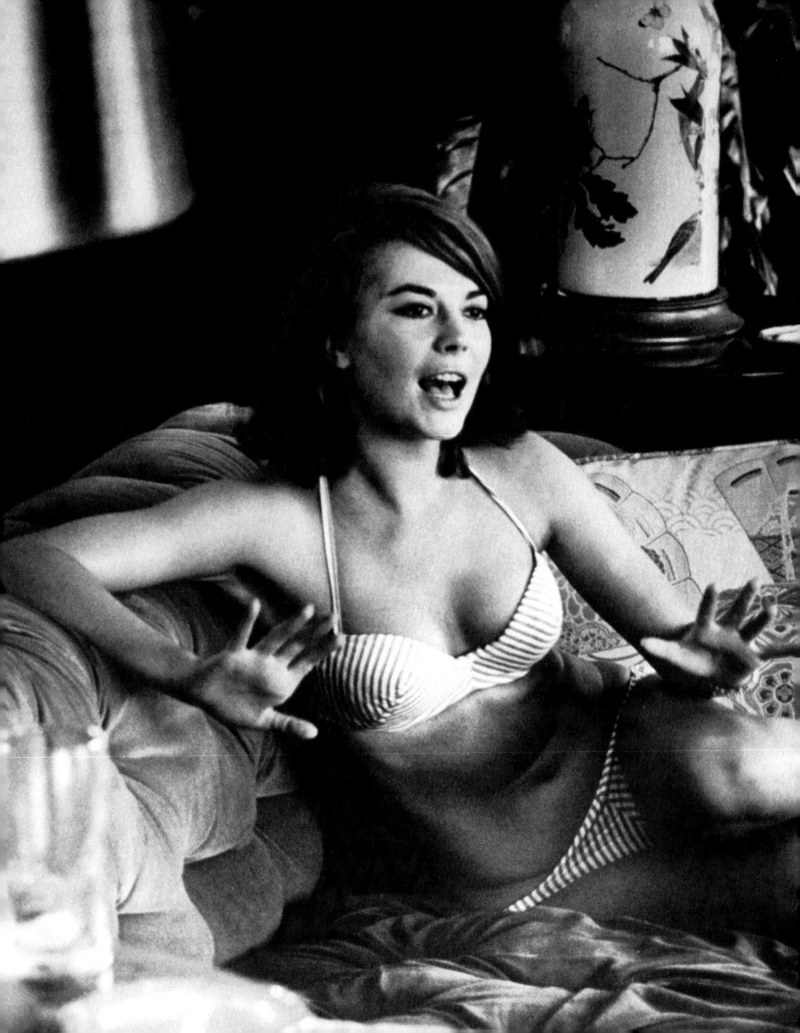

Wood is one of those stars it is hard to categorize: Was she an actress or a sexpot? Here, in 1963, she is playing a game called Act Out with an unseen friend. She is portraying "slightly sensuous"—*slightly* being a clear impossibility.

John Belushi

1949~1982 YOU CAN MAKE THE CASE for a very linear, All-American success story. Born in Chicago to an Albanian immigrant family, Belushi went on to become a star linebacker with the Wheaton Central football team, serve as homecoming king, marry his high school sweetheart, gain early success in his native city and then proceed to greater achievements in New York and Hollywood. That's the American Dream, isn't it?

But Belushi's personality, which informed his art at every turn and certainly contributed to his phenomenal professional success, continually bent and dented this particular Horatio Alger story. "The same violent urge that makes John great will also ultimately destroy him," said *Saturday Night Live*'s Michael O'Donoghue, who wrote the first-ever SNL skit, which featured Belushi and himself. (O'Donoghue also would die young, of a brain hemorrhage, at age 54.) "He's one of those hysterical personalities that will never be complete. I look for him to end up floating dead after the party."

That's how it played out. After becoming famous for *Saturday Night Live* and transcendentally so for his star turn as Bluto Blutarsky in one of the funniest films ever made, *Animal House*, Belushi (at left, in an *SNL* skit with Buck Henry) found that he could not resist the trappings of success. He ingested the wild life, dusk to dawn, and when he was injected by drug dealer Cathy Smith with a speedball combo of heroin and cocaine in his bungalow at L.A.'s Chateau Marmont, he died of an overdose. It could have been predicted. In fact, it had been.

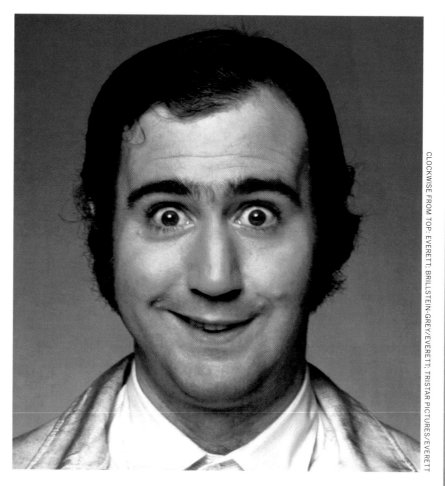

CLOCKWISE FROM TOP: EVERETT; BRILLSTEIN-GREY/EVERETT; TRISTAR PICTURES/EVERETT

PAUL FUSCO/MAGNUM

The Comics' Curse

As with far too many rock stars, whom we will meet in later pages, several of modern America's young comedians, some energetically adopting the rock 'n' roll lifestyle, died young. The patron saint of flame-out comics is certainly the legendary Lenny Bruce, who OD'd at 40 in 1966. Freddie Prinze was only 22 when, after suffering bouts of depression and struggling with a drug problem, he shot himself in 1977. The eccentric and brilliant performance artist Andy Kaufman (above) contracted lung cancer and died in 1985 at age 34. The sweet John Candy, who could never get a grip on his weight problem, died of a heart attack at the age of 43 in 1994. "Lust, gluttony, booze and drugs are most of the things I confess to," said Chris Farley (below, left), another *Saturday Night Live* comedian who idolized John Belushi. He overdosed in 1997 at 33. Phil Hartman (right), yet again an *SNL* star, was 49 when he was murdered by his wife, who had struggled with alcohol and drugs, in 1998. She later shot herself, leaving two children parentless.

Gilda Radner

1946~1989

SHE WAS A CASTMATE of John Belushi's when *Saturday Night Live* was washing over American culture like a tsunami, but she was in most ways besides her youth and irreverence an entirely different person from her costar. Her characters all had an innate sweetness, and she too was sweet. The main thing she shared with Belushi was that both performers were intrinsically, instinctively funny. We could choose to highlight here any of Radner's incarnations—Baba Wawa, Roseanne Roseannadanna, Lisa Loopner—but Emily Litella translates most uproariously on the page. Litella was the woman of a certain age, hard of hearing, who would appear on "Weekend Update" to rebut arguments made in recent editorials concern-

ing, to take a few examples, "the deaf penalty" or "flea erections in China" or "pouring money into canker research" or "youth in Asia" or "firing the handicapped" or "making Puerto Rico a steak" ("Next thing they'll want is a *baked potato*! With sour cream and chives and little tiny bacon bits and pieces of toast."). When corrected as to the topic, she would respond meekly to the audience and to host Chevy Chase, whom she called Cheddar Cheese, "Never mind." The catchphrase is with us still.

But Radner is not. She married fellow comic actor Gene Wilder in 1984, and only two years later developed ovarian cancer, which she fought bravely and with characteristic humor until 1989. Radner leaves a legacy beyond her indelible comedy. She inspired the founding of the Gilda's Club movement, which now has wellness and counseling centers for cancer sufferers in several states (above, in Santa Monica, California, in 1988). Gilda lives.

Bruce Lee

1940~1973 BORN IN SAN FRANCISCO to a Chinese father and Chinese German mother, Lee, who was raised in Hong Kong, would straddle the Asian and American cultures his entire life. He returned to the Bay Area after turning 18 and worked at various jobs, from waiter to kung fu teacher. In the martial arts, he was preternaturally gifted. Before he was discovered by Hollywood at a 1964 karate tournament in Long Beach, California, Lee put his abilities to work in other ways. Moving between Hong Kong and the U.S., he continued to teach but was also, meantime, involved in gang fights, in which he developed a fearsome reputation.

On the screen, his fame was made in a small handful of Hong Kong and U.S. films, including *Enter the Dragon* (1973), which helped spur a worldwide martial arts frenzy. Fame turned to legend when, a short time before *Dragon*'s release, Lee died suddenly and, according to lore, *mysteriously* at age 32. The cause of his death in Hong Kong was listed as a brain edema. Some Lee disciples hold that he was murdered for his past gangland associations. Lee, for his part, once asserted that he would never argue with fate: "If I should die tomorrow, I will have no regrets. I did what I wanted to do. You can't expect more from life." Eerily, his son, the actor Brandon Lee (below, with Dad in 1966) would also die young, at age 28, after a mishap on the set of an action-thriller film in 1993.

DORIS NIEH/GLOBE

TED THAI

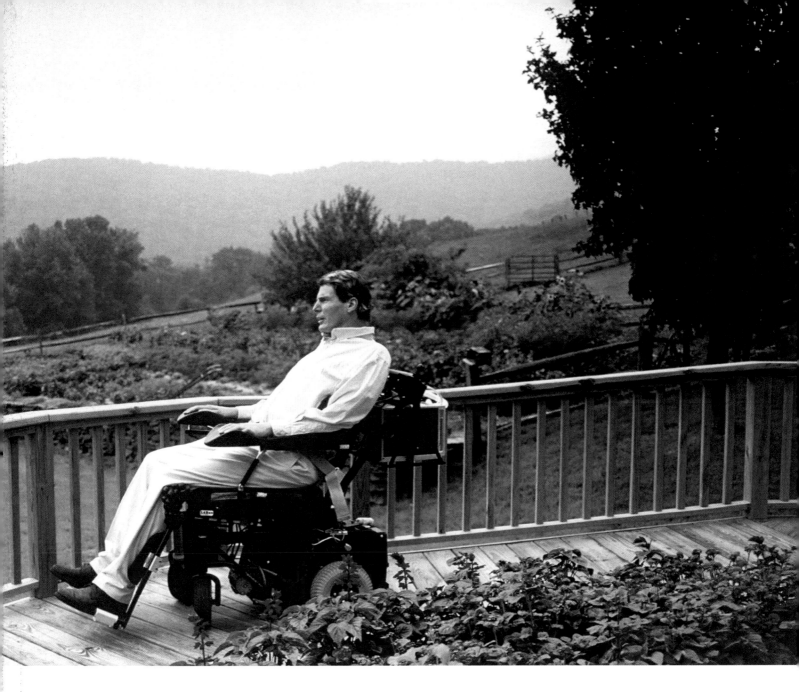

Christopher Reeve

1952~2004

HE EMBODIED SUPERMAN. With his good looks, six-foot-four physique, obvious intelligence, stand-up bearing and evident wit, he was, in four movies, the only actor on the daily planet anyone might imagine playing Superman. It has been pointed out by others that Christopher Reeve's personal fate represents the harshest sort of irony. Superman doesn't exist, not in real life.

Reeve was born in New York into an intellectual, upper middle class family, and first caught the acting bug in prep school. He focused on theater at Cornell and then at Juilliard—where he befriended classmate, and fellow sure-thing student, Robin Williams. He worked on the stage in New York and elsewhere, and against the odds landed the role of Superman when he was still unknown. He literally and figuratively soared to fame.

On May 27, 1995, Reeve was competing in an equestrian event in Virginia when his horse threw him. He was left paralyzed, a quadriplegic. He would be wheelchair-bound, tied to a respirator, the rest of his days (above, at his summer home in Williamstown, Massachusetts, in 1996).

He said many times that the love and support of his wife, Dana, saved him. He discovered new purpose, founded the Christopher Reeve Paralysis Foundation (now known as the Christopher and Dana Reeve Foundation), raised millions for the cause and lobbied for stem-cell and spinal cord research. In 2004, a fast-spreading infection claimed his life. Just as tragically, Dana contracted lung cancer within the year and followed him in death, leaving a 13-year-old son. They had helped so many, but, for themselves, could overcome only so much.

John Ritter

1948~2003

IN THE PRESENT DAY, television stars can develop a rapport with their audience that even the most popular film actors of yesteryear could never achieve. There may have been mass adulation attending the Monroes and Deans and Clifts and Valentinos, but at best their fans had the opportunity to enjoy them on the big screen twice or thrice a year. TV stars walk through the door and enter the intimacy of the American living room on a weekly basis (more often if in reruns; almost hourly if employed by *Law & Order*). When the star seems as earnestly affable as the character he or she is playing—in other words, when the artifice of acting gives way to the real person—a true bond can develop. Such was the case with John Ritter (opposite, in 2003).

A cynic could say he mightn't have been capable of the artifice anyway. Starring roles in the situation comedies *Three's Company* and *8 Simple Rules for Dating My Teenage Daughter* certainly didn't demand a Method approach, and in fact might have been undone by it. Ritter, son of the ever-smiling country music singer Tex Ritter, brought an easy charm and deft comedic timing to his assignments; his audience always knew it was being delivered John Ritter, whatever the character's name was.

He was on top of the world at age 54 with his second sitcom success when, on the set one day, he suffered a tear in the main coronary artery and died hours later on the operating table. Those who had come to not only like him but love him were stunned. They had lost not just a favored performer. They had lost a friend.

Heath Ledger

1979~2008

FOR A MOVIE CAREER SO BRIEF, it nevertheless had two distinct chapters. In the first, Ledger was one of the pack, a talented and good-looking young guy who was more than serviceable in films such as *10 Things I Hate About You*, *The Patriot* and *A Knight's Tale*. (For this last effort, he was nominated for an MTV Movie Award in the category Best Kiss, but he lost.) The second chapter concerns his work in two lavishly lauded films: *Brokeback Mountain* (2005) and *The Dark Knight* (2008). In these movies, and also in 2007's *I'm Not There*, Ledger announced himself as a force to be reckoned with—not just another pretty boy, but perhaps the next Leonardo DiCaprio or Johnny Depp. A true actor and a true star.

His ascension to the highest rank happened without him. He did receive the best supporting actor Oscar for his performance as Batman's nemesis, the Joker, in *The Dark Knight*. But by the time the awards were handed out in early 2009, Ledger was already dead.

He had relocated earlier from his native Australia (above, in Perth in 2000) to Los Angeles and then to Brooklyn, where he lived from 2005 to 2007 with actress Michelle Williams and their

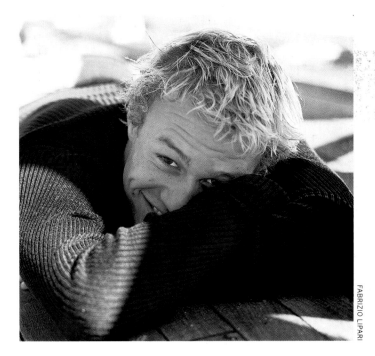

FABRIZIO LIPARI

daughter, Matilda Rose. After he and Williams split up, Ledger took an apartment in the southern Manhattan SoHo district. It was in those lodgings that he was found on January 22, 2008, having ingested a fatal quantity of prescription drugs. Ledger had been suffering from insomnia for some time, and his death was officially ruled an accident. He was gone before we really got to know him.

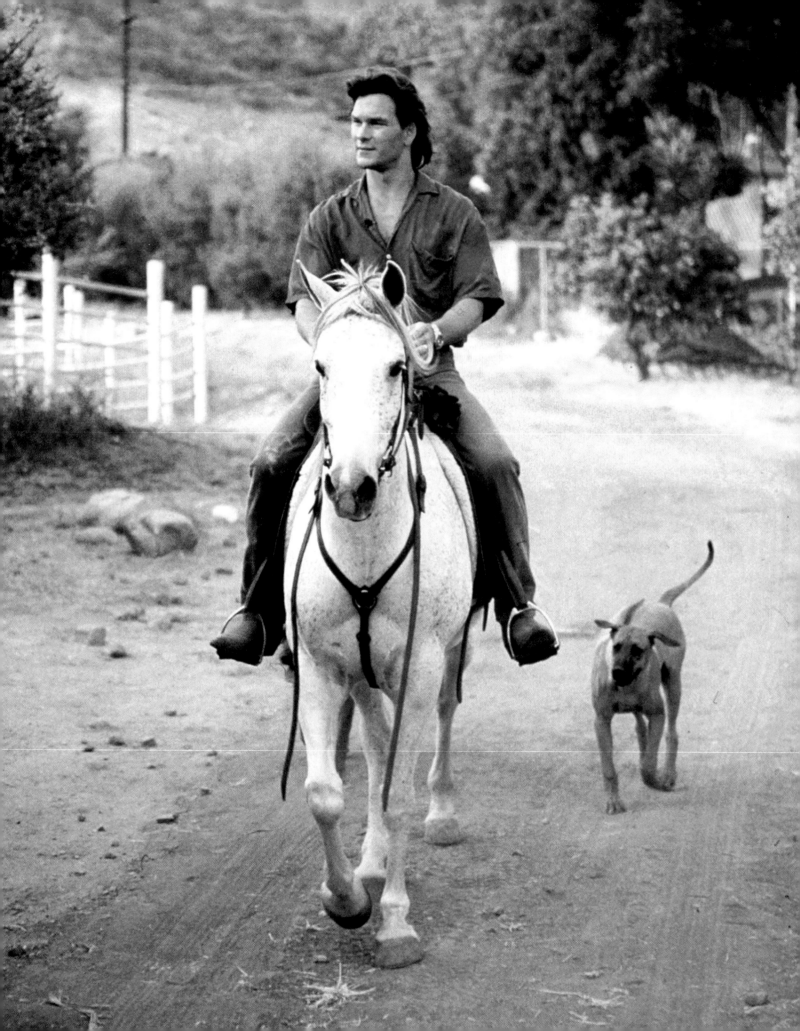

Patrick Swayze

RON WOLFSON/LFI

1952~2009

His mother had been a professional choreographer when he was a boy, and young Swayze had a menu of pursuits that was unique if not downright odd in his native Texas: football . . . and classical ballet; horseback riding . . . and ice skating. He was athletic in the extreme, but sustained a knee injury while playing football. Shortly after high school, he moved to New York City, where he focused on ballet, but the earlier injury ultimately derailed his career.

He could also act, and he worked on Broadway. He tried television, and was noticed for his role in *North and South*, a 1985 miniseries. Still, few had yet seen the complete Patrick Swayze.

The fictitious Johnny Castle was a dance instructor destined to win the girl in a straight-to-video film called *Dirty Dancing*. The part and the entire project were perfect for Swayze. He danced, he wooed Jennifer Grey, he sang on the soundtrack. The movie was supposed to have a weekend-long run in theaters then be relegated to Blockbuster. But it *became* a blockbuster, propelling Swayze into the stratosphere.

His audience—particularly the women, who heartily concurred when he was named *People* magazine's Sexiest Man Alive—adored him, and he had his second huge success with *Ghost* in 1990.

His fans applauded his enduring marriage to Lisa Niemi, whom he had met when both were teens and she was taking dance lessons from his mom. The fans rooted for him as he battled alcoholism. They kept tabs on him when he retired to his Sylmar, California, ranch and beloved Arabian horses (left) in order to get well. And they sat vigil for him when he developed the cancer that would claim his life. Today, they miss him.

Farrah Fawcett

1947~2009 PATRICK SWAYZE WAS WELL into his fifties when he died, and Farrah Fawcett was 62 when she too succumbed to cancer. How can it be that they were gone "too soon"?

The determination relies on the fact that the public made eminently clear that it wanted more time with these two people. The lamentation that attended their deaths was not dissimilar to that associated with the passing of the gods and goddesses of Hollywood's golden era. There's no telling how much larger and more prolonged the mourning for Fawcett might have been, had not Michael Jackson perished on the very same day.

Fawcett became big, and quickly, on the small screen. When the television series *Charlie's Angels* debuted in 1976, she, as the sexiest of three gorgeous female private eyes, was transformed overnight from just another Texas farm-fed beauty into a superstar. In this period she was known for two things: the TV show, and the poster. The red-bathing-suit shot—which sold perhaps 10 million copies worldwide, made a lot of money for Fawcett (who retained rights to the image) and launched a million imitation hairstyles in addition to many millions of adolescent fantasies—is the only pinup to rival Marilyn Monroe's nude and Betty Grable's leggy come-on.

Fawcett later garnered critical acclaim for dramatic television and feature film roles, and then she got sick. Her final years were strange as they played out in public through television shows. But the response to these programs served to confirm the allegiance of her multitudinous fans. The documentary *Farrah's Story*, which won her a posthumous Emmy nomination as producer, was watched by nearly nine million people when it first aired on NBC in the spring of 2009. A little over a month after it was broadcast, Fawcett passed away.

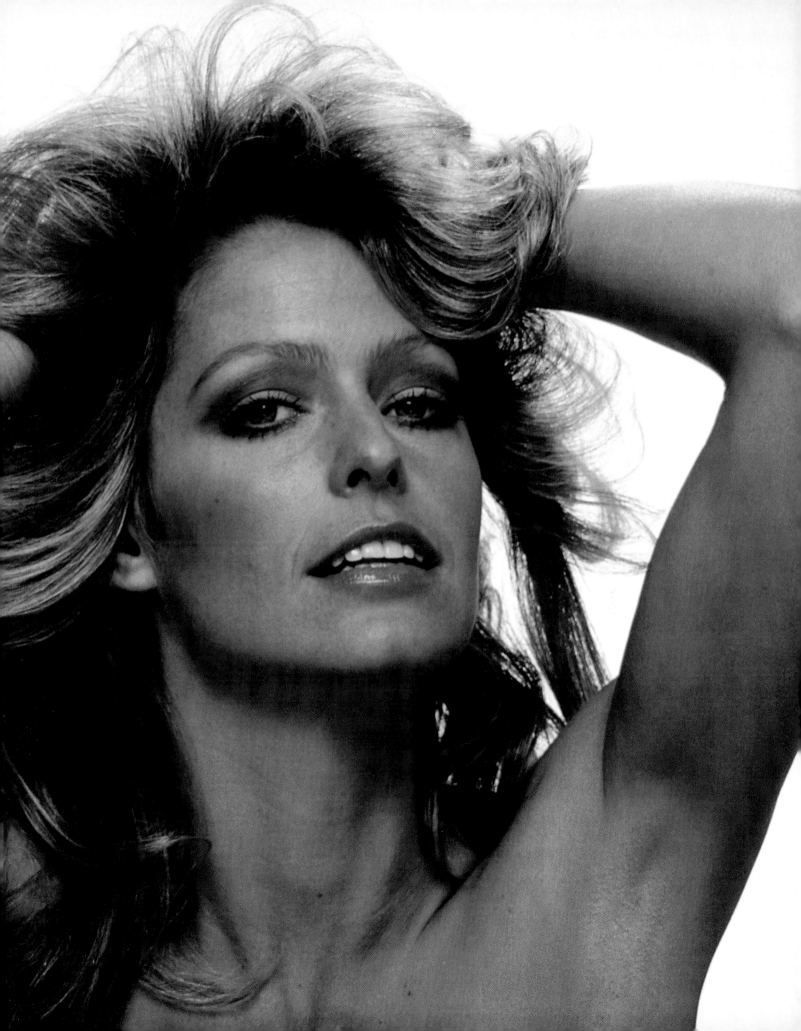

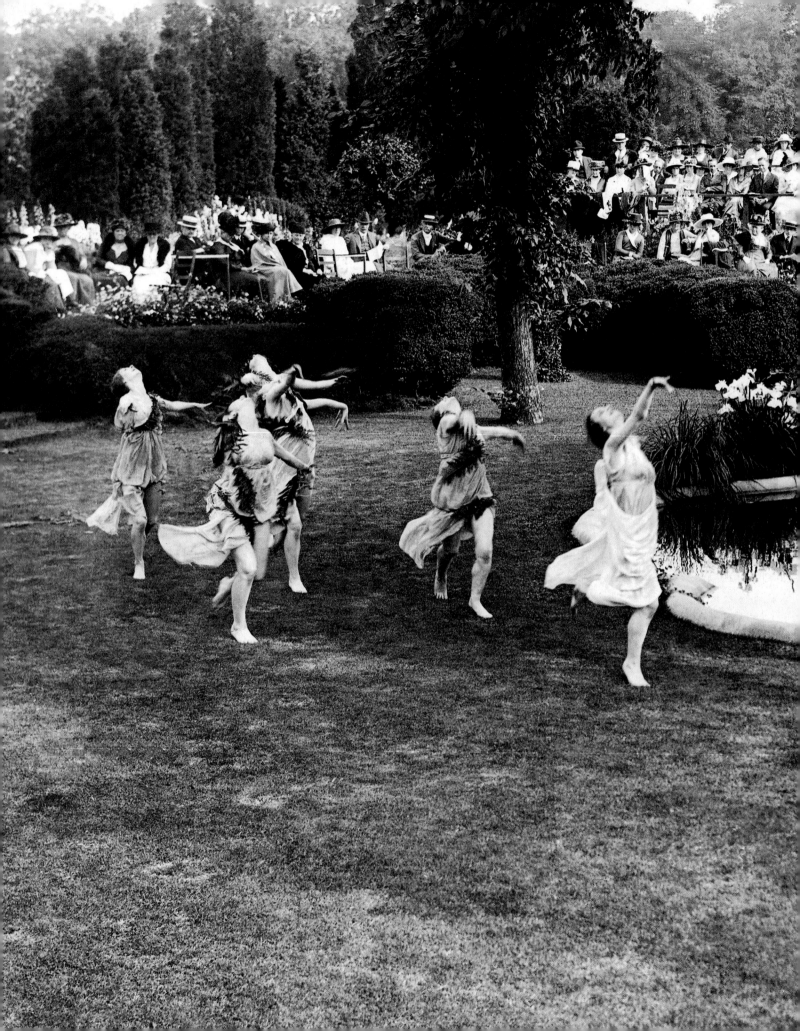

Romance
of the
Tragic Artist

Isadora Duncan frolics with
five flamboyant femmes in
June 1918 during a garden
fete on Long Island, New
York, to benefit the Italian
War Relief Fund. Please see
page 76 for Duncan's story.

John Keats

1795~1821 OTHER EXTRAORDINARILY attractive and talented British writers and poets who died young are, we hope, accorded their due in the sidebar just below. Yet it is fair to ask: Why do we choose Keats to lead this brigade? Why is he the main article, and the others are mere matter for the postscript?

As said: fair question.

Our modest defense is that Keats (opposite, in a portrait by his devoted friend Joseph Severn, who would nurse him as he died), the last of the English romantic poets to make his mark, was the youngest to die, and thus stands as a kind of ultimate emblem. He was also, quite probably, the best of them.

It was certainly not thought that Keats, the son of a London livery stable keeper, would be able to make his way as a poet. However, while he was headed for a career in medicine, his passion for literature and verse overcame him. He was first published in 1817, and that year he decided to redirect his life. He made influential friends and began to gain some note as one of the new kids on the writerly block, though early critical reaction to his poetry was mixed; in fact, Keats's considerable literary reputation would not be established until after his death. What today are considered classics, such as "Endymion," were savaged by some influential critics in their day.

"Beauty is truth, truth beauty," Keats wrote in "Ode on a Grecian Urn," "that is all/ye know on earth, and all ye need to know." He saw beauty everywhere, and created much himself during his last five years. Through this entire period, he showed signs of suffering from tuberculosis, the disease that claimed him at age 25. The English audience didn't know what a titan it had lost. That impression grew through the decades as Keats's voice was finally heard in full.

The Curse of Romanticism

These young men and women—idols of Keats, rough contemporaries and associates of Keats, disciples of Keats—combined with him in the early 19th century to forge the image of the artist who lived and created with outsized passion, then saw his or her flame extinguished before its time. George Gordon Byron, sixth Baron of Byron (best known to fans of belle lettres as Lord Byron, opposite, bottom left) was profligate of words, emotion and action, both social and political. "Mad, bad and dangerous to know," said Lady Caroline Lamb, getting it spot-on. He quilled "She Walks in Beauty" and was quick to dive into the Greek War of Independence, before dying of fever in Greece in 1824 at age 36. Byron's friend Percy Bysshe Shelley (center) was another hedonist and idealist who, like Keats, went largely unappreciated as a poet in his lifetime, but who gained great fame after his premature death. His verse inspired all romantics who followed, while his political philosophies influenced Thoreau and Gandhi. Sailing his schooner *Don Juan,* Shelley drowned in a storm at sea at age 29. His sad end could have been written by any of the three Brontë sisters (right), none of whom would reach age 40. Charlotte, Emily and Anne, born between 1816 and 1820, survived a severe upbringing to create gothic romance novels that are classics today: *Jane Eyre, Wuthering Heights, Agnes Grey* (all published in 1847). Emily and Anne died of TB in 1848 and '49, respectively. Charlotte briefly seemed the lucky one, finding herself in a happy marriage in 1854. But she died in 1855 of illness while carrying her first child.

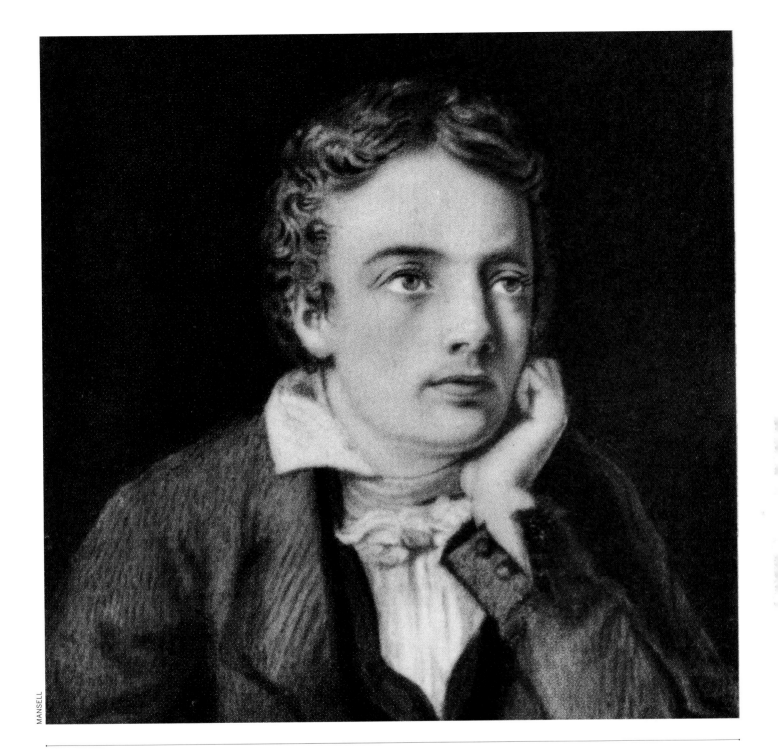

MANSELL

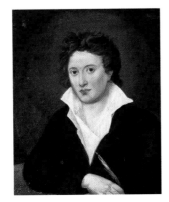
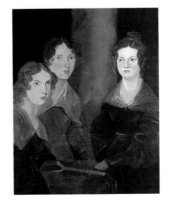

GRANGER (3)

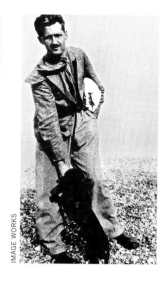

IMAGE WORKS

Henry David Thoreau

1817~1862

Aᴌᴏɴɢ ᴡɪᴛʜ ʜɪs ꜰʀɪᴇɴᴅ Ralph Waldo Emerson, another member of the famous and transcendentally brilliant literary circle in 19th century Concord, Massachusetts, Thoreau was one of the very most influential writers who ever lived. His philosophy, which ranged widely and touched on subjects from nature to slavery to economics, was expressed in essays, poems and personal journals that were self-consciously profound and provocative. These books have spurred social movements and informed others. Tolstoy discussed Thoreau with Gandhi; Martin Luther King Jr. took tactics as well as general guidance from his pages. Thoreau's seminal memoir, *Walden*, and his essay "Civil Disobedience" contain original thinking that are part of life's daily debate on the role of government and the individual's place in society (below, left, Thoreau in an 1855 daguerreotype that cost him 50 cents to have made; right, his simple grave in Concord).

Because he built that cabin by the pond and experimented with a solitary life, Thoreau is often perceived as a loner. He was not. He not only engaged with such as Emerson and other neighbors, he was activist when he felt compelled to be, for instance speaking publicly in favor of abolition. Because he wrote seriously about deep matters, he is often perceived as a graybeard. He was not. He died at age 44 of tuberculosis.

Had Thoreau been granted his fair measure of life, what more might he have bequeathed to the social discussion? With such an idiosyncratic genius as Thoreau, it is impossible to know. It can be supposed, however, that whatever other new—even revolutionary—ideas he placed on the table, they would have benefited us all.

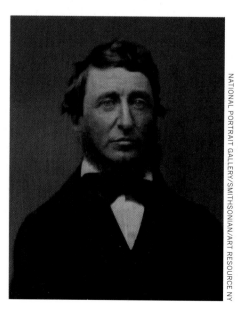

NATIONAL PORTRAIT GALLERY/SMITHSONIAN/ART RESOURCE NY

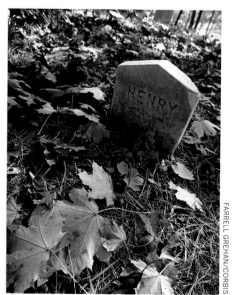

FARRELL GREHAN/CORBIS

Tuberculosis and the Writer

I t's a phenomenon worth noting. Certainly the disease that is short-handed "TB" has claimed millions upon millions of lives around the world, and therefore it should be unsurprising, perhaps, that any particular subset of the population might have been tragically visited. But still: Keats (and his brother Tom), two Brontë sisters, Thoreau—all claimed young by tuberculosis. We now add to this sad list the great English novelists Jane Austen (dead at age 41, TB a hypothesized culprit, along with Addison's disease and Hodgkin's lymphoma), D.H. Lawrence (44, opposite, bottom left) and George Orwell (46, above). Also dying of TB were the American novelist Thomas Wolfe (opposite, bottom right), who perished after a quick onset of tuberculosis of the brain at age 37, and Russian playwright and short-story writer Anton Chekhov (44, opposite, top).

Several other famous writers, from the 18th century French philosopher Voltaire to the 20th century American crime writer Dashiell Hammett and playwright Eugene O'Neill, suffered from TB, too, even if it cannot be said that this was the particular cause of their death or that they died particularly young.

Tuberculosis and the writer: a curious and lamentable correspondence.

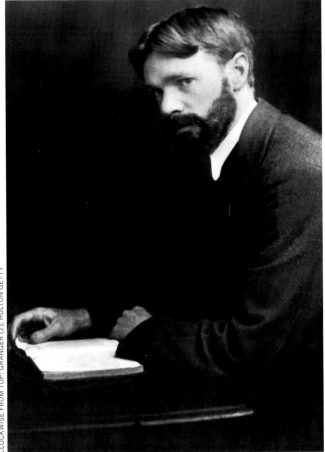

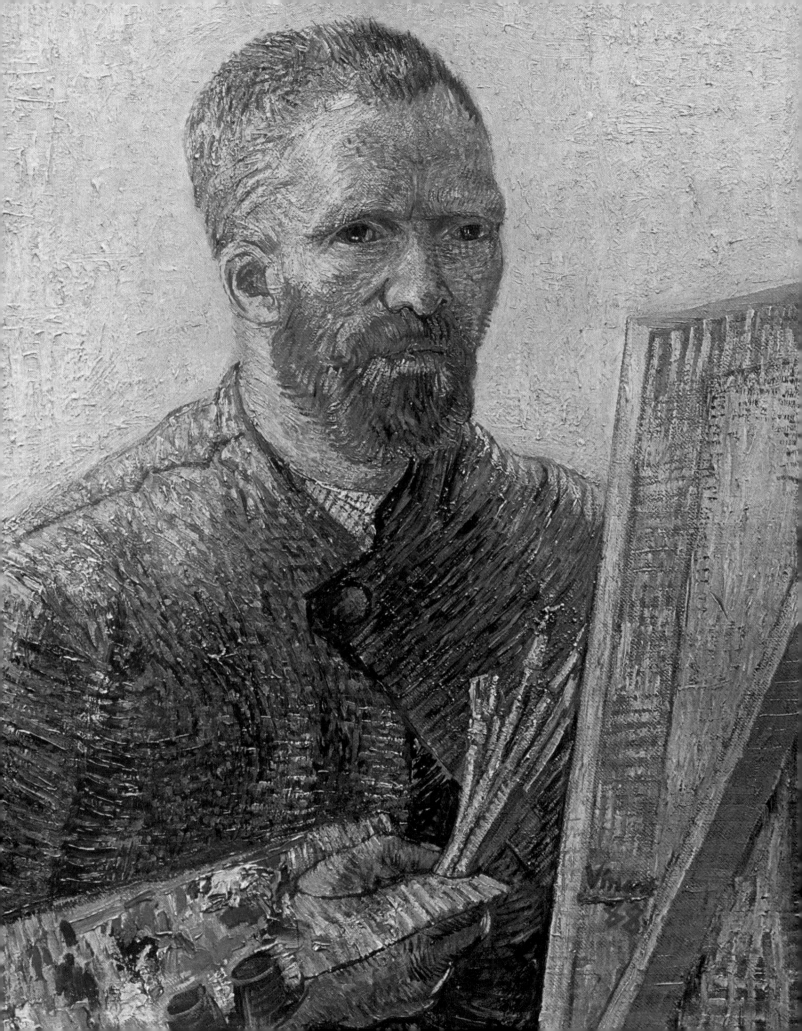

Vincent van Gogh

1853~1890

HE PRODUCED SO MUCH, influenced everything that came after him, and yet painted for so short a time. Although the Dutchman van Gogh (seen opposite in an 1888 self-portrait) worked for art dealers in England as a young man, his aim was to become a preacher, and by his mid-twenties he was working as a Christian missionary in Belgium. There he began to sketch and then paint the local citizenry, and in 1885, now in his early thirties but with only a handful of years left to live, he produced "The Potato Eaters," an early masterwork.

The following year he was in Paris, becoming a serious artist and finding himself influenced by the French impressionist movement. He moved to the south of France and began producing his thrilling, vibrantly colored landscapes and portraits. He was largely ignored. His brother, who was well aware of Vincent's undiagnosed but quite apparent mental illness, was his advocate and preservationist, making sure that van Gogh's nearly a thousand paintings and more than a thousand drawings would be seen—if not today, tomorrow.

Most of what now constitutes van Gogh's monumental reputation was produced in his last two years. He was an inventive technician and is often credited as the father of 20th century modernism. But he was a sublime painter regardless of his innovation. His paintings move the viewer in ways that few others do.

The grievously troubled van Gogh died at 37 years of age from a self-inflicted gunshot wound.

Jack London

1876~1916

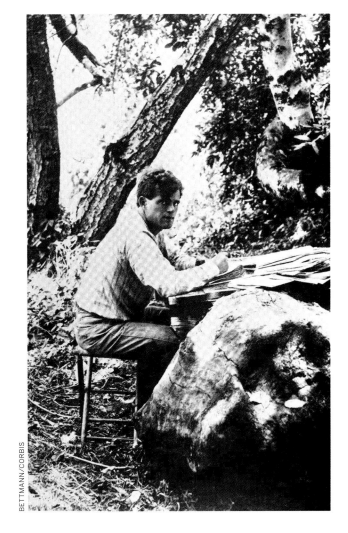

IN HIS SOCIAL ACTIVISM (as vigorously manifested in literary form), he foresaw such as Sinclair Lewis. In his adventurousness and larger-than-life mythos, he was an earlier Ernest Hemingway. In his durability—which is due not only to *The Call of the Wild* and *The Sea Wolf* but to the riveting journalism from San Francisco's 1906 earthquake and, particularly, to the large portfolio of superb short stories—he rivals any of them. Jack London was widely read in his time (he was one of the first Americans to make a truly good living from fiction-writing). He has been read ever since. He will be read tomorrow.

With no knowledge of his biological father and raised by a vagabond mother, Jack survived a rootless youth in the Bay Area, his schooling interrupted at regular intervals by stints as a cannery worker, an itinerant sailor and, after the nationwide financial panic of 1893, a hobo. In 1897 he fled to the Klondike Gold Rush in Alaska, where he found early fodder for his fictions, including the material for his classic short story "To Build a Fire." He returned from his arduous work in the north a committed socialist and aspirant writer.

The Call of the Wild, published in 1903, was a wild success and made London (right, in 1905) a literary celebrity. Three years later his firsthand account of the earthquake, published in *Collier's*, only furthered his fame. He remained one of America's best-known and best-loved literary figures until his death at his California ranch, an end probably hastened by uremia. As London was a romantic figure, suicide has been raised as a cause of death. But most biographers agree that the generally happy Jack would not have taken his own life.

Isadora Duncan

1877~1927 Her life—and her death—were avant-garde in the extreme, and were bizarrely of a piece, as if the end had been scripted as the last scene in one of her altogether unique, extraordinarily moving ballets. Long, luxurious scarves were among the many signature flourishes dear to Duncan's heart, both on the stage and in the streets, and when she was motoring in France one day in 1927, her neckwear became entangled in the car's open-spoked wheels and she was left dead with a broken neck.

Duncan (opposite, in 1923), seemingly a creature of the world who would gain celebrity first among the glitterati of Europe, was born in America—albeit in that crucible of bohemianism, San Francisco. She was both like and unlike her direct contemporary and Bay Area kinsman Jack London. She was creative, freethinking, bold and ambitious, yes; but she was the footlights figure to his outdoorsman. Still a teen and having not finished school, she joined a theater troupe in New York City, then kept moving east to London and Paris. By her early twenties, she was a celebrated dancer. She was new, she was dramatic, she was impulsive and improvisational, she was openly emotive, she was barefoot. That she might one day be regarded as the mother of modern dance was securely on the rails. That she had become a European goddess—the subject of sculptures and paintings—was already evident.

Drawn to what she perhaps misperceived as the romance of revolution, she moved to Moscow in 1922 and aligned herself with the new Soviet Union. But politics were not what would define Duncan, modernism was. She was dance's van Gogh, a revolutionary in the egalitarian realm that is art. And she was a woman who died as she had lived—crazily.

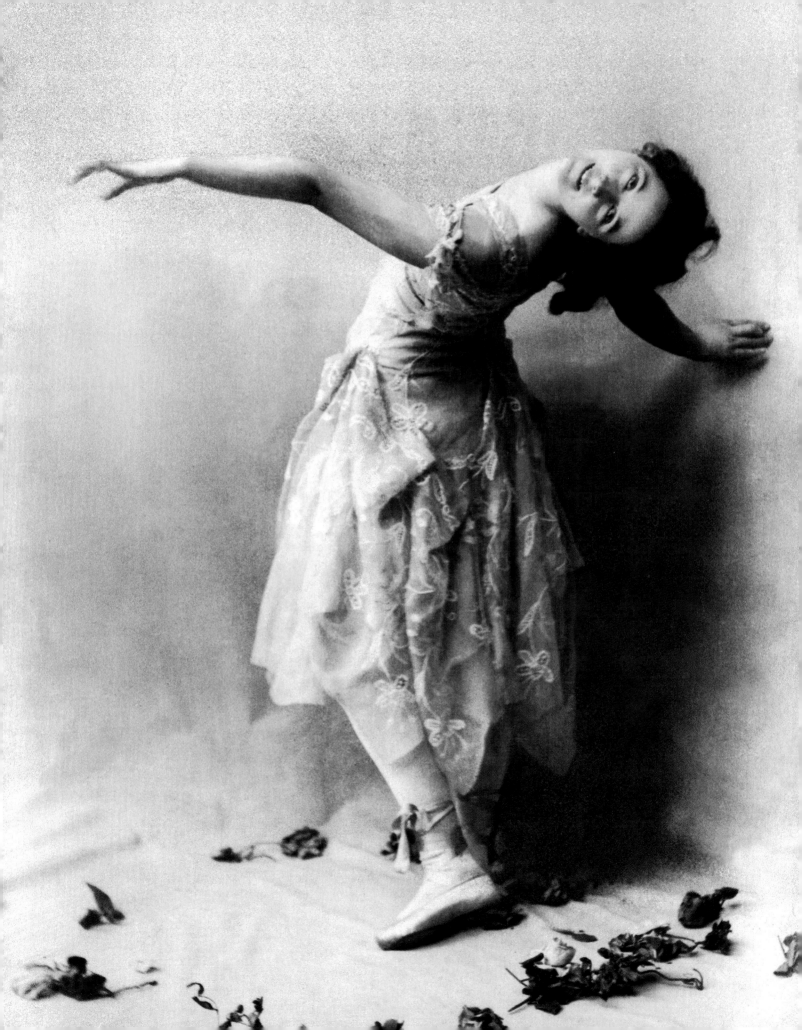

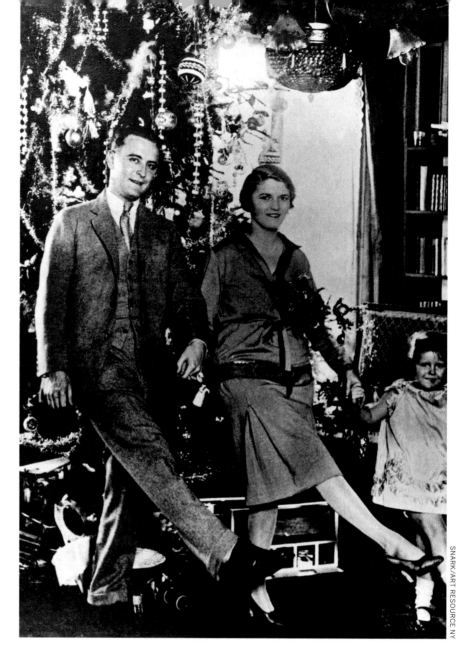

SNARK/ART RESOURCE NY

F. Scott Fitzgerald

1896~1940

HE EPITOMIZED BOTH the Jazz Age and the disaffected Lost Generation to a fatal degree. Gifted with rare intelligence, a perspicacious ability to limn his species and a divine facility for writing, he crafted some of the 20th century's greatest novels and short stories. But he was a slave to the bottle from his college days at Princeton, and drink killed him. He claimed there were bouts of tuberculosis, perhaps hoping to align himself with a more innocent literary tradition, but with Fitzgerald there can be little doubt: The booze did him in.

An Irish Catholic from St. Paul, Minnesota, he was energetic, distracted and impulsive from the first, not finishing his studies at Princeton, serving in the Army during World War I and marrying young, to the even-more-volatile-than-he Zelda Sayre. When his first book, *This Side of Paradise*, became a sensation, so did Scott and Zelda (above, celebrating Christmas in France with daughter Scottie in 1925). *The Great Gatsby*, one of the finest American novels ever written (and along with *Moby Dick*, *Huckleberry Finn* and *The Scarlet Letter*, one of the most frequently nominated as "The Great American Novel"), made its author the very biggest thing in 1925. The apex was a dangerous place for Scott Fitzgerald—and for Zelda—and both of them spiraled downward the rest of their days, even as he created another masterwork, *Tender Is the Night*, and other worthy prose.

On their joint grave in Rockville, Maryland, is an inscription of the last lines from *Gatsby*, which might apply to so many in our book: "So we beat on, boats against the current, borne back ceaselessly into the past."

The Curse of the Bottle

I f Fitzgerald is the poster boy for the Alcoholic Writer, he has company. The poet and short story writer Edgar Allan Poe (top left) was certainly disturbed, but principally he was a drunk, and died in 1849 at age 40. Dylan Thomas (bottom left), the Welsh poet and memoirist, was 39 when he passed away in New York City in 1953. Jack Kerouac (top right) gave nomenclature to his generation, the Beats, just as Fitzgerald had done with the Jazz Age; Kerouac died in 1969 at 47. Of the seven Americans awarded the Nobel Prize for Literature, five battled with alcoholism. The cause of this link is uncertain, but the truth is undeniable. Close cousin to the Alcoholic Writer is the Alcoholic Artist, of whom Jackson Pollock (bottom right) was one. DUI, he crashed his car on Long Island in 1956, at age 44.

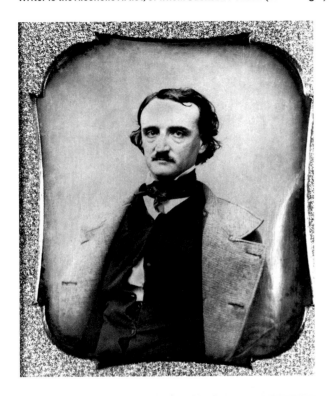

Antoine de Saint-Exupéry

1900~1944 MOST AMERICANS THINK of him, if they know his name at all, as a children's book author. *He's the fellow, who wrote* The Little Prince, *isn't he?* Well, yes, he is—or was. But he was much more, and in his too-short lifetime he gained greater fame for other, earlier endeavors (above, Saint-Exupéry's passport circa 1930).

He was an aviator in the days when the term connoted one who was "daring," "intrepid," "dashing." Born to privilege in France, Saint-Exupéry received his air training in the military, but then took an office job in Paris to placate his family. The nine-to-five life was not for him, however, and by 1926 he was flying again: one of the legendary Aeropostale pilots handling planes that featured minimal (at best) instrumentation. His novel *Night Flight*, which was based on his experiences, detailed his Aeropostale derring-do and secured his fame in France.

He did crash in the Sahara Desert in 1935, as readers of *The Little Prince* might surmise, and survived to tell the tale. On a reconnaissance mission for the Free French Forces in 1944, however, he disappeared for good after taking off from an airbase in Corsica in the Mediterranean Sea. He had been assigned to report on German troop movements, and whether he was shot down or crashed accidentally has never been proved, although in recent years remnants from his plane have been found, and a former Luftwaffe pilot has come forward claiming that he had downed a P-38 Lightning that could well have been Saint-Exupéry's. No matter the underlying facts, this was a storybook life, with a storybook end.

Sylvia Plath

1932~1963 SHE WAS A TROUBLED young woman who expressed herself intimately in prose and poetry. Plath's readers felt they really knew her—knew her as a friend, a confidante—and when she killed herself at age 30, many of them felt they knew why.

A native of Massachusetts, daughter of a college professor father and a schoolteacher mother, she was precociously bright and artistically inclined; Sylvia saw one of her poems published in a Boston newspaper when she was only eight, and won two awards for painting as a teenager. She matriculated at Smith College. She continued to be noticed for her writing, continued to win awards, was popular with classmates and men. But whatever happiness she could grasp represented only fleeting relief from chronic depression.

Plath felt she was marrying a soulmate in the English poet Ted Hughes, and they had two children together, but his infidelity shattered her. She was separated from him and raising their son and daughter on her own when, on February 11, 1963, she attempted suicide—not for the first time—and succeeded. Before turning on the gas in the oven, she put wet towels against the kitchen's door frames so no one else would be hurt.

But of course others were. The readers of her semiautobiographical novel *The Bell Jar* were devastated, as were the devotees of her poems, for which she posthumously won a Pulitzer Prize. The woman with whom Hughes had had an affair also would kill herself, as would, much later, Hughes and Plath's son, Nicholas. Sylvia Plath's was a sad story that has only become sadder since she died.

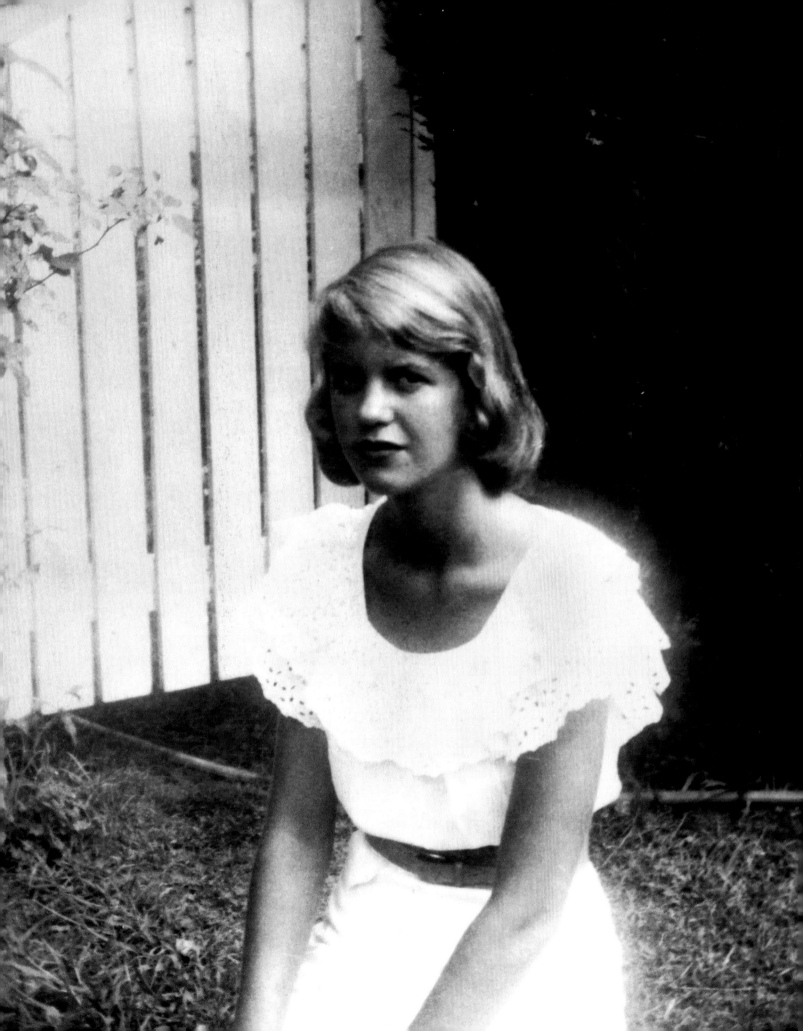

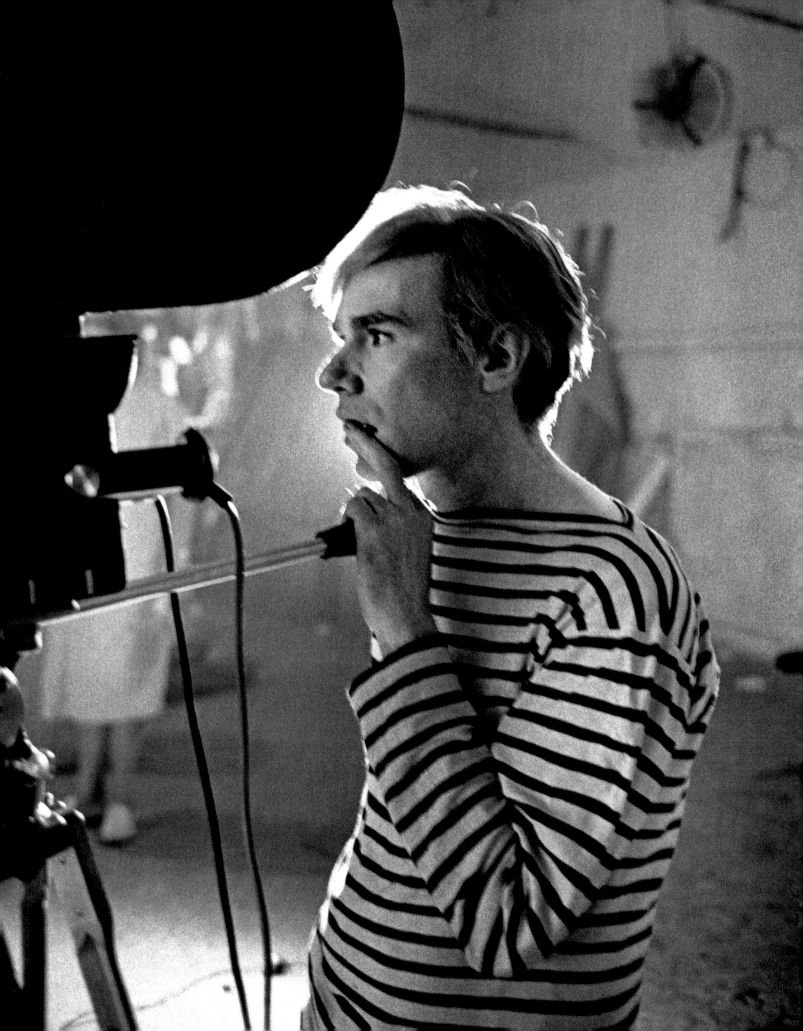

Andy Warhol

1928(?)–1987

MOST OF US who think we know who he was really have little idea. (He wouldn't even confirm for us the year of his birth!) We think of Andy Warhol and we see and hear New York City, dark glasses, the wig, pop art, soup cans, Marilyn and Elvis, the Factory, the Velvet Underground, Edie Sedgwick and Ultra Violet, "everyone will be world famous for 15 minutes," $100 million bids at art auctions. The man we do not see is the painfully shy Andrew Warhola, native of Pittsburgh, son of Czechoslovakian immigrants, serious student, diligent worker, devout Byzantine Catholic, daily churchgoer. Andy Warhol might have appreciated the irony. He always appreciated irony.

He had great talent. Once he was established in New York City, his reputation as a master illustrator precluded, for a time, any consideration of him as a serious artist. That changed as the answer to the seminal question "What is art?" began to change. Warhol was positioned well to ride America's seismic cultural shift in the mid-1960s. He was the guru of a weird scene headquartered at "the Factory" (opposite) that included wannabe movie stars and filmmakers, serious artists, rock 'n' rollers, druggies, lowlifes and other hangers-on. In regular attendance was the radical-feminist writer Valerie Solanas, who in 1968 shot and nearly killed Warhol, explaining later that he "had too much control over my life."

Warhol, a longtime hypochondriac who avoided doctors and hospitals like the plague, died two decades later from a postoperative heart problem after routine gallbladder surgery. He was buried back in Pittsburgh in Saint John the Baptist Byzantine Catholic Cemetery. He was attired for the hereafter in a cashmere suit, platinum wig, paisley tie—and of course those sunglasses. Looking down from on high, he certainly appreciated the irony.

FROM TOP: HELENE BAMBERGER/GAMMA/EYEDEA; JULIO DONOSO/SYGMA/CORBIS

Andy's Heirs

Few cultural trendsetters have had more devout acolytes than Andy Warhol. Many—make that, most—of his devotees are forgotten today. Two who are not are Keith Haring (top) and Jean-Michel Basquiat (bottom), artists who saw their own careers, too, cut short by fate.

Haring, another son of Pennsylvania like Warhol, was first recognized for grafittiesque chalk drawings in the New York subways that were clearly of an elevated level of sophistication. Warhol became a friend and mentor as Haring's murals and canvas paintings became internationally recognized. Haring died of AIDS in 1990 at age 31.

Basquiat, too, began his career as what was known as a "grafitti artist" (not quite an oxymoron) on the streets of New York, his native city. A high school dropout from a shattered family, he got noticed for his talent at the 1980 Times Square Show. A leading neo-expressionist in the '80s, he collaborated with Warhol and gained a fair measure of pop culture fame. He had his schtick: He would paint while wearing Armani suits, then proudly appear later in the ruined threads. He died of a heroin overdose in 1988 at age 27.

BOB ADELMAN/MAGNUM

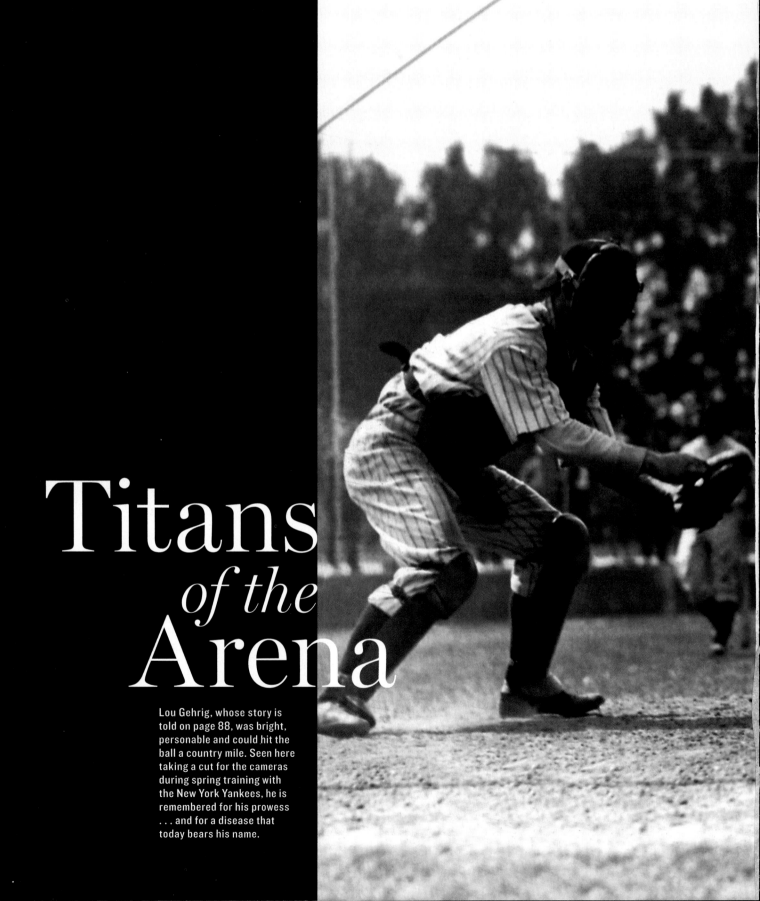

Titans
of the
Arena

Lou Gehrig, whose story is told on page 88, was bright, personable and could hit the ball a country mile. Seen here taking a cut for the cameras during spring training with the New York Yankees, he is remembered for his prowess . . . and for a disease that today bears his name.

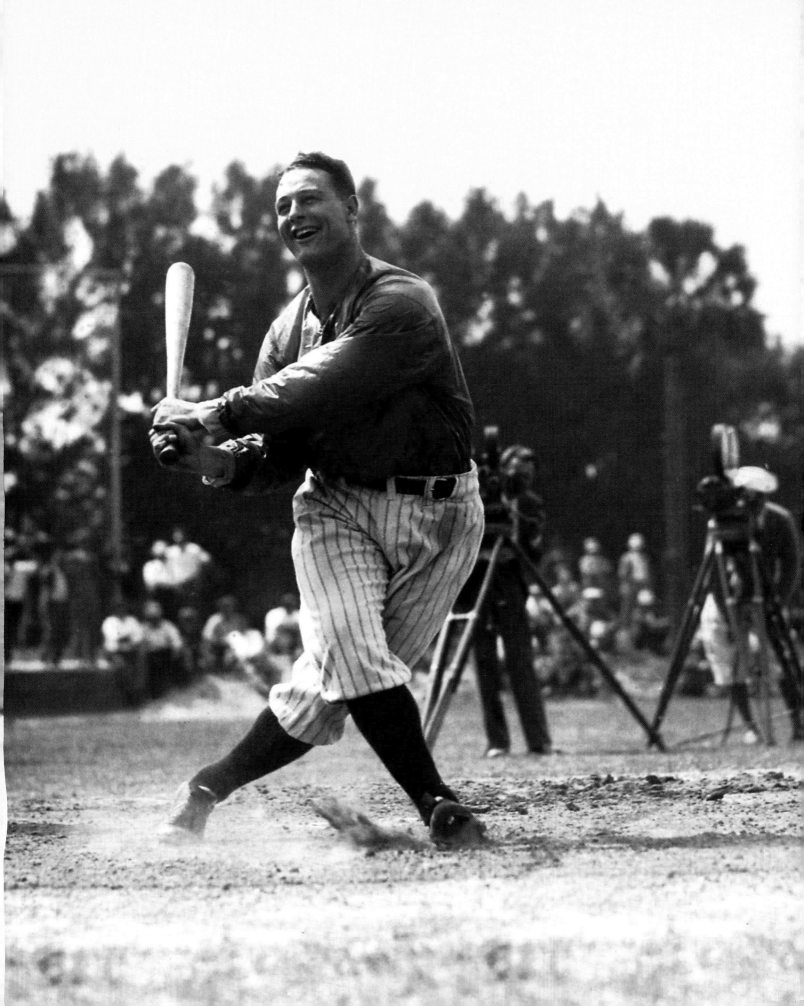

George Mallory and Sandy Irvine

1886~1924

1902~1924

IN THE WORLD of adventure, there were a select few grails more desperately coveted than others in the first half of the 20th century, among these were the North Pole, the South Pole and the 29,028-foot summit of the world's highest peak, Mount Everest, on the Tibet-Nepal border. No one would successfully reach the top of Everest until New Zealander Edmund Hillary and his Sherpa climbing companion Tenzing Norgay, members of a British expedition, did so in 1953. Before that, all of the many attempts failed.

Or did they?

In 1924 an earlier British effort included, among its nine members, 37-year-old schoolteacher George Herbert Leigh-Mallory (at left) and 22-year-old engineering student Andrew Comyn "Sandy" Irvine (at right). Mallory was a veteran climber taking his third shot at Everest in four years; Irvine was his eager young partner when the two set off for the summit, now only 1,000 feet distant, on June 8. At 12:50 p.m., teammate Noel Odell saw the men as "black spots" below the peak, moving forward with alacrity. They disappeared into the clouds, "going strong for the top," and were never seen alive again. In 1999 the Mallory and Irvine Research Expedition found Mallory's frozen corpse on a wind-scoured ledge at nearly 27,000 feet. It was determined that he was descending when he had fallen to his death. But descending from where? Did Mallory and Irvine reach Everest's summit, or were they forced to turn back earlier? The truth remains tantalizingly unknown.

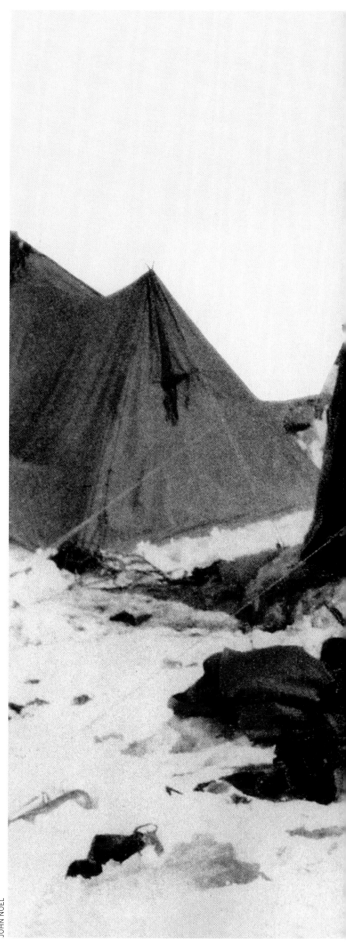

JOHN NOEL

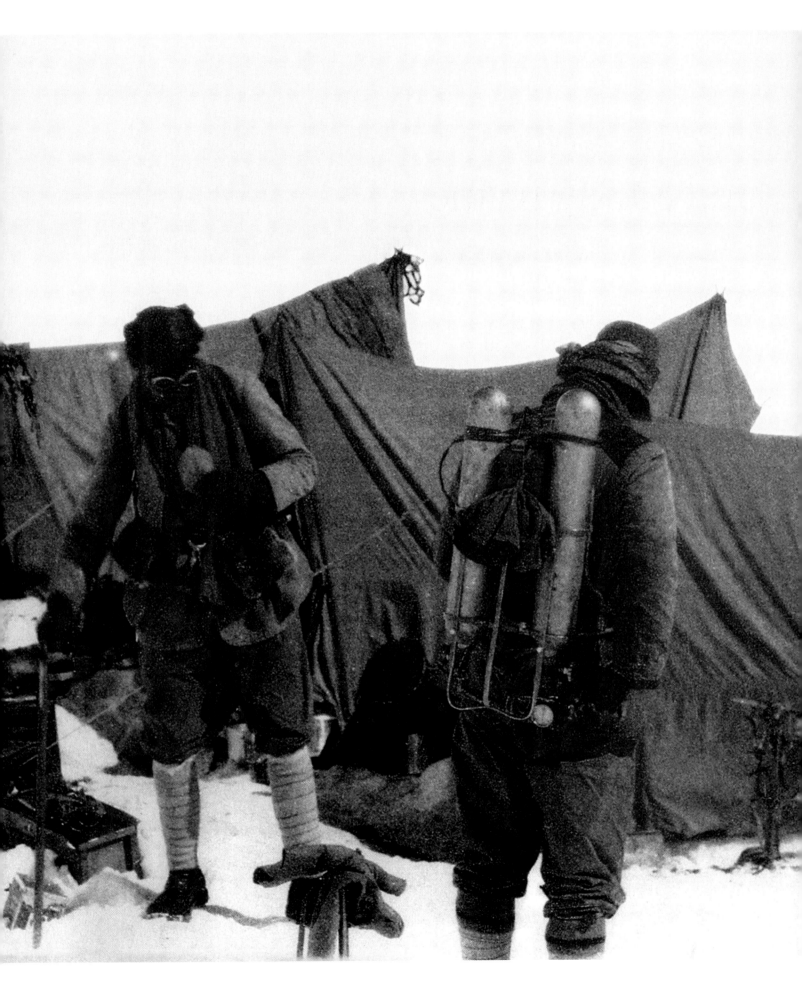

Lou Gehrig

1903~1941

BASEBALL LORE IS FILLED with stories of great pathos, but none is the equal of Henry Louis Gehrig's saga. Here was a man who played the game prodigiously well, played it every day come hell or high water, and then accepted his disastrous fate with equanimity when illness said he could play no more.

He was to the pinstripes born. A native New Yorker, the son of German immigrants, Gehrig hit a grand slam out of a major league ballpark for his New York School of Commerce team when he was 17, starred in baseball and football at Columbia College, then moved a few dozen blocks northeast as a member of the Bronx Bombers. And he certainly was a bomber: a heavy hitting and durable first baseman, the most fearsome batsman in the game . . . except for his teammate, the outfielder known as Babe.

As opposed to the large-living Babe Ruth, Gehrig showed up every day ready to play; he started a record 2,130 straight games, earning himself the nickname the Iron Horse. He might also have been called Mr. Clutch: His record 23 grand slams stands today.

In the spring of 1939, his abilities declined precipitously. The Yankees manager would not sit Lou Gehrig down, but finally Gehrig himself, acknowledging a problem, said before the game on May 2, "I'm benching myself." He was diagnosed with amyotrophic lateral sclerosis, a degenerative and incurable neurological condition that today is known as Lou Gehrig's Disease. On July 4, 1939, Yankee fans feted their hero at Lou Gehrig Appreciation Day (right). Though he knew he was facing a death sentence, Gehrig began his emotional and eloquent farewell speech by saying: "Today I can say that I consider myself the luckiest man on the face of the earth."

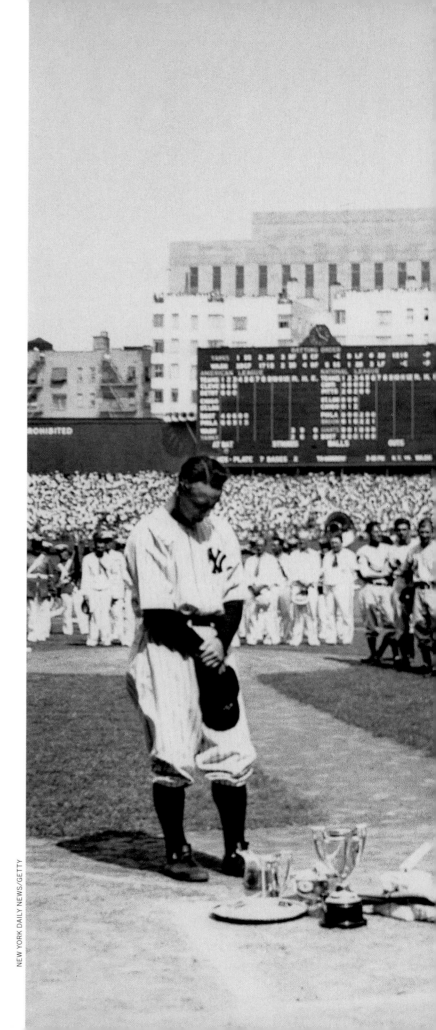

The Risks of Hardball

The name Ray Chapman is often given in answer to a sports trivia question: Who was the baseball player killed by a beanball? Yes indeed, Chapman, the fine 29-year-old Cleveland Indians shortstop (above), was fatally hit in the head by a pitch from the Yankees' Carl Mays in 1920.

Chapman was not the only major league ballplayer to die from injuries suffered on the field. In 1909, the veteran Mike "Doc" Powers (top), a catcher with the Philadelphia Athletics who happened to be a licensed physician (hence the nickname), crashed into a wall while chasing a foul ball. He would undergo three intestinal surgeries and die after postoperative infections led to peritonitis.

And an addendum: Only a short walk from the grave of Ray Chapman in Cleveland's Lake View Cemetery is that of Charles "Cupid" Pinkney. In 1909 he was batting for the Dayton Veterans as dusk came quickly on, and was beaned by a pitch. That night he died at the hospital, but is little remembered today because Dayton was a minor-league team.

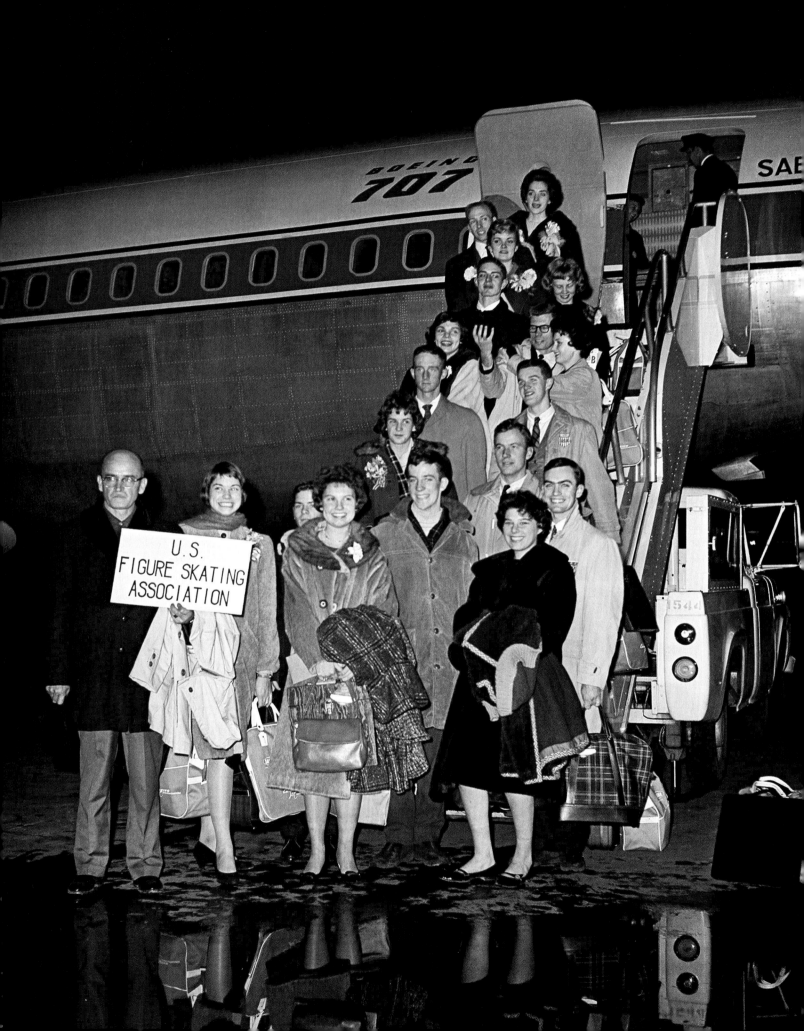

The United States Figure Skating Team

Died 1961

MANY OF THE STORIES in this book could be regarded as the saddest or most tragic of all, but in terms of how much vital life was claimed, and how many youthful dreams were extinguished by fate, none rivals that of Sabena Flight 548. The Boeing 707 (opposite) left New York City's Idlewild Airport on February 15, 1961, heading for Brussels, Belgium. Among the 72 people aboard were athletes, coaches, officials and family members affiliated with the United States national figure skating team, who were destined for the world championships in Prague, Czechoslovakia. During approach maneuvers in Belgium, the pilot lost control of the plane, which crashed into a field and burst into flames, killing all passengers as well as a farmer on the ground.

Eighteen athletes—among them, men's national champion Bradley Lord, as well as nine-time ladies' champion Maribel Vinson Owen and her two daughters, reigning ladies' champion Laurence Owen and pairs champion Maribel Yerxa Owen, plus Maribel's pairs partner, Dudley Richards—perished. President John F. Kennedy, a personal friend of Richards from summers on Cape Cod, issued a heartfelt message of condolence. The 1961 World Figure Skating Championships, where the Americans were sure to perform splendidly and place high, were cancelled altogether.

Because the tragedy happened long ago and in a non-Olympics year, the story of the '61 figure skating team has been largely lost in the mists of time. It is therefore fitting that the U.S. Figure Skating Hall of Fame announced in September 2010 that the sole inductees in the next year's class would be those lost on Sabena 548. Said Dr. Lawrence Mondschein during the announcement: "The dreams and hopes of the team have been realized by U.S. skaters at the World Championships, Olympic Winter Games and international skating events around the globe over the past 50 years. The spirit of the 1961 World Team continues to live on today."

GEORGE SILK

Ernie Davis

1939~1963

THIS PENNSYLVANIAN (at left, above, in 1962) who starred as a running back for Syracuse University might have been one of the very best football players of all time. We will never know for sure, as leukemia ended his life at 23.

He was certainly one of the best college players ever and something of a collegiate Jackie Robinson in blazing trails. A high school standout in basketball and baseball as well as football, Davis was offered more than 30 athletic scholarships at a time in the 1950s when most blacks were receiving no invitations to college. He chose Syracuse, where he became the first black member of a national fraternity system that was, historically, Jewish. From 1959 to 1961 he was twice a first-team all-American and led his team to an undefeated season and national championship.

Davis was the first African American to win the Heisman Trophy, emblematic of college football's best player. "Seldom has an athlete been more deserving of such a tribute," wrote President Kennedy in a congratulatory telegram. "Your high standards of performance on the field and off the field reflect the finest qualities of competition, sportsmanship and citizenship . . . It's a privilege for me to address you tonight as an outstanding American and as a worthy example of our youth. I salute you."

He set another landmark as the first African American to be the top pick in the NFL Draft. The Cleveland Browns hoped to establish an unbeatable backfield of Davis and Syracuse's other legendary Number 44, Jim Brown, who was already on the roster. But in the summer of '62, Davis fell ill. He was dead within a year.

Roberto Clemente

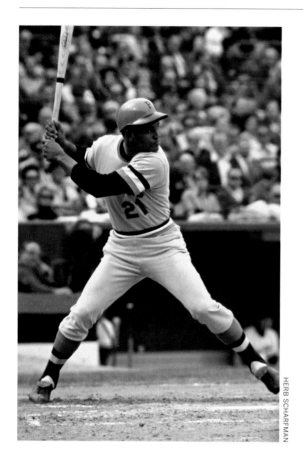

HERB SCHARFMAN

1934~1972 TODAY MAJOR LEAGUE BASEBALL is blessed with a bounty of wonderful Latin American athletes. Roberto Clemente Walker was the pioneer. He was the first Hispanic player to win his league's Most Valuable Player award (in 1966), win the World Series MVP (in 1971) and be elected to baseball's Hall of Fame (posthumously, in 1973). A wonder on offense and defense, Clemente (left, during the Pittsburgh Pirates '71 Series win over the Baltimore Orioles) was one of the finest baseball players ever, and one of the finest men to ever play the game.

A native of Puerto Rico, Clemente was distressed by the racial tensions he encountered when called up to the Pittsburgh Pirates. "I don't believe in color," he said. Others did, but Clemente won them over through his exemplary play and overarching sense of dignity. He was a fielding marvel from the first and, once he'd added 10 pounds of muscle in the U.S. Marine Corps Reserves, a potent hitter. With the possible exception of Willie Mays, there might never have been a player as exciting as Clemente. He remains one of the few batsmen to ever hit three triples in a single game, and the only one to end a game with a walk-off inside-the-park grand slam.

Too many ball fans didn't know of his military service on behalf of the U.S., and they didn't know of his tireless humanitarian work on behalf of Latin American countries. When Nicaragua was hit by a huge earthquake two days before Christmas in 1972, Clemente leapt into action, personally chartering relief flights. He was aboard one that was overloaded by 5,000 pounds and crashed into the Atlantic soon after taking off from Puerto Rico.

A hero—not just a sports hero—was lost that day.

Arthur Ashe

1943~1993 LATE EACH SUMMER, scores of the finest tennis players from around the world gather in New York City to compete in the U.S. Open tournament. The best of them are fortunate to spend time on center stage, which is the court at the heart of Arthur Ashe Stadium. It is safe to assume that some of the young athletes who convene for the competition have no idea who Arthur Ashe was. This is a true shame, not because Ashe (opposite, top, at Wimbledon in 1968) was such an estimable champion—though he surely was—but because he was such an exceptional man.

A native Virginian, he starred as a collegiate at the University of California at Los Angeles, and won the NCAA singles title. He would go on to win the U.S. amateur crown, the U.S. Open, the Australian Open and Wimbledon; he was the first man of African descent ever to win a Grand Slam singles event, and he won three. Meantime, he served in the U.S. Army (1966–1968), attaining the rank of first lieutenant. A star of, and later captain of, the U.S. Davis Cup team, he was a patriot and a man of principle. He was twice arrested in Washington, D.C.—once for protesting outside the South African embassy against that nation's apartheid policies, and once when agitating against the treatment of Haitian refugees.

Ashe also became a leader in the fight to combat AIDS. He first developed heart problems in 1979, precipitating his retirement from tennis and leading to surgeries. During one of these operations, he was administered a transfusion apparently tainted with the HIV virus. He finished writing his memoir only days before his death. Its perfect title was *Days of Grace*.

FOX PHOTOS/GETTY (2)

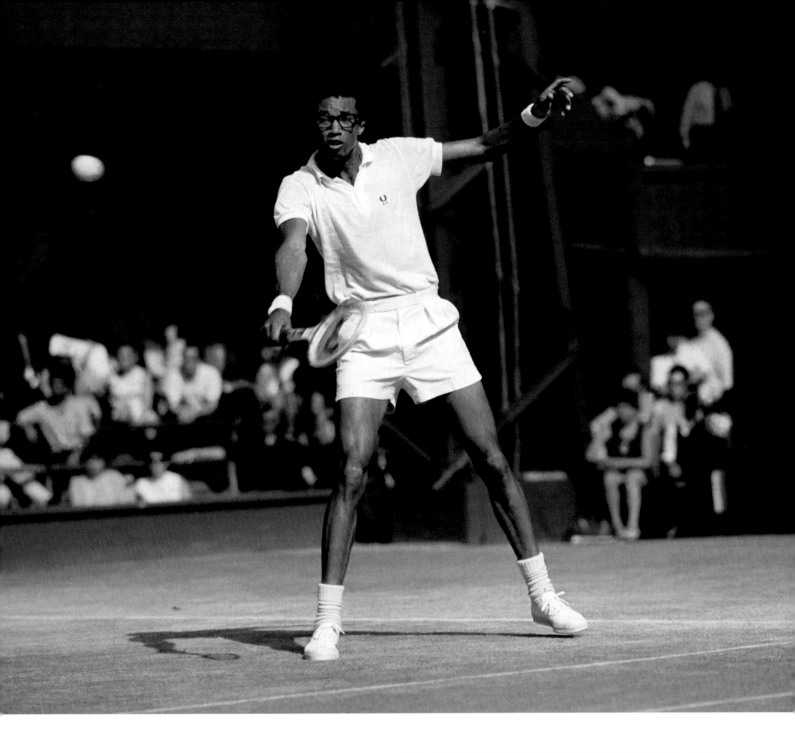

The Too Short Life of Little Mo

If Arthur Ashe is remembered by not enough tennis fans, Maureen Connolly is remembered by fewer still. This is criminal, as the teenager from San Diego might have been the finest female player ever. Connolly became, in 1953 (right), the first woman to win the Grand Slam (all four major titles in the same year). She won the last nine major tournaments in which she competed and was one of the most famous athletes in the world when, in 1954, she was engaged in her other great passion—horseback riding—and a collision with a truck caused massive injuries to her right leg, ending her tennis career at age 19. Tragedy would visit Little Mo more consequentially when she contracted stomach cancer and died at age 34 in 1969.

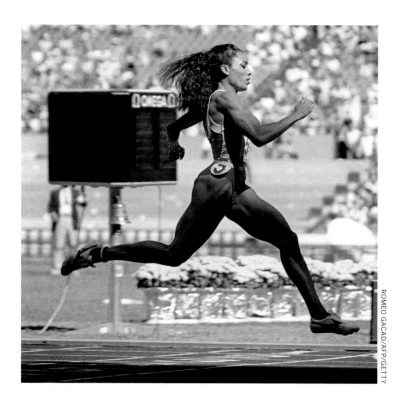

<div style="text-align: right">ROMEO GACAD/AFP/GETTY</div>

Florence Griffith-Joyner

1959~1998 SOME OF THE BIOGRAPHIES in this book are of people who will never be allowed to rest in peace; this is one of those biographies. Los Angeles native Florence Griffith, who would marry fellow U.S. track standout Al Joyner, became a sports superstar of the highest echelon based on her record-setting performances in sprints, her stunning attractiveness and her flamboyance, which manifested itself in wild running suits and inches-long, colorfully painted fingernails. Jim Thorpe, Babe Didrikson, Roger Bannister and Carl Lewis notwithstanding, track-and-field has boasted few if any transcendent personalities the equal of Flo-Jo.

In 1988 she set records in the 100- and 200-meter races that still stand today; she remains known as "the fastest woman of all time." She won four medals—three gold and one silver—at the '88 Olympics in Seoul, Korea (above). She was wildly celebrated . . . and widely suspected.

Her glory year, during which her times were significantly faster than what she had run before, came in an era when many world-class athletes, including track stars such as the Canadian sprinter Ben Johnson, who was disqualified in Seoul, were taking performance-enhancing drugs. Griffith-Joyner, who retired in 1989, was accused without any proof. When she died in her sleep at age 38, the skeptics started up again—*"It must be related to drugs!"*—even though the woman had a history of epileptic episodes, and an autopsy pointed to a congenital brain condition that may well have triggered a fatal grand mal seizure. This last time, Flo-Jo didn't hear the whispers.

Dale Earnhardt

1951~2001 A TOUGH-AS-NAILS THROWBACK to NASCAR's early years, when the circuit's fiercest drivers were as likely to have learned to drive fast in the bootlegging trade as on a local dirt track, the North Carolinian Earnhardt dropped out of high school to concentrate on racing. He was called the Intimidator, and aggressively used his stock car as a weapon as much as a vehicle. He won 76 races including the big one, the Daytona 500, and was a member of the first class elected to the NASCAR Hall of Fame in 2010.

Once he had risen to stardom, he commanded a legion of fans throughout the South and beyond; in a sport with lots of larger-than-life legends, Earnhardt was as big as any. He rode the wave to mainstream celebrity when, in the 1990s, NASCAR Nation was revealed as a far larger, more widespread and passionate entity than the elitist East Coast media establishment had credited.

And then, just as NASCAR was reaching its apex as a national pastime, Earnhardt crashed during the last lap of the 2001 Daytona 500 and was killed. He and his famous black Number 3 car (opposite, in 1990)—week-in and week-out fixtures of the American sports scene—were gone. All of a sudden.

Earnhardt's popularity, if not yet his phenomenal success, has been bequeathed to his handsome car-racing son. Dale Junior can justifiably claim a role as NASCAR royalty, but only his father could, with his swagger and snarl and heavy foot, embody the NASCAR ethos. Stock cars were meant to be raced by people like Dale Earnhardt, and they were meant to be driven hard.

<div style="text-align: right">KENNY KANE/DOZIER MOBLEY/GETTY</div>

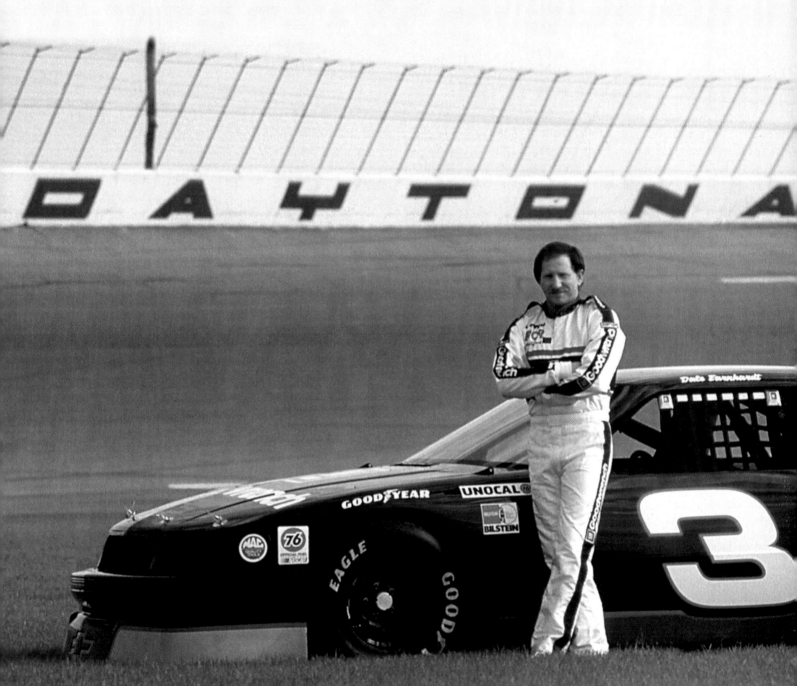

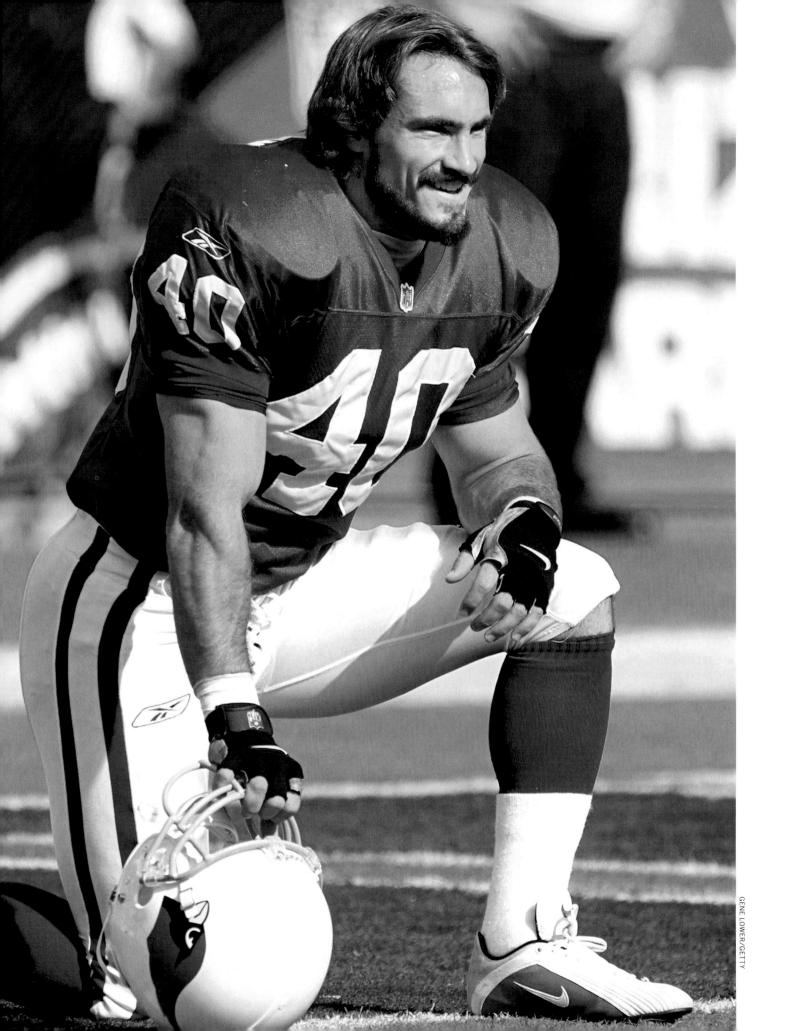

Pat Tillman

1976~2004 THAT A STRAIGHTFORWARD, inspirational parable of patriotism and self-sacrifice was turned into a sordid episode of obfuscation by officials of the United States military—the very institution that Pat Tillman gave up everything to serve—seems as reprehensible as it is incomprehensible. The Army has apologized and said that it owed the Tillman family better treatment than to lie about the circumstances of their son's death. That mea culpa does not go nearly far enough.

Tillman was an achiever and leader from his earliest days in San Jose, California. He not only starred as a football player in high school and then at Arizona State, he excelled in the classroom; his college grade-point average was 3.84 and he graduated in just three and a half years. He was thought to be undersized for the defensive positions he played at ASU and then for the Arizona Cardinals of the NFL (opposite, in 2000), but he confounded all skeptics.

And then, in the wake of 9/11, Tillman walked away, as he and his brother Kevin enlisted for duty in the hardcore Army Rangers.

On April 22, 2004, he was killed by friendly fire issuing from U.S. weapons in the mountains of Afghanistan. The Army fabricated details of his death in an attempt to martyr their famous volunteer, awarding him a posthumous Silver Star while claiming he had been felled in a firefight with the enemy. In fact, as details have unspooled, some people have suggested that fragging might have been involved: Tillman may have been purposely killed—assassinated—by his fellow Rangers. Whether the whole truth will ever be known is yet to be determined.

Tillman was not what everyone wanted him to be. He was probably an agnostic and perhaps an atheist; he had quarrels with the war in Iraq. But he was an intelligent and forthright young man—a man of principle and a true American. The United States Army was lucky to have him, and ultimately it betrayed him and his family.

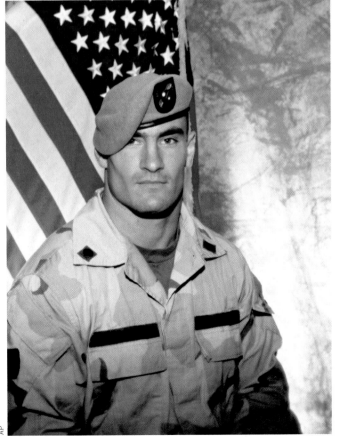

AP

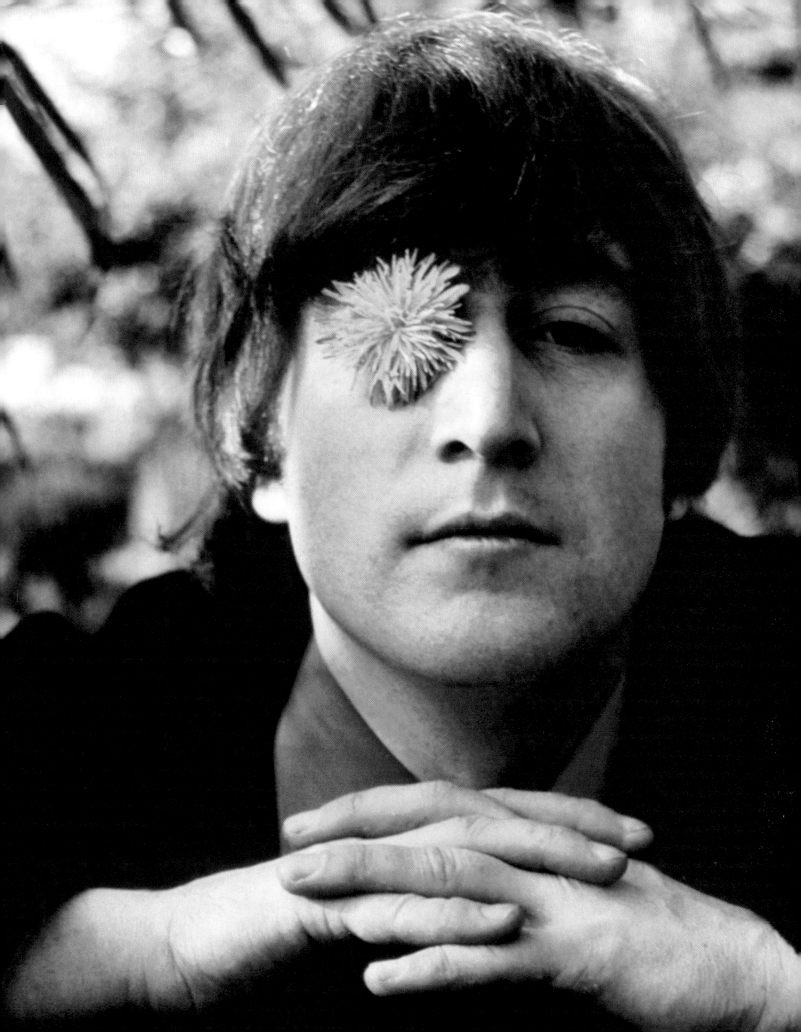

The Song Is Over

In the mid-1960s John Lennon, whose death is recounted on page 121, was still a Beatle, and still a cut-up, when posing by the pond at a home he shared with his wife, Cynthia, and firstborn son, Julian.

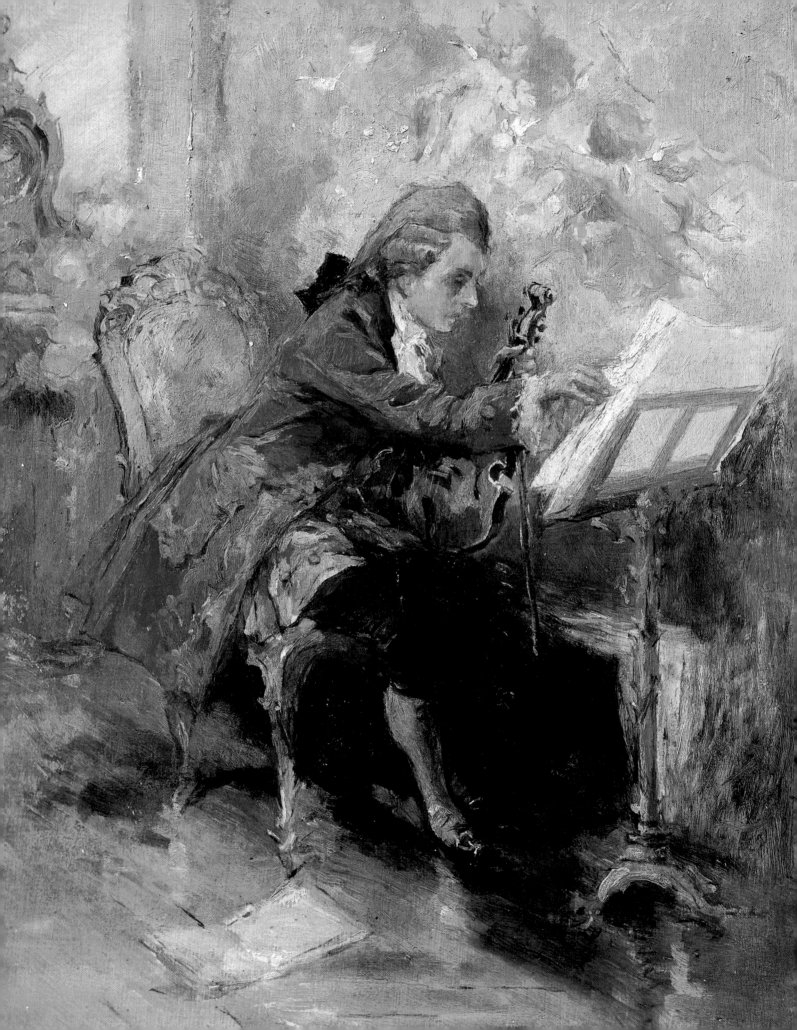

Wolfgang Amadeus Mozart

1756~1791

NO LIST OF THE world's greatest composers, no matter how truncated, neglects the Austrian composer Mozart, who died tragically young in his mid-thirties. The good news for music lovers is that although his life was short, he was both prolific and a prodigy, and so produced great works from his teen years onward. He would eventually compose more than 600 symphonies, concertos, operas and other choral pieces, sonatas and chamber works. His fellow composer Joseph Haydn wrote, "Posterity will not see such a talent again in 100 years." He could have amended his timeline to: "Ever."

Famously, Mozart was a dazzling pianist when barely a toddler in Salzburg. He wrote his first compositions when he was five, then never slowed down. Young Mozart was a court musician in his home city at 17. In Vienna (opposite), he gained favor and fame if never great fortune. He married and became the father of two sons.

In Prague for the premiere of one of his operas in 1891, he became ill. What malady befell him will never be known; theorists have posited no fewer that 118 possible causes of death, from flu to mercury poisoning. It is highly unlikely that Mozart was done in by his jealous rival, Antonio Salieri, as centuries of rumor-mongering and modern-day award-winning dramatizations have posited.

Mozart, who was, eerily, at work on his *Requiem* at the time of his death, was buried in Vienna, and almost immediately his already considerable reputation as a composer began to rise—an ascent that has continued to the present day.

 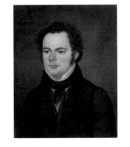

The Curse of the Composers

The tradition holds that throughout history conductors (many of whom, it should be said, wrote much sublime music) have wound up living to ripe old ages, perhaps because of all the upper-body muscular and aerobic exercise. Many of the world's best-loved composers have, by contrast, died young—and it can only be imagined how much richer the classical music repertoire might be had they lived full, long lives. Besides Mozart, we have (above, from left) the 17th century Englishman Henry Purcell, who died at age 35 or 36, possibly of tuberculosis; the 19th century Pole Frédéric Chopin, who died at 39, also of TB or possibly of cystic fibrosis; the titanic German Ludwig van Beethoven, who could have lived longer than his 56 years had his liver not been damaged, probably by too much alcohol; Beethoven's pallbearer and torchbearer, the Austrian Franz Schubert, who died one year after his hero, in 1828, at only 31 years of age; and finally, in this short list, Russia's Modest Mussorgsky, who died a week after his 42nd birthday in 1881, also of the effects of alcohol.

George Gershwin

1898~1937

YOUNG JACOB GERSHVIN from Brooklyn made his way across the East River to conquer the Great White Way—and so much else. The breadth of his genius was underappreciated in his own time and still is today, except by the cognoscenti. Consider: The largest giants of the American songbook, like Gershvin (who would become Gershwin), Cole Porter and Irving Berlin, are often referred to as "tunesmiths." The term, particularly when applied to Gershwin, seems derogatory.

It is true: Most of his best-known music first was heard on Broadway, in shows—misses as well as hits—with lyrics supplied by his elder brother, Ira. "I Got Rhythm," "Shall We Dance," all of *Porgy and Bess* . . . the list is, if not literally endless, certainly a mile long. (Just by the way, *Porgy and Bess* was a flop in its day.)

But George Gershwin, both before and after he had become a big success (above, circa 1931), would not be constrained by demands for a four-minute showstopper or a big act-one climactic ballad. He was listening to other music—jazz, classical—and was swayed by what modernists including Maurice Ravel, Claude Debussy, Arnold Schoenberg and Duke Ellington were doing. His legend includes stories of him asking to study under Ravel or Schoenberg or Igor Stravinsky, only to receive the response, "Why be a second-rate me, when you can be a first-rate Gershwin?" Whether influenced by such an incident or whether it ever happened at all, Gershwin also wrote *Piano Concerto in F* and, particularly, *Rhapsody in Blue*, a seamless and thrilling blend of classical music and jazz that is played at both the Village Vanguard and Carnegie Hall today. Gershwin, still brimful of ideas, died of a brain tumor at age 38.

Glenn Miller

1904~1944

WHAT GEORGE GERSHWIN was to Broadway, Glenn Miller was to big bands, the swing orchestras that dominated the popular music scene in the 1930s and '40s. Born in Iowa and raised there and in Nebraska, Missouri, Oklahoma and Colorado, he was a farm boy who bought his first trombone with dough he'd raised milking cows. After graduating from high school, he dabbled in college but had his sights set on becoming a professional musician.

He was good, and soon found himself in various bands on both coasts. He co-wrote his first composition in 1928 with a fellow aspiring young blood, a clarinetist named Benny Goodman. They would team up off and on in the early years, each eventually aspiring to lead his own outfit, and meeting with regular frustration. Goodman recalled much later in life: "In late 1937, before his band became popular, we were both playing in Dallas. Glenn was pretty dejected and came to see me. He asked, 'What do you do? How do you make it?' I said, 'I don't know, Glenn. You just stay with it.'"

Glenn did, and with a talent for arrangement and a keen ear for subtle differences, found a signature sound that set his band apart, and entranced the public. You *knew* when a Glenn Miller song was spinning on the jukebox as surely as the teenagers of 1956 would *know* an Elvis rocker and those of 1964 could pick out the latest Beatles hit. At the height of his popularity he received an officer's commission in the Army Air Force in 1942 and organized a service band (opposite, that year, the boss sits in on drums). He was in transit over the English Channel in 1944 when his plane disappeared into the waters.

CHARLES E. STEINHEIMER

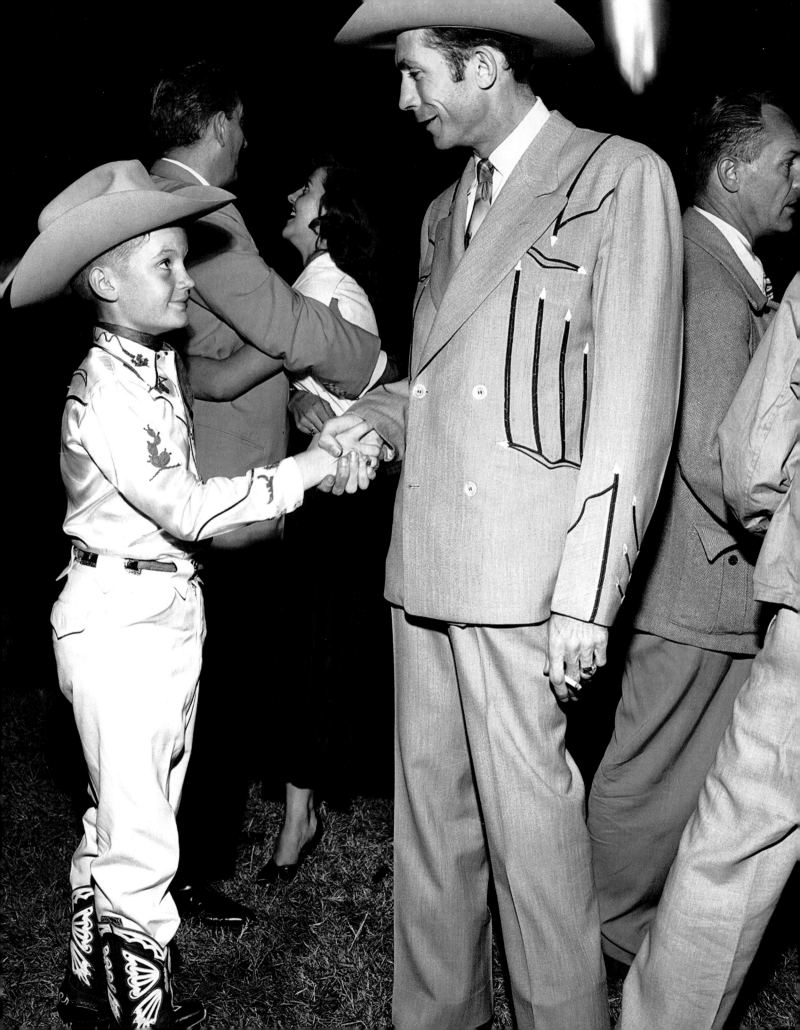

Hank Williams

1923~1953

It is astonishing to think that he was only 29 years old when he died; in his songwriting and singing, this ultimate country music superstar (opposite, with a young fan in 1950) could seem an old soul, and in his lasting influence he seems a figure who must have been there forever. But he was not. He was, in fact, in the public eye for barely more than a decade.

Born in a log cabin in Alabama, Hiram King Williams took the stage name Hank when he began singing on WSFA radio in Montgomery and also began thinking of a longer-term career in showbiz. He dropped out of school in 1939 and took to touring the Southeast with the first incarnation of his band, the Drifting Cowboys. From the outset, his success on the stage would be constantly challenged by his troubles off it, particularly a never-to-be-ended battle with the bottle. Band members would get fed up and quit; WSFA canned its popular singer in 1942 for habitual drunkenness.

And yet the music poured forth: "I'm So Lonesome I Could Cry," "Your Cheatin' Heart," "Hey, Good Lookin'," "Cold, Cold Heart," "Lovesick Blues," "Jambalaya (On the Bayou)," "Take These Chains from My Heart" and, prophetically, his final single release: "I'll Never Get Out of This World Alive." The original versions of these and so many other classic songs were brilliant and have subsequently been re-recorded by everyone from Johnny Cash, Bob Dylan and Ray Charles to Tony Bennett, Louis Armstrong and Norah Jones.

Williams suffered from spina bifida, and over the years morphine and other painkillers were added to the booze as ways to ease the pain. He died in West Virginia while being driven to a concert. What he left behind will live forever.

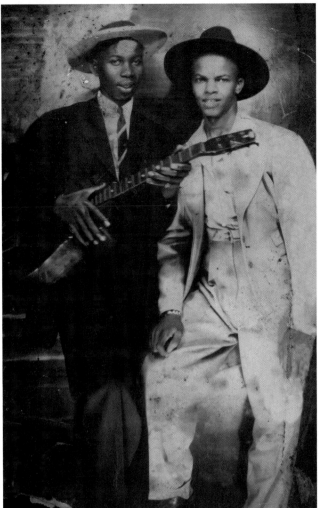

So, Too, with the King of the Blues

All the monarchs left too soon. Elvis was the king of rock 'n' roll, Hank Williams was the king of country and Robert Johnson (at left, above, with fellow musician Johnny Shines, circa 1935) was the king of the blues—even if few regarded him as such in his day. "The most important blues singer that ever lived," according to Eric Clapton. Maybe so, but his death at age 27 was not one of those that provoked widespread alarm. Few uttered in shock, "Did you hear Robert Johnson died?" Few knew that he had.

Johnson made little more than a year's worth of recordings, but those performances have shaped popular music—blues, R&B, rock 'n' roll, hard rock, rap, hip-hop—ever since, and have also set a benchmark for blues guitar playing. He was born in Mississippi in May of 1911; the adults who raised him, including at intervals his birth mother, were variable. His existence and career, both early and late, are almost impossible to sketch with clarity (they only profit from their mythological quality), but the key fact is: He learned how to play guitar like no one had before, and even as an itinerant musician traveling the Delta he became a known quantity. By 1936, he was a legend to those who dug the blues, and Brunswick Records set up space in the Gunter Hotel in San Antonio, Texas, to record him. He sang and played for three days, laying down wax that would prove indelible.

He died in 1938 back in Mississippi. The myth has him being given a poisoned bottle of whiskey by the husband of a woman he had wooed while performing at a country dance, but then: The myth also has him selling his soul to the devil at an intersection of two roads in exchange for his miraculous musicianship. Maybe he drank some bad hooch, or maybe he just drank too much. But Robert Johnson had come and was gone—too soon, vanished, like a ghost.

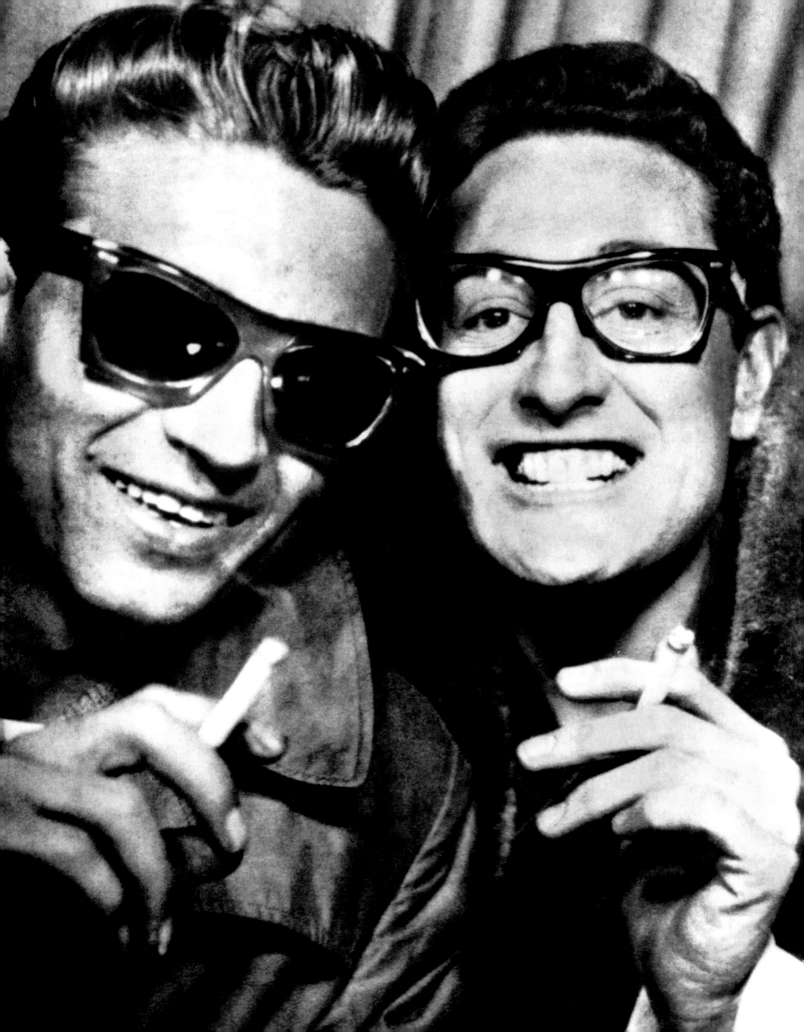

Buddy Holly

IN THE BEGINNING, yes, rock 'n' roll looked and sounded like Little Richard and Elvis Presley, but it looked and sounded like bespectacled Buddy Holly, too. He might not have been the very first practitioner of the raucous art, but he was present at the creation and he showed all rockers who followed, including the Beatles and the Stones, how to rave on.

For all of his vast influence, he was only on the scene for the briefest time—barely 18 months. Buddy (a family nickname for Charles Holley) was born in Lubbock, Texas, and was taught how to play the guitar by his older brothers. He could always sing and would fool around with bluegrass stylings on his own while also harmonizing in the high school choir. Nineteen fifty-five was a seminal year for Holly, as it was for rock 'n' roll. He and his band opened for Elvis at a show in Lubbock. Shortly thereafter, they opened for Bill Haley & His Comets. Buddy, not yet 20, was signed to a record contract, but this seeming good fortune was in fact a bad break. First, the company misspelled his surname as "Holly" (Buddy went along), then it dropped him after a year.

The second time was a charm. "That'll Be the Day," "Peggy Sue" and "Oh Boy!" became big hits, with more to follow. Buddy Holly and the Crickets performed on *The Ed Sullivan Show*. At New York's Apollo Theater, Holly, during a weeklong residence, won over the black audience. Without getting into the technical aspects that set Holly's style apart—and there were several—his seemed to be a music that bridged gaps and pointed a way to the future, at least to the future of the young. It was propulsive, lively, different. It rocked.

Holly (opposite, at right, with bandmate Waylon Jennings) was killed when the small plane in which he was traveling crashed on February 3, 1959. More about the circumstances of that terrible accident—and so many other terrible accidents—is provided in the sidebar at right.

The Days the Music Died

The circumstances surrounding Buddy Holly's death constitute a well-known chapter in music history—up there with Robert Johnson's mythical meeting with the devil at the crossroads, Bob Dylan's visit with Woody Guthrie in the hospital or Paul being introduced to John at the church fete in Liverpool. The details: Holly, before he knew his wife had become pregnant, agreed to take part in the Winter Dance Party tour, a rock 'n' roll road show in the Midwest that would costar Dion and the Belmonts, Richie Valens and the Big Bopper (a.k.a. J.P. Richardson, a.k.a. "the guy who sang 'Chantilly Lace'"). As a historical footnote: Holly's mutable version of the Crickets included on bass guitar, for this three-week gig, future country music star Waylon Jennings. Yes, it is true that Jennings gave his seat on the ill-fated charter plane to the Big Bopper, and supposedly Holly joked with Jennings: "I hope your ol' bus freezes up!" to which Jennings responded, "Well, I hope your old plane crashes!" Everyone chuckled, as Holly climbed aboard.

The plane did crash, of course, and Holly, Valens and Richardson were killed on that date in 1959 immortalized in the Don McLean song "American Pie" as "the day the music died."

Facts are: Rock 'n' roll, or any kind of touring enterprise, could represent a risky lifestyle in an era of crummy highways and puddle-jumping airplanes—and in a time when the music itself urged the kids to drive fast, live fast and even, yes, die young. Patsy Cline (above), the country music superstar, was killed when her tour plane went down in 1963 near Camden, Tennessee. Eddie Cochran died in Wiltshire, England, in 1960, when the taxi he was traveling in crashed. Otis Redding died in a plane crash in 1967 just before his enormous hit "(Sittin' On) The Dock of the Bay" was released, and Ricky Nelson, the former teen heartthrob of the *The Adventures of Ozzie and Harriet* (and singer of several terrific rockabilly hits) died in a chartered plane accident in

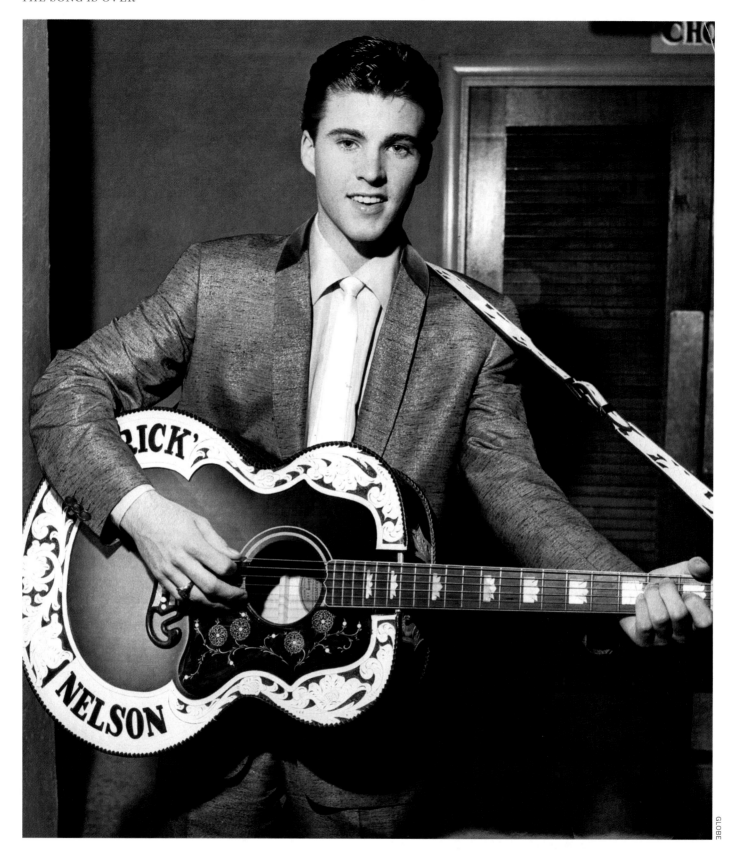

GLOBE

1985. The band Lynyrd Skynyrd lost several members in an airplane crash in 1977, and the great Texas bluesman Stevie Ray Vaughan died in 1990 when being transported by helicopter. The singer-songwriters Jim Croce, Harry Chapin and John Denver died in a small plane crash, car accident and recreational aircraft failure, respectively, in 1973, 1981 and 1997. (Ricky Nelson is pictured above, and on the opposite page we see, clockwise from top, Denver, Croce and Chapin.)

As said, this is a regrettable but not altogether surprising phenomenon: the many deaths of pop singers in air travel accidents plus the occasional car crash. These were young people who needed to get from place to place—by *tomorrow*—in an era when the method of transport simply wasn't what it is today. (John Denver, who liked to float gliders over the thermals of the Pacific for fun, represents an exception; his death was extracurricular.)

But even if it is unsurprising, it is nevertheless very sad indeed.

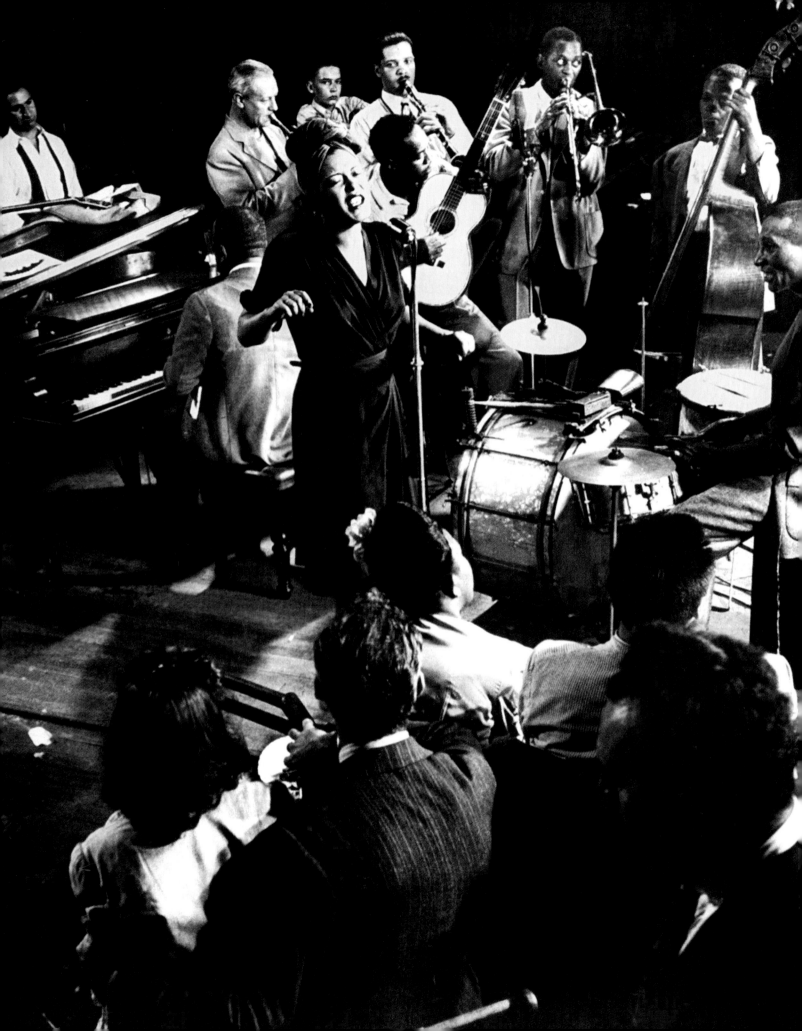

Billie Holiday

1915~1959

THE CONTEMPORARY SINGER Madeleine Peyroux, who is superb in her own right, has been both blessed and cursed since she first displayed her extraordinary voice to the public.

"She sounds like Billie Holiday."

"Wow, that's not Billie Holiday?"

"How eerily like Billie Holiday!"

With no disrespect for—indeed, with great respect for—the talented Ms. Peyroux, there never was and will never be another Billie Holiday. Peyroux is different, as she would be the first to assert. And Holiday was different from anyone else, ever.

She was born Eleanora Fagan in Philadelphia in 1915, and her youth was so rough and ragged it is a wonder she survived it at all. She shuffled between struggling caregivers, sometimes including her mother, and reform school; she was raped when she was 10 and was a prostitute in Harlem by age 14. She had, meantime, heard the music of Bessie Smith and Louis Armstrong, and miraculously found her muse.

She sang in brothels and then in clubs. Her rise in popularity in New York City was swift, so unique was her way with a song. Jazz stars and record producers, including the influential John Hammond, noticed her, and she cut her first records with Benny Goodman in 1933. She was immediately on the charts.

Holiday's untrained, ethereal voice redefined songs written by others, such as the wrenching "Strange Fruit" (composed by schoolteacher Abel Meeropol), and introduced future classics that she co-wrote: "Don't Explain," "Lady Sings the Blues" and "God Bless the Child." In the public eye, the entertainer known as Lady Day was simply a preternaturally gifted singer who seemed on top of the world. Her past had vanished.

But she suffered addictions and wore herself down. Her looks, which were the idiosyncratically beautiful equivalent of her singing, eroded. She was arrested for heroin possession for the first time in 1947. She died in a New York City hospital of liver and heart disease even as she was about to be busted again.

Her childhood might have presaged her end. It never could have predicted her stardom.

DENNIS STOCK/MAGNUM

The Curse of Addiction

Even as the jazz world watched Lady Day fade away throughout the 1950s, it was aware that one of its greatest instrumentalists, Charlie Parker (above), saxophone maestro and bebop progenitor, was an addict; the big man known as Bird would die at age 34 in 1955. If air travel was an occupational hazard for performers in the postwar era, so too, it seemed, were drugs and alcohol. You had a cohort of young people with available money and lots of time on their hands before the footlights went on each evening, then still more time and an adrenaline rush to deal with after those lights were extinguished 'round midnight. Some who struggled with drugs survived their addictions and lived their fair share of years. Others did not.

It wasn't only the artists who might be tempted by the drugs that infected the scene. The most famous rock manager of all time, with the possible exception of Elvis's Colonel Tom Parker, was Brian Epstein (seen on the following page, top, between George Harrison and John Lennon), who handled the Beatles and a few other acts. Sure of himself when dealing with record executives and booking managers, he had personal insecurities. He became a heavy user of stimulants, and although the Beatles surely knew of Epstein's problem, they were nonetheless shocked when, in 1967, he died of a barbiturate overdose at age 32.

Few in the British rock world were surprised to learn that the Who's manic drummer, Keith Moon (page 113, top left), whose public image as a man out of control was hardly an act, was dead of an OD of prescription drugs in 1978. Three of America's very biggest rock stars also died in the 1970s after ingesting too much alcohol and too many drugs. The incendiary guitarist Jimi Hendrix (to Moon's right) was 27 years old when he passed away in England in 1970. That same year, the soulful blues-rock singer from Port Arthur, Texas, Janis Joplin (page 112, bottom), also 27, died of a heroin overdose in Los Angeles. And in 1971 Jim Morrison (beneath Moon), lead singer of the L.A.-based band the Doors, succumbed in Paris; he, too, was 27. The circumstances surrounding all three deaths are endlessly parsed and debated by devoted fans of the artists as well as dedicated conspiracy theorists, but

GJON MILI

CLOCKWISE FROM TOP LEFT; REX USA; ELLIOTT LANDY/MAGNUM; ROBERT ALTMAN/RETNA; YALE JOEL

the facts of the matter are: Excess claimed these performers.

Students of rock 'n' roll seem to willfully shroud the deaths of all of their heroes in murk and mystery, but the circumstances surrounding the demise of singer-songwriter Gram Parsons (bottom right) were certifiably bizarre. Parsons, who emerged from Harvard University to steer the Byrds toward country-rock and made important albums as lead member of the Flying Burrito Brothers and later as a solo artist, over-

dosed on morphine and alcohol at age 26 while hanging out in 1973 with friends in Joshua Tree National Monument in Southern California. His body was in a coffin at Los Angeles International Airport destined for burial back in Louisiana when Parsons's mates stole it, hastened it back to the desert at Joshua Tree and incinerated it—fulfilling, they said, the singer's wishes. The death of Gram Parsons constitutes a ballad too strange to be sung.

Édith Piaf

1915~1963 OKAY: YOU'RE NOT GOING to believe parts of this biography—particularly some early parts—and, frankly, there's no reason you should. Much of the myth of the legendary French singer Piaf (a given name, meaning "sparrow") is just that: legend. The myth reads that she was born in Paris and abandoned by her mother, a singer in cafes, and her father, a street acrobat. Her dad came back onto the scene a short time on, then handed her off to his own mother as he went off to fight in World War I. This grandmother ran a whorehouse, and her employees helped raise young Édith, who was blind until age seven. The prostitutes so adored the girl, they chipped in a portion of their hard-earned pay to buy her a pilgrimage to pray to Saint Thérèse de Lisieux, and in this time her eyesight was miraculously restored. Her father returned from the war, and Édith, 14, began appearing as a singer in his acrobatic shows. She left her dad, began singing in the Parisian streets on her own, then had a child at age 17 (the girl would die two years later). She fell for a pimp who demanded part of her singing money in exchange for not pimping her, and then was discovered by a nightclub owner. The rest is history—more easily confirmed, though no less remarkable, history.

The nightclub owner was killed by mobsters once known to Piaf (below, in 1936), and she was accused as an accessory in the crime. She was acquitted. Her fame rose, and her popularity survived World War II, even though she had entertained the occupying Nazis during the conflict. She became internationally famous, appearing on Ed Sullivan's show and at Carnegie Hall.

After a car crash in 1951, Piaf took to—and became addicted to—morphine and alcohol. This led to her decline and death. Tens of thousands of devotees mourned the tiny songstress at a Parisian cemetery.

JEAN-GABRIEL SERUZIER/RAPHO/EYEDEA

Judy Garland

1922~1969 MINUS THE BIZARRE childhood—unless of course you consider being a three-year-old vaudevillian and then a teenage Hollywood superstar bizarre—she was America's Piaf, the ultimate diva, today recalled more as icon than person. In 15 years at MGM in the 1930s and '40s, she made hit films alongside Mickey Rooney and other costars, including most prominently a cowardly lion, a tin man and a scarecrow. For some movie buffs, she would always remain Dorothy. Others in her fandom would, through the years, appreciate Garland for such work as her dramatic 1954 film comeback in *A Star Is Born* and her charismatic concert performances.

Perhaps because the audience had first come to know Judy as a sweet young girl, it anguished, sympathized and loved her all the more as it watched the adult Garland struggle through difficulties. She married five times, and her fans lamented that she couldn't make it work with the handsome movie director Vincente Minnelli (father of their talented daughter, Liza). They heard Garland was addicted to drugs. They heard that her finances were a mess, and that the IRS was after her. They heard about her suicide attempts.

Pretty much everything they heard was true, and Garland died at 47 (almost the precise same age as Piaf) of an accidental overdose of prescription drugs. In the years since that 1969 tragedy, Garland's cult has only grown. She is regarded today as one of the greatest stars in Hollywood history, one of the greatest singers the country has produced, and certainly one of the most enduring entertainment personalities ever.

HERBERT GEHR

Bobby Darin

1936~1973 HE WAS MUCH MORE than "Mack the Knife." In fact, Darin was so many things—a latter-day Sinatra, a semi-rocker, a demi-folkie, an Oscar-nominated actor, "the husband of Sandra Dee" (above, in 1965)—that the real Darin, a six-barreled entertainer not unlike Judy Garland, often gets lost. People ask: That guy who sang "Mack the Knife" and "Beyond the Sea" also sang "Splish Splash" and "If I Were a Carpenter"? Really? He put out a gospel Christmas album? Really? The answer is yes. Really.

Darin was born in New York City, in the Bronx. The Great Depression was raging, and his people were poor; his crib was a cardboard box. He was often sick as a child, suffering from rheumatic fever more than once. He heard a doctor tell his mother he would be lucky to live past age 16, and Bobby determined to make life matter during whatever time he had.

His destiny was delivered to him by fate: He was one of those kids who was instinctively musical, and could master all sorts of instruments just as soon as he tried them out. He was also smart, and was admitted to the elite Bronx High School of Science. But he dropped out of college to give it a go as an entertainer.

Once he got into the recording studio, he first tried his hand as an Elvis manqué. That didn't work, but "Splish Splash" became a smash in 1958. "Dream Lover" followed in 1959 and "Mack the Knife" in 1959; Bobby Darin was on his way.

Darin's career veered all over the place in the 1960s. What should be remembered above all, however: He was an exceptional person. He encouraged young talent and boosted the careers of black performers in an age of bigotry. Knowing of his own problems, he worked tirelessly for the American Heart Association among other charities. He was 37, still a top draw in Vegas and star of his own TV show, when complications from his heart ailment claimed him.

"Mama" Cass Elliot

1941~1974 TO SAY THE VERY LEAST, the 1960s were a funny time. The merest indicator: In 1967, there aired on TV a tribute show dedicated to the Broadway songwriters Richard Rodgers and Lorenz Hart, with Quincy Jones as musical director. Bobby Darin opened the show with a terrific version of "The Lady Is a Tramp." Other guests—the Supremes, the Count Basie Orchestra—followed, including the Mamas and the Papas. This was a folk-rock group that featured lovely, melodic vocals, many of them with the strong singing of "Mama" Cass at the forefront. They, like Darin, could perform either Rodgers and Hart or rock 'n' roll without any affectation. It was an interesting time.

Born in Baltimore and raised there and in the D.C. suburbs, young Cass (a nickname she chose for herself) dropped out of high school to pursue a stage career in New York City, singing in *The Music Man* on Broadway but losing a featured part in *I Can Get It for You Wholesale* to another ambitious young woman, Barbra Streisand. Elliot fell into the booming folk-music scene, and was eventually invited to join a quartet that would become the Mamas and the Papas. They enjoyed huge hits—"California Dreamin'," "Monday, Monday"—before sundering in 1968. She had recorded a cover version of "Dream a Little Dream of Me" for the group, but it was released on her first solo album and she became a star in her own right. Elliot (opposite, in London in 1969) appeared on *The Tonight Show Starring Johnny Carson* more than a dozen times and was a substitute host once. Her concerts routinely sold out, including several during a two-week engagement at London's Palladium in 1974. After the final show in that run, Elliot retired to a flat she was borrowing from the singer Harry Nilsson (who would also die young, at 52), and she passed away after suffering a heart attack while sleeping. She was 32. The myth that she choked on a sandwich is just that: pure myth. What is not myth is that the Who's drummer, Keith Moon, would die in the same room four years later.

POPPERFOTO/GETTY

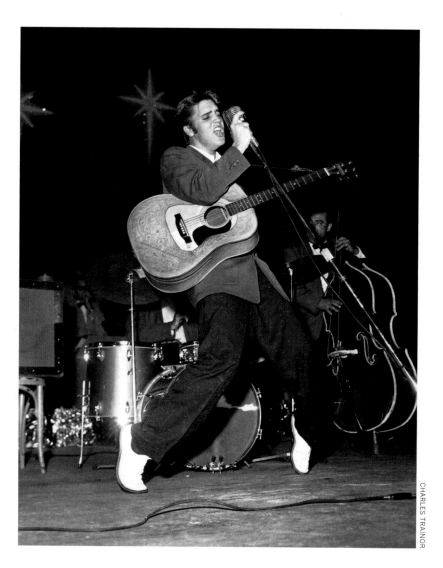

CHARLES TRAINOR

Elvis Presley

1935~1977 WHAT IS THERE LEFT to be said about him, the man who was perhaps the most famous and idolized singer of all time? Any casual or diehard fan of the King's knows the outline of his biography: Born in Tupelo, Mississippi, and raised by his doting parents there and in Memphis, he walked into the Sun Records studio one day to cut a disc for his mother; the studio's owner, Sam Phillips, heard in Presley's singing the perfect blend of black rhythm-and-blues and rock 'n' roll raucousness; Phillips was right; Presley, his hips all a-swivel, became the biggest thing ever (left, in 1956, during a sold-out run in Miami, and opposite, the following year, on the set of *Jailhouse Rock*); his career was interrupted by a stint in the military; he returned and made a string of cheesy movies; he roared back to rock relevance with a scintillating TV special in 1968; he became an all-conquering hero of the concert stage, racking up record-breaking receipts during long encampments in Vegas; bloating, he started to strain the seams of his sequined jumpsuits; he began to hear whispers about his drug use—whispers he knew to be all too true (Dr. George Nichopoulos prescribed 19,000 doses of narcotics, sedatives and stimulants for Presley in the 32 months preceding his death, according to *The New York Times*); and then he died alone in the bathroom of his storied mansion, Graceland, at age 42, the traces of 10 or more drugs in his bloodstream.

It is a tragic tale, to be sure, made even more so by the knowledge that there were so many people in orbit around Presley, including his manager and some of his best friends, who acted as nothing but enablers, feeding off the King's fame and fortune as they watched him succumb to the unbearable pressures of his celebrity. The phrase "lonely at the top" applies to no one else as aptly as it applies to Elvis Presley.

MGM/MPTV

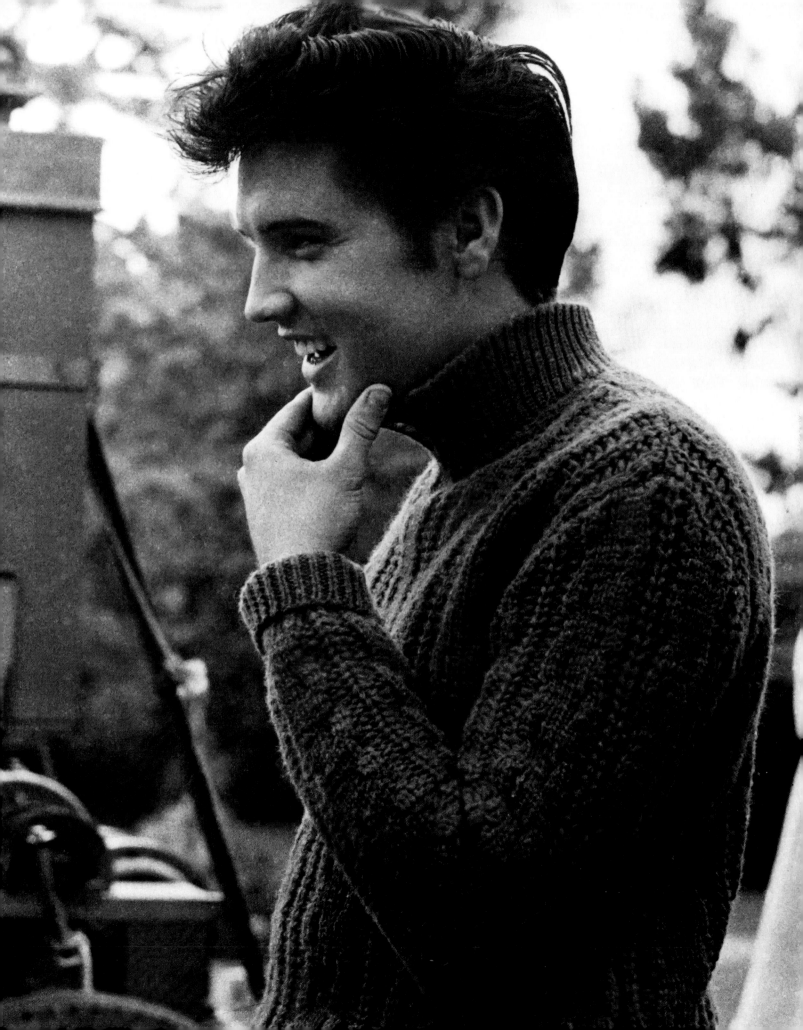

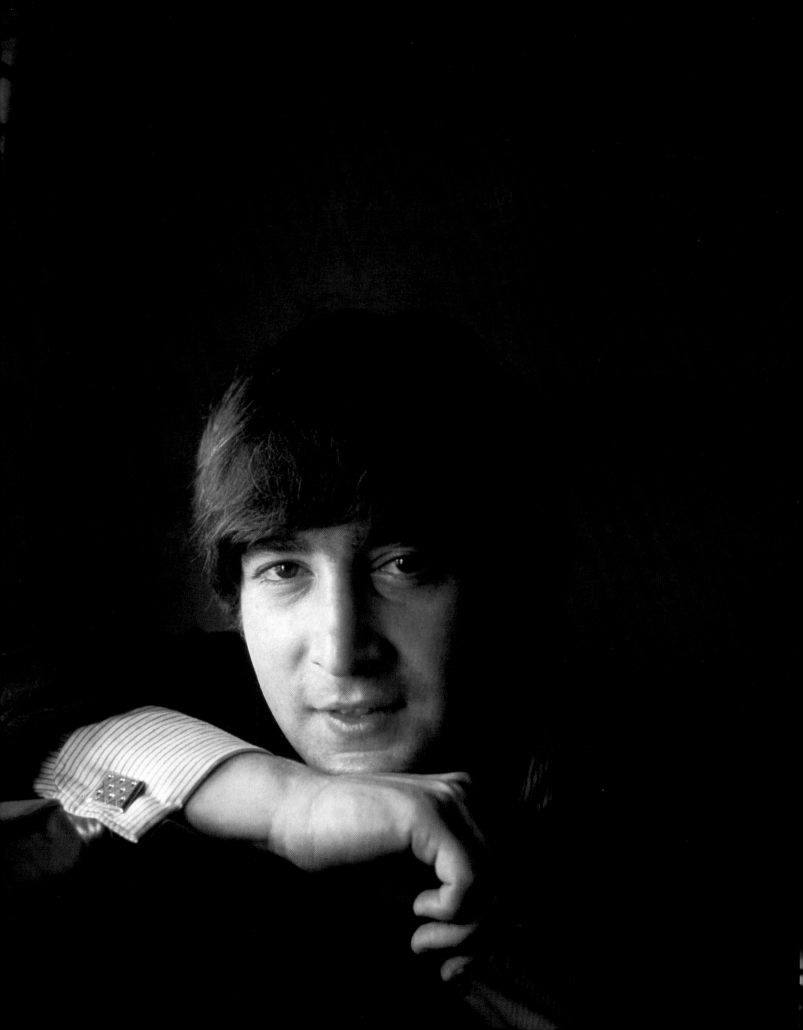

John Lennon

1940~1980

IF ELVIS HAS RIVALS as Biggest Thing Ever, they are very few. Bing Crosby, maybe. Frank Sinatra, perhaps. And then the Beatles. With apologies to Michael Jackson, that's about it.

John Lennon (left, in 1964) was, of course, one of the Fab Four. As much as they had a leader, he was it, especially early on. He, like his bandmates Paul, George and Ringo (that's the required order, always: John, Paul, George and Ringo) grew up in Liverpool, England, in thrall to Presley, Holly and all other American rockabilly and rock 'n' roll musicians. John formed a skiffle band; Paul and George eventually joined; the future took care of itself.

Pop culture wisdom holds that "the Beatles were together for so short a time," but, in fact, they were together for more than a decade (if you discount the fact that drummer Ringo was asked to join only after they had a recording contract). They were *famous* for "so short a time" before they broke up—about six years, from 1963 through 1969—but they had been mates for longer, and would mend their mateships later.

But the Beatles simply could not be shared forever by John Lennon and Paul McCartney, and so they did dissolve. John's subsequent solo career was brilliant, and his always interesting personal life continued to be always interesting. He and his second wife, Yoko Ono, had a son, Sean, and John disappeared for a time to be what was then called a "househusband." He reemerged, and was on the cusp of embracing his adoring fans anew with the terrific album *Double Fantasy* when a deranged young man shot him dead outside his New York City apartment building.

It can be argued that several of the deaths recounted in our book were senseless. It can also be argued that this was the most senseless of them all.

Other Victims of Violence

John Lennon was not the only musician to be claimed by violence. Shortly we will consider Marvin Gaye, who was shot to death by his father. That was obviously a domestic situation, and seems somehow marginally different than these next several cases, which involved, as did Lennon's, random (or nearly random) acts of malice.

The 1995 death of Selena Quintanilla-Perez (above), the Mexican-American singer songwriter who was considered the Queen of Tejano Music—Mexico's Madonna—was just as devastating to her fans as Lennon's was to his. She was murdered at age 23 by the former president of her fan club in an act that emphasized the dangers these singers face when, through their powerful art, they incite deep passions.

Traveling back in time, there was Sam Cooke (seen on the following page, top left), the king of soul, who produced dozens of hits—"You Send Me," "A Change Is Gonna Come," "Wonderful World," "Bring It on Home to Me"—in the late 1950s and early '60s. This was a man of substance who founded a record company and ran a publishing firm to present his own and others' music—he was primed to emerge on the scene as a cross between Berry Gordy and Otis Redding—and who was actively engaged in the civil rights movement. His singing career gave rise to those of Otis, Aretha, Stevie and all the rest. He was shot and killed at age 33 in 1964 by the hotel manager at the Hacienda in L.A. in an incident whose circumstances will never be satisfactorily settled.

Sid Vicious (to Cooke's right) was another thing altogether, neither a man of substance nor any kind of musical pioneer. In fact, the London-born John Simon Ritchie was a nasty piece of work, and not much of a musician, regarded as the member of the Sex Pistols who couldn't play, which says it all. But the bassist became a celebrity of the underground sort after what *The New York Times* felicitously called a "particularly rabid series of offstage carryings-on." His was not technically a death by violence, but violence was very

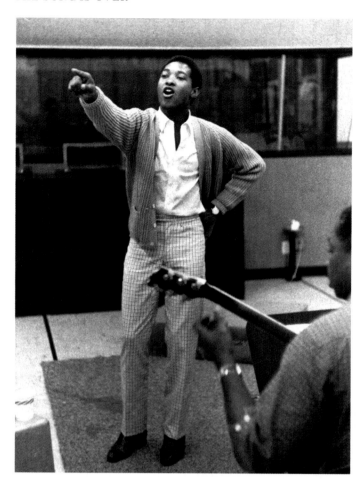

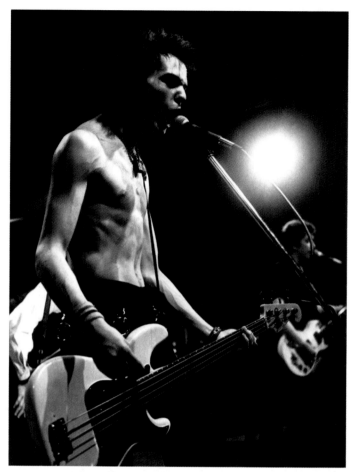

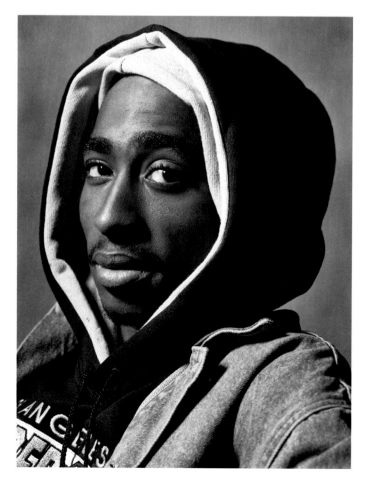

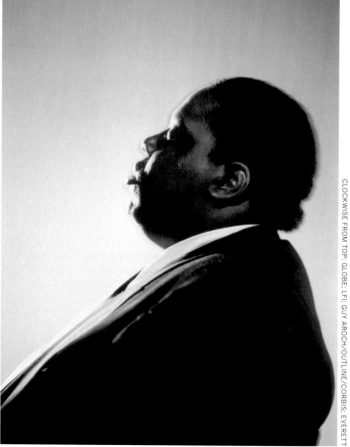

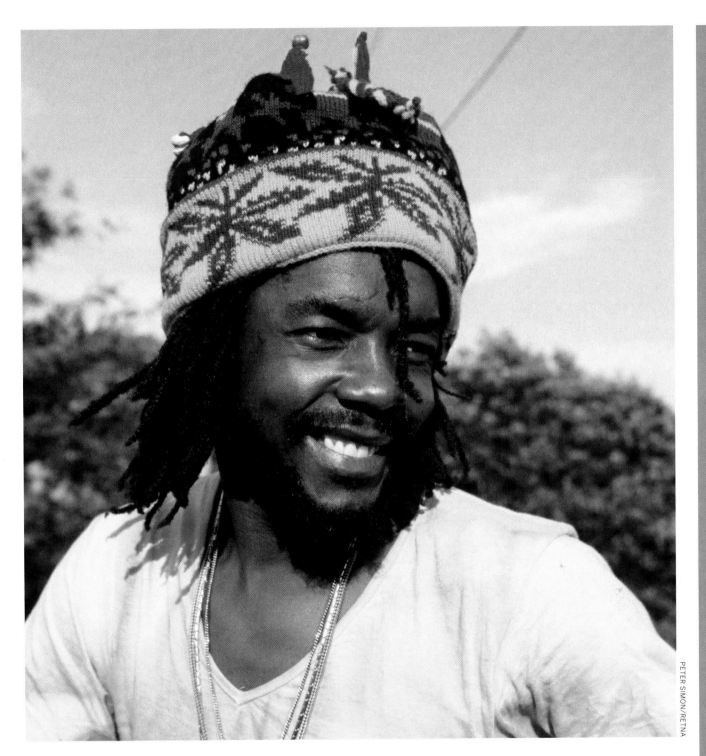

much involved: In late 1978 his lover Nancy Spungen was found dead of a knife wound in the Chelsea Hotel room she shared with Vicious in New York City, and when Vicious overdosed early the next year he was out on bail, facing prosecution and craving death.

Punk rock represented a violent milieu, and so did rap. Two deaths that will travel through history forever entwined are those of Tupac Shakur and the Notorious B.I.G. (opposite, bottom, left to right), popular hip-hop stars of the mid-1990s who were assassinated within months of each other. The first attempt on Shakur's life occurred in 1994, and he became convinced that a former friend of his, Christopher Wallace, also known as B.I.G. or Biggie Smalls, had some-how been involved in the attack in New York City. In 1996, Shakur was gunned down for good in Las Vegas, and rumors quickly circu-lated that Smalls was involved in the killing. Six months after Shakur was shot, a Chevy Impala pulled up next to a green Suburban that was

stopped at a light in L.A., and a gunman with a 9-millimeter automatic pistol pumped several shots into Biggie's chest. He was DOA. No one has ever been charged in either murder, and fans are left to wonder what both men might have contributed musically and poetically if only peace could have been brokered in the hip-hop community.

There are intrigues to some of these early deaths, and then there are crummy facts. Peter Tosh (above) was one of the original three Wailers, along with Bob Marley and Bunny Wailer. After that band's rise, he was enjoying a successful solo career—he had just won the Grammy for Best Reggae Performance—when, in 1987, a gang of three men burst into his house in Jamaica and demanded money. Tosh said he had none on hand, and was shot twice in the head.

The Wailers, who sang of peace and justice, were an ill-fated group. On the page immediately following we will learn of the life and prema-ture death of their most famous member.

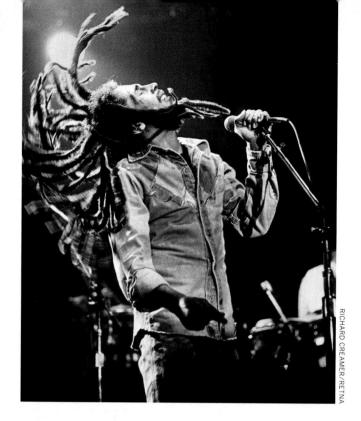

Marvin Gaye

1939~1984

ONE OF THE MOST INTELLIGENT and innovative artists in American music history—and an altogether phenomenal singer, to boot—Marvin Gaye went through, as many performers do, "periods." In the first, his hitmaker phase, he was a member of Motown's stable of successful soul singers and ensembles. Gaye had a string of his own Top Ten singles, including "How Sweet It Is (To Be Loved by You)" and "I Heard It Through the Grapevine," and many other smashes in duets with Tammi Terrell (who herself died young of a brain tumor at age 24), Mary Wells, Kim Weston and Diana Ross, including "Ain't Nothing Like the Real Thing," "It Takes Two" and "My Mistake (Was to Love You)."

Next came what might be called Gaye's consciousness period. His 1971 *What's Going On* album evinced a deep involvement in the tumultuous issues of the day, while sacrificing none of the musicality for which he was renowned. Indeed, it pushed the boundaries of R&B, as did the follow-up *Let's Get It On.* Gaye was inventing new genres as he went, including today's enormous grab-bag known as "adult contemporary."

But Gaye, like so many, had personal issues, including drug use, and he dropped out for a time to get clean. He came back strong in the 1980s with the album *Midnight Love*, which featured the much-loved "Sexual Healing," but while touring to promote his new material he grew weak. He retired to his parents' house to rest, and there he started getting into it again with his father; theirs had long been a difficult relationship. During an altercation on April 1, 1984, Gaye, one day shy of his 45th birthday, was shot dead by Marvin Gay Sr.—a very strange end to this particular soul saga.

Bob Marley

1945~1981

HIS IS ONE OF THE unlikeliest stories in the annals of pop music. He came forth from the streets of Jamaica armed with the music of his native land, and with it he conquered the world. To be sure, indigenous beats and rhythms have always been able to travel and cross-pollinate; American jazz, for instance, has at its core a blend of African, South American and Caribbean musical traditions. But the assimilation is usually gradual, involving many players over several generations. Marley, however, was a pioneer and a catalyst—an igniter. One day, the broad western audience didn't know what rocksteady or reggae was, and the next day, it couldn't hear enough of it. Many of the greatest standards of the genre—"I Shot the Sheriff," "Could You Be Loved," "Jamming," "Redemption Song"—are Marley's. Just as the British Invasion needed the Beatles, the reggae explosion required Bob Marley (above, in 1975).

As the fate of Peter Tosh indicates, Jamaica could be a violent place. It was also a politically volatile one. When, in 1976, one faction thought Marley's appearance at a benefit concert was in support of another faction, members of the first faction invaded Marley's house, wounding him and his wife with gunfire. Marley performed while recovering from his injuries: "The people who are trying to make this world worse aren't taking a day off. How can I?"

He couldn't be stopped by would-be assassins, but he eventually was stopped, at age 36, by malignant melanoma. His deathbed words to his son Ziggy, who was already forging his own reggae career, were: "Money can't buy life."

LFI

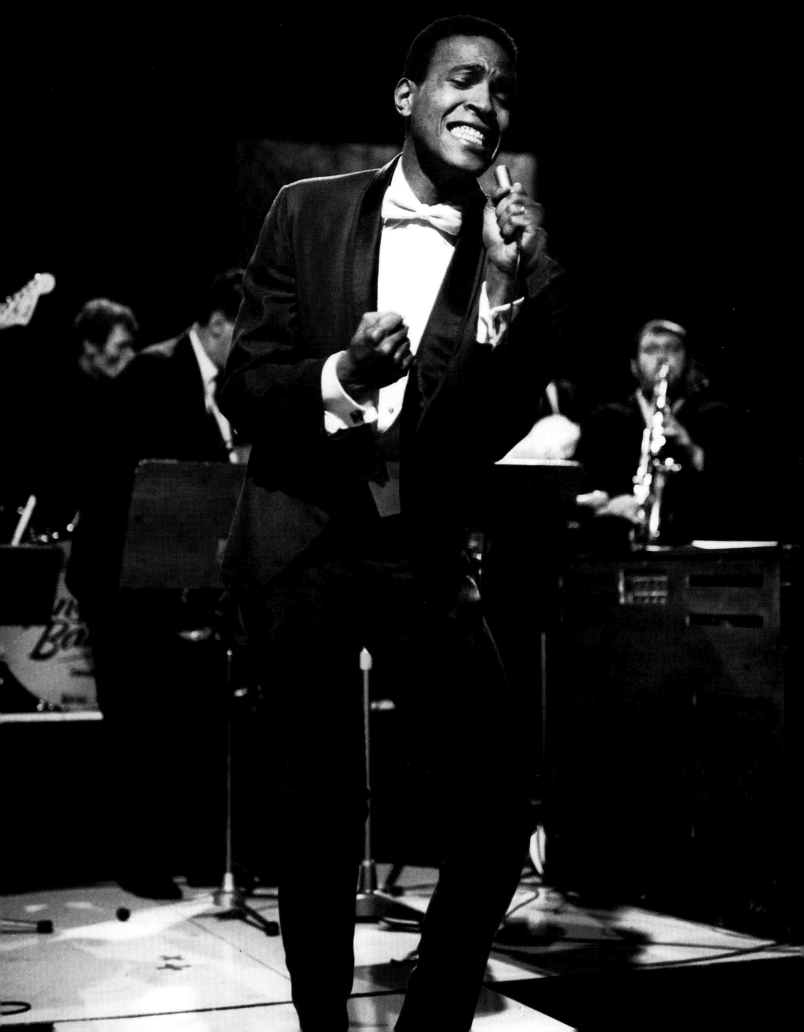

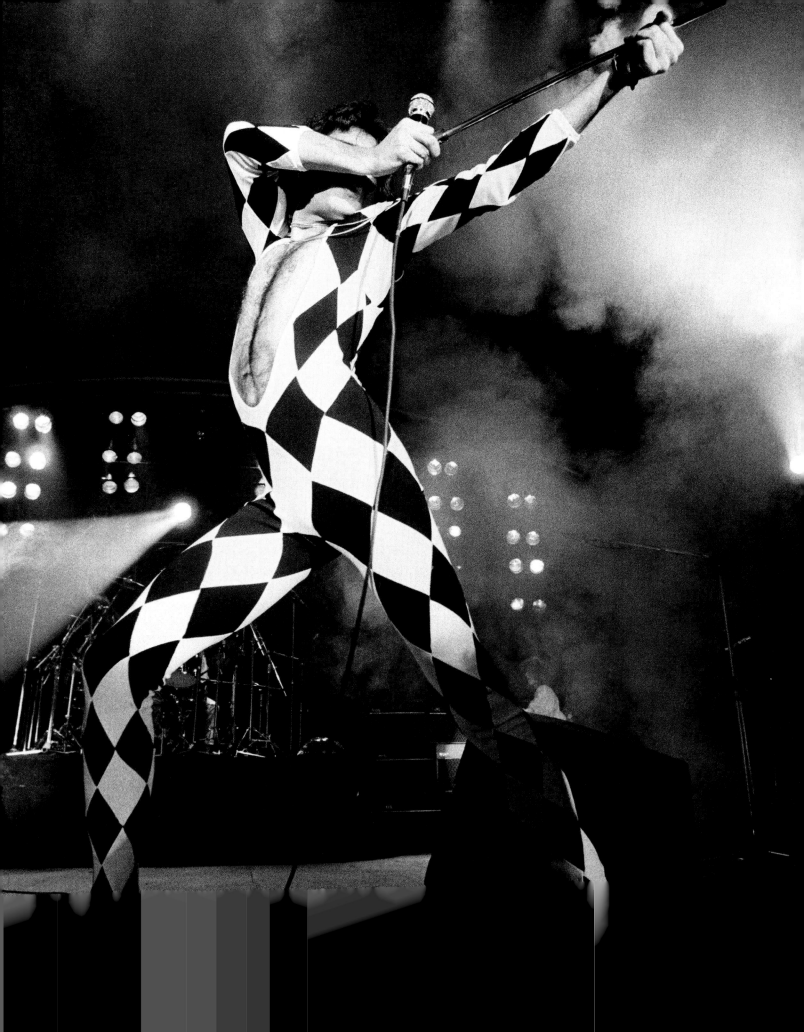

Freddie Mercury

1946~1991

EVERY SINGLE DAY, high school bands across the land perform "We Are the Champions" and four-year-old children thump out "We Will Rock You" during Music Time. These standards of the American youth-pop repertoire originated with a British band and a flamboyant lead singer as far removed from the football field or bright-and-shiny preschool as can be imagined. Once he had become a big star as the frontman for the rock quartet Queen, Freddie Mercury, born Farrokh Bulsara in what is now Tanzania, moved into a mansion of more than 20 rooms in London's posh Kensington district and lived a private lifestyle only marginally removed from the flash and glam that he projected onstage (opposite, in Copenhagen in 1977). His music and public persona were way beyond baroque and seemingly without restraint, and when rumor began circulating in the late 1980s that Mercury had contracted AIDS, few of his followers were shocked, though of course all of them were deeply saddened.

Before Queen's ascent to the arena circuit, the entertainment world had seen showmen like Freddie Mercury, but not *quite* like him. "Of all the more theatrical rock performers, Freddie took it further than the rest," the sufficiently outré David Bowie said to *Rolling Stone* magazine upon Mercury's death. "And of course, I always admired a man who wears tights." Indeed, Mercury spent as much time in spandex as normal folk do in cotton or wool, asserting constantly that he was not normal folk. But we are all, at bottom, normal folk, and those who knew Mercury best, loved him, and testify that beneath the glitz and glamour, there was a far quieter and very kind soul.

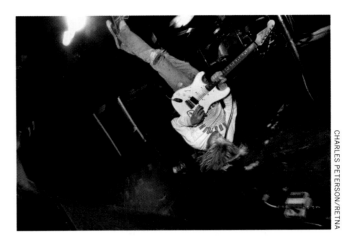

Kurt Cobain

1967~1994

BORN EVEN AS THE BEATLES were dying, he grew up on Beatles songs and always considered John Lennon his idol. It wouldn't have been thought in the 1980s that Washington state was a particularly fertile breeding ground for future rock stars, but Cobain and his friend Krist Novoselic helped to make it so after they formed the band Nirvana in Aberdeen in 1985. Incorporating heavy metal and punk sensibilities and sounds, but always with an ear for a Beatlesque melody, Nirvana became the spearhead for what was known as, alternatively, "the Seattle scene" or "grunge rock." Pearl Jam and Soundgarden would follow, but first Nirvana broke through.

They did so, big time, in 1991 with their second album, *Nevermind*, which contained an anthem of sorts: "Smells Like Teen Spirit." Cobain (above, in '91 in Vancouver, Canada) wrote and sang the songs, and became a reluctant spokesman for Generation X. It is too easy to say the pressures of this fame led to his drug use. The product of a broken home, a belligerent adolescent long before he became famous, Cobain was well versed in alcohol and drug abuse before *Nevermind* was recorded. By the time Nirvana was asked to star on *Saturday Night Live*, he was a full-blown heroin addict; in fact, he took the drug on the day of the gig. His wife, Courtney Love, arranged an intervention, and Cobain entered rehab. But he literally skipped the fence at the clinic, flew back home to Washington and, unable to escape his demons, ended his life with a gun.

It needs to be understood: The young people who revered Nirvana—and particularly Kurt Cobain—were devastated in a way that Lennon's fans had been, Elvis's had been, Judy's had been. This was the same magnitude of loss.

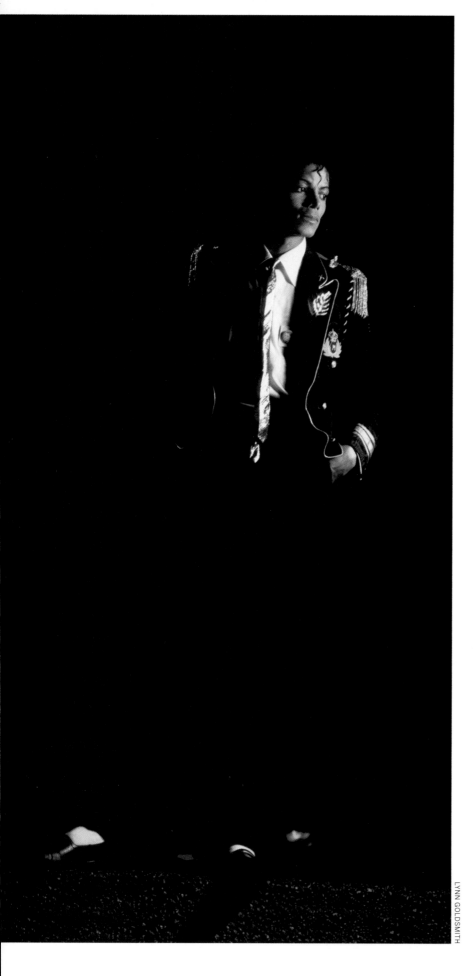

LYNN GOLDSMITH

Michael Jackson

1958~2009 THE KING OF COUNTRY: gone too soon. The king of the blues: gone too soon. The king of soul: gone too soon. The king of rock 'n' roll: gone too soon. And then, in 2009, the king of pop (whether he was self-proclaimed, or anointed by his friend Elizabeth Taylor): gone too soon.

In the beginning, it all seemed so sweet and innocent: These five talented kids from the Jackson family of Gary, Indiana, could dance and sing, and the little one up front, Michael, was really something else. The Jacksons had a bunch of Motown hits, guested on the *The Ed Sullivan Show* and became everyone's darlings.

Post-Jackson 5, the teenage Michael had a nice solo career going with the occasional hit ballad, like the one about the rat. And then the 1980s arrived: a decade that he had been waiting for, a decade that was waiting for him. He was ready to stun—to thrill—and the music and dance and even fashion worlds were eager to be stunned. He released the biggest album of all time; he moonwalked; he yelped; he changed everything overnight.

Many people focus on "world records" when seeking to define Michael Jackson, but as we close our book, we don't want to focus on records or numbers. We ask the question: Why do we feel that he was gone too soon?

Because we loved him. And lost him. And we knew that, when he left us, he had more to give and, just as important, he still wanted to give it.

This was so very true of Michael . . . and of all the many others who had come, and gone, before.

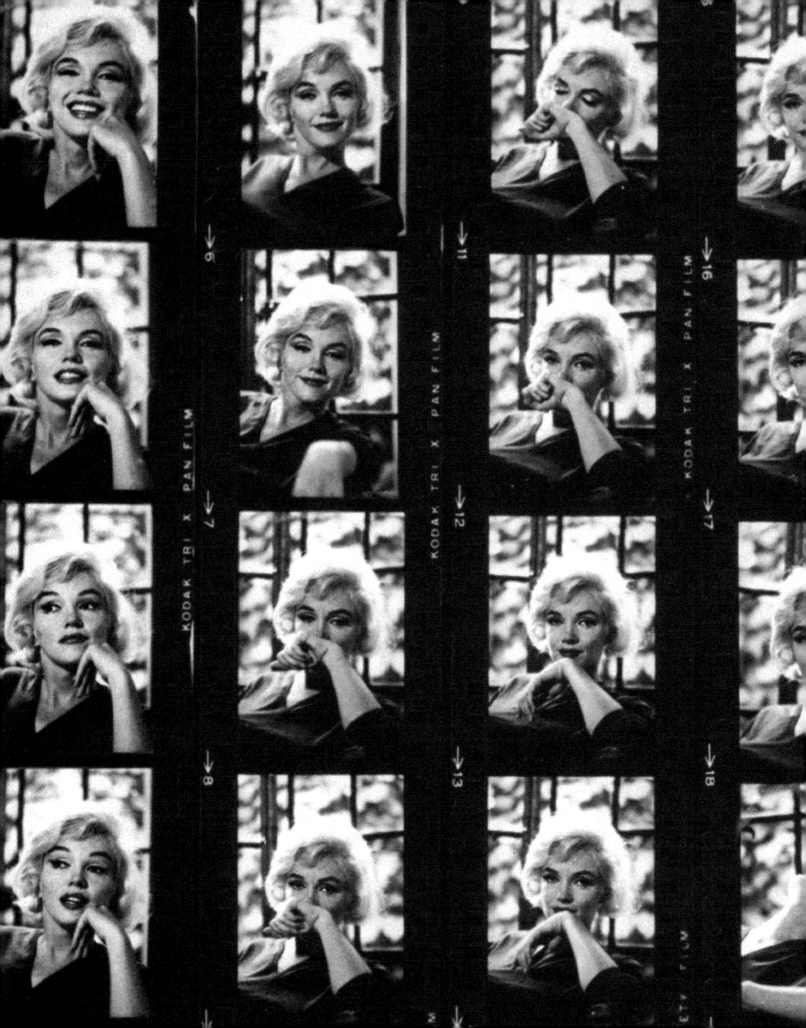